2.17 (3)

W9-CPP-916

TYLER PERRY'S AMERICA

TYLER PERRY'S AMERICA

Inside His Films

Shayne Lee

ROWMAN & LITTLEFIELD
Lanham • Boulder • New York • London

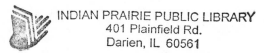

Published by Rowman & Littlefield
A wholly owned subsidiary of
The Rowman & Littlefield Publishing Group, Inc.
4501 Forbes Boulevard, Suite 200, Lanham, Maryland 20706
www.rowman.com

Unit A, Whitacre Mews, 26-34 Stannary Street, London SE11 4AB,
United Kingdom

British Library Cataloguing in Publication Information Available

Library of Congress Cataloging-in-Publication Data
Lee, Shayne.
Tyler Perry's America : inside his films / Shayne Lee.
pages cm
Includes bibliographical references and index.
Includes filmography.
ISBN 978-1-4422-4185-5 (cloth : alk. paper) — ISBN 978-1-4422-4186-2
(electronic)
1. Perry, Tyler—Criticism and interpretation. I. Title.
PN1998.3.P4575L44 2015
791.4302'33092—dc23
2014046661

♾ ™ The paper used in this publication meets the minimum requirements of
American National Standard for Information Sciences Permanence of Paper
for Printed Library Materials, ANSI/NISO Z39.48-1992.

Printed in the United States of America

CONTENTS

INTRODUCTION

Early in Tyler Perry's seventh film, *Madea Goes to Jail*, Madea's trail of unpunished crimes and indiscretions catches up with her and a prison sentence seems probable. Pondering the matter, Mr. Brown, a recurring madcap character in Perry's movies, forecasts a gloomy fate for Madea: "Well she's going to jail this time, to the big house, prison, the slammer. They're going to lock her up, press her down, shake her together, and run it over and it's going to be in her bosom!" When I first heard Brown's bizarre prediction, I almost fell out of my chair chuckling. But some people seated near me in the jam-packed theater were not laughing. Perhaps they missed the punch line because they didn't clue in to the source underlying the logic of Brown's zany misquotation: the Bible!

Tyler Perry's Christian upbringing likely exposed him to many preachers and congregants reciting the King James Version of Luke 6:38: "Give, and it shall be given unto you; good measure, pressed down, and shaken together, and running over, shall men give into your bosom." There is no mistaking that Perry is appropriating this popular scripture, presuming his Christian patrons will appreciate the ironic hilarity in hiding an immensely optimistic biblical sentiment within Brown's grim prognosis for Madea. The filmmaker's stealthy use of biblical satire corroborates his uncanny ability to signify Christian culture within the comedic texture of secular movies.

Tyler Perry's artistic instincts have long and rich ties back to the days of his youth attending Greater St. Stephen Missionary Baptist Church

in New Orleans—a point the church's leader, Bishop Paul Morton, inadvertently alluded to when Perry came back to address the congregation in 2006. Standing next to his former member, Morton joked that Perry's acting career did not begin with his plays and movies but as a young member of Greater St. Stephen's choir, pretending that he could sing. While the bishop's playful banter generated laughter from his congregants, it rings remarkably true. Tyler Perry's artistic career did in fact begin in the choir singing songs within an energetic worship experience at a black mega church. Perry discovered early on that religion could be upbeat and fun, and would later infuse many of his films with the pulsating gospel music and theatricality he enjoyed at Greater St. Stephen. As a filmmaker, Perry embodies many of the same pragmatic ideals, existential resources, and aesthetic folk-cultural vitalities that keep black mega churches crammed with members every Sunday.

This book offers a fresh look at one of the most highly successful African-American filmmakers of any generation. Through a rigorous evaluation of his movies, I present Tyler Perry as an innovative filmmaker who contributes immensely to our understanding of race, religion, and modernity in the post–civil rights era. A central theme of this work discusses how Tyler Perry's movies are profoundly descriptive of social conditions in their scope and even more inspirational and instructional in their reach. They offer lenses through which we can see representations of modern life in all its triumphs and challenges and provide prescriptive "re-visions" for how social conditions can improve. Perry's films depict African Americans achieving multiple levels of status and professional privilege, but also address and critique what he perceives as the excesses of modern living. In all their slapstick humor, musical wizardry, and religious imagery, Perry's films inspire deep levels of personal reflection and instruct the "post-soul" generation on how to handle the vicissitudes of their era.

Simply put, this work situates the distinct features of Perry's appeal within an overall assessment of his dual function as a cinematic curator of black lives and existential healer of black pains. Studying Perry's dual role as curator and healer explicates how the filmmaker's unique place in American cinema rests in the ways in which his movies deploy religious, cultural, and social artifacts often neglected in Hollywood films, while simultaneously inspiring penetrating contemplations on existential themes such as freedom, self-discovery, personal healing, citizen-

ship, familial responsibilities, social relationships, hope, and forgiveness.

ART IMITATES LIFE

My curious inquiry into the mechanics of Perry's cinematic dynamism and appeal led to an understanding of how the filmmaker's artistic assets emanate out of his own life story. Perry's aforementioned early membership in a black mega church is only part of the preparatory equation. His childhood struggles, lifelong exposure to a wide range of Southern folk significations, and class journeys on both sides of the socioeconomic track also offer him much fodder for filmic explorations and therapeutic mediations on surviving and thriving in the post–civil rights (or post-soul) era, the epoch beginning in the late 1960s and continuing to this day. Hence, the ways in which the filmmaker's early life provided paint for his cinematic canvas cannot be overstated.

In the Special Features section of the DVD for Perry's first movie, *Diary of a Mad Black Woman*, actor Shemar Moore, who plays Orlando in the movie, is asked, "Who is Tyler Perry?" to which he responds, "I think he's dazed and confused and luckily found Hollywood to where he could just put all his issues out there for the people to see, and everybody called it talent." Perry jokingly confirms Moore's saucy assessment in the same section of the DVD when he states, "Tyler Perry is crazy as hell!" Shemar Moore and Perry playfully allude to an important psychotherapeutic dimension of Perry's artistic consciousness derived from the filmmaker's own difficult childhood. Long before an episode of *Oprah* inspired him to begin writing as a means of cathartic release, young Tyler was escaping into different worlds and creating imaginary characters to distract himself from depressive aspects of his life mostly instigated by his father's alleged bullying. Oprah Winfrey's advice to write about your pain prompted Perry immediately to channel those imaginative escapes toward the achievement of an artistic apparatus of existential empowerment.

The practice of addressing issues of pain and providing medicinal solutions quickly became a vital component of Tyler Perry's artistic energies, first as a means of self-therapy, next as a professional tool in his own theatrical productions, and later in his movies and television

sitcoms. Perry discusses in the aforementioned Special Features section how he finally learned to forgive his father, which explains why forgiveness remains a salient theme in his artistry. Perry works out the pangs of his childhood and the demons of his past through his art, offering pragmatic assets that many moviegoers find useful toward negotiating their own tragedies and disappointments.

Perry's artistic resourcefulness also has important ties to growing up in the dynamic and complex city of New Orleans. Music and eclectic dispatches of folk culture that now infiltrate his cinematic appeal surrounded him as a precocious child. Perry recounts in interviews how trips to Bourbon Street allowed him to gauge and uncover vastly diverse strands of the human condition. And the fact that Perry worked at a prominent hotel in the French Quarter only highlights his strategic positioning to catalog a bevy of personalities. New Orleans gave young Tyler a bird's eye view of the abject poverty and harrowing social challenges that plague the city and surrounding area. His own humble socioeconomic positioning and struggles within that experience inform his ability to offer filmic engagements of complex urban problems.

But in addition to attending a thriving black church, enduring a troubled childhood, transcending humble beginnings, and growing up in a culturally vibrant and complex city, an even more fruitful educational experience within Perry's filmic training resided in his early excursions in directing and performing in front of African-American audiences as a playwright. Tyler Perry's professional career as an artist began not as a filmmaker but as an actor, writer, and director of his own theatrical productions. Perry left New Orleans for Atlanta as a young adult in hopes of striking it big in theater. Between 1992 and 1998, Perry's early to mid-twenties, he endured six years of harsh living conditions and disappointments until he received his big break in 1998 in the form of a sellout play in Atlanta that opened new doors for more plays and larger audiences. Perry quickly became an immensely popular playwright within the urban theater circuit, an appendage of theater halls and public spaces that hold African-American artistic productions in cities nationwide. By the early 2000s Perry was one of the most popular black playwrights in the nation, drawing thousands of people to his plays and generating generous DVD sales of those performances.

Perry's early theatrical career is important for reasons beyond jumpstarting his vocation as an artist. If Perry's Southern upbringing, Chris-

tian experience, and familial struggles helped fashion in him the kind of artistic proclivities and cultural capabilities that would later resonate with many needs and tastes of contemporary African Americans, his theatrical career provided space to practice incorporating those cultural tools into his artistry. Spending countless hours before live audiences honed his comedic timing and sharpened his ability to create scenes that elicit passionate responses, helping him distinguish theatrical tactics that don't work from those that do. In the Oprah Winfrey Network's 2011 special on him for its series *Visionaries: Inside the Creative Mind*, Perry confirmed that his plays functioned as fruitful dramaturgical experiments for his films, pointing out that "there is no better training than just sitting there in front of 10,000 people letting them tell you this is good or it's not." Similarly, in the Director Commentary of the DVD for his film *Madea's Family Reunion*, Perry states, "I'll never abandon theater because the live experience gives me what works on film so I love to test it first before it's permanent."

Traveling the nation as a writer, actor, and director imparted an important edge to filmmaking, making Perry a lay ethnographer of African-American audiences. But the fact that Perry's widely successful plays eventually secured him a national following, years before he ventured off into film, was even more relevant to his cinematic entree and success. Tyler Perry came to the risky and costly field of film having already secured a loyal African-American fan base nationwide through his plays. And so after experiencing initial skepticism from Hollywood executives and investors who viewed black audiences as unpromising targets for cinematic endeavors, Perry was able to leverage his prolific patronage to venture into cinema with his debut effort in 2005, and to do so in a way that allowed him to break all the rules of Hollywood branding and gatekeeping. As the first filmmaker to wield black Southern populist power in Hollywood at little risk of insolvency, Perry has enjoyed the privilege of writing, directing, and producing movies of his choice and building a large production studio.

As a result of his ability to connect with largely African-American audiences, Perry films have been indisputably profitable. For example, his first movie, *Diary of a Mad Black Woman*, generated sales almost ten times its budget, and his aforementioned film *Madea Goes to Jail* grossed over $90 million even though its budget was under $20 million. Most of Perry's films double or triple their budget at the box office,

placing him in exclusive space as a cinematic artist who can freely choose his content, themes, and actors without worrying about conforming to obtrusive prescriptions for economic viability. Perry's profitability allows him to indulge in casting underrepresented ethnicities, unconventional body types, and underexplored existential themes in mainstream Hollywood films. Perhaps Perry is the only filmmaker who could pull off casting meaningful roles for elder stateswomen like Maya Angelou and Cicely Tyson in the same movie (*Madea's Family Reunion*), providing scene-stealing roles in two movies for a neglected black legend like Louis Gossett Jr. (*Daddy's Little Girls*; *Why Did I Get Married Too?*), and twice featuring the comedic capacities of Sofia Vergara long before the Latina actress emerged as an international star and sex symbol (*Meet the Browns*; *Madea Goes to Jail*). This is a development with great sociological relevance: a black Southern folk-religious filmmaker enjoying unprecedented freedom and power to produce movies that exhibit the cadences of his intriguing path.

BOOK OVERVIEW

Tyler Perry's America: Inside His Films is generated out of a quest to gain a clearer understanding of the social components of Perry's cinematic artistry and appeal. This work underscores how Tyler Perry's movies are sociologically relevant for understanding the complex dimensions of black modern identities and experiences. In the same vein that scholars are beginning to explore how black mega churches and superstar preachers serve as prisms through which we can envision broad social and cultural changes within this post–civil rights epoch (Harrison 2005; Lee 2005; Lee and Sinitiere 2009; Walton 2009), this book presents Perry's emergence as a construction in the backdrop of post-soul proclivities and tensions and explains how Perry's appeal resides in projecting those tendencies and conflicts through his characters and plot developments. Each chapter unfolds Perry's dual role as cinematic curator of the triumphs, complexities, and challenges of black modern lives and as existential healer of the struggles and misfortunes of black modern pains.

Chapter 1 shows how Perry gives careful filmic attention to the dividing continuum between black socioeconomic promise and despair.

His romantic comedies walk that fine line between the absurd and the painful, presenting the devastating effect that drugs, the loss of manufacturing jobs, the problem of securing affordable housing and child care, and the vicissitudes of working-class survival have on contemporary black lives. But his movies also celebrate the beauty and efficacy of black privilege by creating more professional and highly educated African-American characters than perhaps any contemporary mainstream artist. Perry's movies display how the post-soul era represents a paradox of unprecedented professional accomplishments and black aristocratic privilege juxtaposed to a growing underworld of black urban chaos. Perry's partial solution to some of the complex social problems his films tackle is a synergistic relationship between privileged African Americans and those in need.

Whereas social scientists, journalists, and activists often portray black working-class vulnerabilities as primary identity markers of black urban experiences, Tyler Perry refuses to limit his representations of poor or working-class blacks as pathological and needy. Instead, he often positions positive black working-class characters as existential mentors to their more privileged African-American counterparts who, while enjoying economic comforts and high status, need to learn how to live more empowered lives from the filmmaker's perspective. So if chapter 1 establishes how Perry's movies create intra-racial connections in which black elites offer economic or professional resources to help the less fortunate, chapter 2 shows how Perry situates working-class blacks as harbingers of valuable existential resources that can mentor high-status African Americans on how to live healthier and happier lives. His movies convey that a synergistic connection to black folk-cultural conduits can help professionals and elites get back on the right track toward fulfilled and satisfying lives. Hence, a profound facet of Tyler Perry's populist appeal posits the privation of black privilege through the remedial gaze of black working-class composure.

From Shakespeare's play *Hamlet* to contemporary movies like *Thelma and Louise* (1991), mad characters have been the hallmarks of creative displays of female power in art. Chapter 3 shows how Tyler Perry builds on this artistic treasure trove of female erratic subjectivity through the hot-tempered behavior of Madea, whose madness is reckless and dangerous but also medicinal and instructive for weak-willed female counterparts. The chapter argues that scholars who are blithely

dismissive of Madea often overlook her import as Perry's apotheosis of muscular interiority. Perry uses Madea's madness as safe space to transgress bourgeois conventions and satirize black folk culture, Christian theology, and modern parental mechanics. The same way Ophelia in her maddened state in *Hamlet* represents obstructions to the gendered norms and tastes of Renaissance European aristocracy, Madea's madness reflects abrupt disconnections from late-modern civility and black Southern respectability politics. Other characters in Perry's oeuvre also defy the constraints of convention and civility, expand their subjectivity, or punish powerful bullies through temporary bouts of madness. So this chapter shows how madness in Perry's movies goes beyond slapstick exuberance to serve more important existential functions.

Similarly attentive toward unraveling the pragmatic functions of Perry's artistry, chapter 4 reveals how part of Perry's emergence as the most profitable African-American filmmaker of his generation involves the vibrant gospel music soundtracks, riveting worship services, and creative preaching moments encapsulated within his cinematic contributions. Perry's movies tap into folk-modern synergies and tensions, speaking to the ways in which populism and spiritual vitality interact within late-modern iterations of contemporary black life and popular religious cultures. But chapter 4 also considers how Perry's spirituality is quite ambivalent, as his movies celebrate human freedom and existential ideals in ways that often challenge traditional assumptions within his Christian heritage. And so while Perry has done more than any of his contemporary filmmakers to incorporate black church cultural forms and Christian sentiments into his movies, when religious tradition stands in the way of individual freedom and health, Perry is willing to renegotiate this terrain in ways that might be upsetting to more traditional Christians. Similarly, Perry's modern take on black spirituality has the tendency to accentuate the power of human initiative and minimize divine providence and intervention. Hence, chapter 4 shows how Perry's cinematic representation of religion is quite complex in the ways in which it both borrows from and renegotiates deeply held beliefs and practices within black church cultures and American Protestantism.

Chapter 5 demonstrates that the key to unlocking the mysteries of Perry's cinematic appeal commences with clarifying the filmmaker's own assumptions about the function of art. Cinema for Perry is a creative combination of dialogue, acting, music, existential empowerment,

and psychological therapy all meshed together for a dynamic entertaining experience. While Perry's pragmatic perspectives emanate out of his own artistic impressions as an autodidact, a careful exploration of his movies demonstrates teleological principles guiding his work, some of which are conversant with a larger American pragmatist tradition of artistic production. Chapter 5 presents five functions of art that are implicit within Perry's approach to filmmaking. Perry envisions his cinematic craft as safe space to commemorate and revise deeply held beliefs and sensibilities concerning love, faith, and family. His artistic dynamism is intimately interconnected with the promise and pain of contemporary African-American experiences as well as with many layers within his past involvements, so his pragmatic functions for art inform his appeal to masses of post–civil rights black Americans. His movies draw upon black Southern folk-cultural excesses and distortions in ways that not only tap into symbolic resources often ignored by mainstream American art but also offer audiences slapstick reprieves from the strictures of modern civility and decorum. But Perry's movies go well beyond an entertainment function to help late-modern African Americans diagnose and reevaluate what the filmmaker perceives as disempowering habits and perspectives.

The appendix establishes how this careful exploration of Perry's movies brings together three promising yet underdeveloped directions within the broader discussion of black cinematic representation and the social import of film. In doing so, this book builds on a vibrant sociological framework within cinema studies that treats movies as creative terrain to address and assess new dimensions within African-American experiences.

In adopting an approach that is driven by curiosity not condemnation, this work brokers a newfound respect for the consumptive choices of Tyler Perry's fans. Quite the reverse, scholars who dismiss Perry's movies often approach Perry's largely African-American fan base as if it needs parental protection. For example, Robert Patterson (2011) asserts that Tyler Perry's success depends on his audience's lack of perception regarding how Perry's movies interact with large structures of patriarchal oppression. Likewise, in the 2012 symposium at Northwestern University entitled "Madea's Big Scholarly Round Table: Perspectives on the Media of Tyler Perry," while all of the panelists were dismissive of the artistic tastes of Perry's fan base, Daniel Black went so

far as to assert that African Americans embrace Perry's movies simply because they suffer from low self-esteem as a race of people. Journalists and scholars often insinuate that millions of African Americans who enjoy Perry's movies suffer from poor aesthetic judgment and are in need of intellectual or activist guides to introduce them to acceptable forms of black representation.

Resisting the notion that Perry's supporters need protection, this book envisions the typical moviegoer not as a gullible hostage to Perry's films but rather as a clever consumer choosing artistry that appeals to her own existential needs and cultural tastes. Mindful of the pragmatic resources Perry's films deploy, I distinguish the Perry moviegoer as a savvy customer who gets more bang for her buck. Just consider this: for the low price of a movie ticket, the Perry patron can ingest the self-motivation of life coach Iyanla Vanzant, the slapstick comedic capacities of the Wayans family, the gospel musical wizardry of the Winans family, the psychotherapeutic healing of an Oprah "aha moment," the folk-cultural depth of a Maya Angelou poem, the Madea-madness of a hip-hop track, and the exuberance and spirituality of a neo-Pentecostal worship service. Note that the preceding references—life coach Iyanla Vanzant, the Wayans clan of comedic performers and actors, the Winans family of gospel music stars, the late poet Maya Angelou, Oprah Winfrey, hip-hop music, and neo-Pentecostal churches—are all immensely popular among contemporary African Americans and provide assets similar to those that Perry's movies project in abundant supply. Hence rather than pathologizing the loyal Perry fan, this work appreciates her savvy to engage a vortex of cultural and existential resources every time she watches one of his movies.

This first book-length study of Perry's movies explores their socio-cultural relevance as windows through which we can gain a clearer understanding of race, class, and religion in the post–civil rights era. It strongly considers how Perry's unprecedented level of cinematic engagement with cultural tools from black churches; expansive employment of black actors; satirical deployment of black Southern tropes and vernaculars; bold representations of pressing social issues like drugs, poverty, and sexual assault; and normative recapitulations of the late-modern imagination in ways that celebrate black folk-cultural existential resources are enough to garner him space among the pantheon of today's greatest cinematic innovators. Hopefully my overindulgence in

highlighting the sociocultural components of Perry's cinematic dynamism will inspire future scholars to illuminate the distinct features of Perry's aesthetic contributions as auteur.

My methodological focus was powered by a sociological inquisitiveness to discover what Perry's films teach us about black modern lives, conflicts, triumphs, and experiences in the post-soul era. But such inquisitiveness approaches Perry as an artist, not a documentarian nor an empiricist, thus giving him great space to represent pluralistic components of the post-soul imagination from the filmmaker's perspective. And rather than preoccupying myself with deciphering whether Perry's movies reach particular standards regarding low or high art, I am deeply committed to gaining insight on how his ability to tap into new markets and resonate with millions of patrons draws strength from his own teleological perspectives on art, and how those perspectives shape his characters, themes, and plots. My methodology is also informed by my knowledge that Perry's artistic proclivities did not come ex nihilo but were incubated within his own unique experience as a young member of a vibrant neo-Pentecostal church, as a native Southerner of a complex city, and as a victim of abuse, tragedy, and pain, and other dimensions of his biographical trajectory.

Assessing Perry's films with a keen eye on his own teleological presumptions about art is a rupture from the prevalent practice that assesses Perry's movies (and black popular art in general) based on the evaluator's own ethical, representational, or political expectations for black art. For example, under such a practice, a womanist onlooker judges Perry's movies based on how they measure up to her womanist ideals. Similarly, a black nationalist keeps a tally on how Perry's movies fail to live up to alleged black-nationalist standards. In both cases, the evaluator functions as the monarch, treats the artist as one of her vassals, and pronounces judgments against the vassal when his work falls short of the monarch's decrees (or expectations). In this model, the aesthetician is the center of the artistic universe and the artist is relegated to following the aesthetician's dictates. Quite the reverse, a sociological approach to Perry's movies takes it for granted that the artist himself is the sovereign ruler of his artistic kingdom, which reassigns my role as aesthetician to that of a lowly sojourner seeking understanding on the interworking of that artistic domain. So in occupying the position of a mere sightseer within Perry's cinematic universe, my methodology is

similar to that of an ethnographer studying a new religious movement. Just as no ethnographer worth his weight in salt would challenge doctrinal positions or impose his own expectations on the new religious movement under study, I attempt to leave my own representational or political presumptions aside and try my best to understand Perry's vantage point within my analysis of his films. It is my belief that the delimiting of my role to that of a curious ethnographer inspires a deeper commitment to engage Perry's artistic universe with rigor and impartiality than if I were to approach Perry's movies with the goal of policing his films based on my political perspectives.

The methodological framework of my sojourn in Perry's artistic universe is a systematic examination of Perry's films beginning with his debut effort in the 2005, *Diary of a Mad Black Woman*, all the way through to his 2012 film *Good Deeds*, with the exception being *For Colored Girls* (2010), which I omitted from the study because another artist's classic play inspired it and I was only interested in pursuing Perry's original efforts. In all eleven movies covered in this study, Perry was the writer and director, with *Diary of a Mad Black Woman* as the exception, a movie he wrote but did not direct. I watched each movie no less than ten times, carefully coding and cataloging themes, plots, and character development regarding their relation to pertinent sociocultural themes. My goal was to approach Perry's characters, scenes, and plots with the same impartiality and meticulous attention to detail that our leading Elizabethan aestheticians extend to Shakespeare's plays. And my manifold comparisons between the early-modern playwright from Stratford and the late-modern filmmaker from New Orleans throughout this text unmask my appraisal that William Shakespeare and Tyler Perry have much in common as custodians of the social geographies of their eras and as existentialists exploring the deepest crevices of the human condition.

1

THE DREAM AND THE NIGHTMARE

Perry's Socioeconomic Crossroads

Tyler Perry's film *Good Deeds* features the unlikely convergence of two African-American characters from opposite sides of the tracks. Wesley is a fourth-generation Ivy League graduate who is running his late father's investment company, and Lindsey is a struggling single mom and janitor. While Wesley and Lindsey work in the same building, a wide gulf of social distance separates them. Their budding relationship narrows the chasm for a combustible existential experiment that ultimately enriches both of their lives. *Good Deeds* is not the first of Perry's films to place a highly successful leading character in close proximity to a working-class sojourner. *Daddy's Little Girls* features a working relationship that morphs into a romantic connection between an auto mechanic and a corporate attorney, and *Meet the Browns* juxtaposes a former professional basketball player with an unemployed working-class mother of three. Perry's interclass contrasts are windows through which we can explore socioeconomic crossroads for African Americans in the post–civil rights era.

Tyler Perry's life arc is as much a socioeconomic crossroads as are the interclass relationships in his films. He was born in 1969 and grew up in a city where black progress is visible and impressive, right alongside a more daunting display of black desolation, making New Orleans both a fascinating and troubling place brimming with paradox. New Orleans brands itself as a festive city, replete with party life, second-line

parades, and prominent black politicians and businesspersons running the city. But when you sneak a glance behind the festive facade, you see a dire educational system, dysfunctional institutions, and generations of structural inequality. The city's intoxicating cultural energies are made possible through the daily grind of a durable underclass of underpaid, poorly educated African Americans. Nothing did more to awaken national attention to the vulnerabilities of black poverty in New Orleans than Hurricane Katrina and its aftermath in 2005.

We should presume that much that informs Tyler Perry's cinematic representation of black working-class struggles against black privilege was birthed within his early experiences in New Orleans and his later travails as an up-and-coming playwright in Atlanta. This makes Perry an intriguing double agent of sorts, an artist who can speak to the challenges and contradictions associated with both sides of the post–civil rights socioeconomic divide. Perry knows firsthand the psychic turmoil of living in economic despair, while he also is quite cognizant of what it is like to be grafted into the upper stratosphere of status. In his early adult years living in Atlanta as a struggling playwright, he was repeatedly homeless; in his later adult years, he has lived in mansions and dined with the president. Perry's own life story along with his cinematic representations demonstrate the ways in which both a socioeconomic dream and absurd urban nightmare characterize life for many African Americans in the post-soul era. His movies curate the tensions and contradictions that exist between the vicissitudes of black poverty and the privilege and ease of life found in black wealth and success. But before exploring Perry's complex portrayal of the socioeconomic conditions in the post–civil rights era, it is important to underscore how the civil rights movement generated seismic change in American society by increasing the range of social mobility for African Americans.

CIVIL RIGHTS PROGRESS AND THE POST-SOUL CROSSROADS

The modern civil rights movement was a critical time in United States history involving over a decade of organized activity through protest marches, sit-ins, and other forms of activist unrest to challenge the structures of Southern segregation and state-sanctioned inequality. In

his seminal study on the civil rights movement, sociologist Aldon Morris (1984) discusses a tripartite system of racial domination in which African Americans were systematically limited to unskilled labor and menial jobs, excluded from political power and engagement, and culturally deprived as a socially segregated lower caste. While Southern states formed battlegrounds for organized protest against segregation, African Americans in Northern cities engaged a vortex of discriminatory institutions and social spheres and suffered from similar forms of social inequality and oppression. William Julius Wilson (1978) reveals that to be a black American in any region of the United States during the pre–civil rights years was to possess a limited range of social mobility because meaningful prospects for economic expansion were more mythic than actual. Elijah Anderson (1999) explains how most African Americans were virtually shut out from functioning as corporate executives, bankers, stockholders, and government agents in the early to mid-decades of the twentieth century.

A contingent of early American films captures the harsh conditions that characterized life for many African Americans in the pre–civil rights years. Powell Lindsay's *Souls of Sin* (1949) begins with a panoramic view of New York City, describing both its enchanting beauty and poverty-ridden slums, and then hones in on one of those slums as the backdrop for a story of three struggling black men who share a cramped one-bedroom basement apartment in Harlem. Released in the same year, Elia Kazan's movie *Pinky* (1949) offers a congruently depressive depiction of black rural poverty in the South. Dicey and her grand-daughter, Pinky, live in a shack, and most of the African Americans in the movie seem similarly destitute. In Michael Roemer's film *Nothing But a Man* (1964), when the protagonist, Duff Anderson, visits his young son and then his father in Birmingham, and when Duff and his fiancée, Josie, drive through a black neighborhood replete with shacks and broken-down houses to visit their own new place, which also looked unlivable until they fixed it up, we get multiple glimpses of the unpleasant living conditions of many African Americans in Alabama. The movie hammers home the point that there were very few job opportunities for black men in the South that didn't involve low-wage backbreaking work along with humble acquiesce to white domination. We see Duff Anderson's spirit slowly crushed by the forces of white supremacy and structural inequality. Zenabu Davis's *Compensation* (1999) and other films

reveal the vicissitudes of black poverty during the decades preceding civil rights legislation, as do numerous literary works. Richard Wright's novel *Native Son* (1985) presents one of the most candid delineations of the despair and destitution of black modern life in a Northern urban city in the 1930s, offering imaginative insights toward understanding the existential toll that such hopelessness imposed on the psyches of young black men.

Martin Luther King Jr.'s "I Have a Dream" speech from the steps of the Lincoln Memorial in 1963 envisioned a nation living up to its ideals and promise, looking ahead to a time when race will not preclude individuals from self-actualizing and living harmoniously with other Americans. King and other civil rights leaders confronted a durable racial legacy that disqualified many African Americans from participating in the full rights and privileges of American prosperity. Civil rights activism and legislation coupled with a booming 1960s economy helped facilitate radical change so that more and more blacks could climb the next rung of the socioeconomic ladder (Landry 1987). By the late 1960s and early 1970s, the beginning of the post–civil rights (or post-soul) era, we had already seen the removal of almost every major law that had permitted the structural or legal denigration of black people. As a result of affirmative action initiatives and civil rights legislation, the black middle class began to progress beyond owners of small businesses in segregated black communities to comprise an extensive range of professionals no longer dependent on or limited to serving those black communities (Anderson 1999). And as the nation began to take steps toward dismantling the residual effects of segregation, there was growing interest in integrating blacks in educational and employment sectors that had previously been closed to them. In this way, black middle-class expansion is a major accomplishment of civil rights activism, and its rise signaled a major shift in African-American lives (Pattillo 2013).

But the expansion of educational, professional, and political opportunities for African Americans only tells part of the post–civil rights socioeconomic story. While progressively more African Americans enjoy the requisite perks of the American dream, many more endure the residual hardships of poverty, social immobility, and structural inequality (Wilson 2009). So what we then have is a socioeconomic crossroads of epic proportions. On the one hand, the decades following the civil rights movement see the greatest epoch of black economic and social

progress, the highest level of blacks among the upper and middle classes, the highest number of black millionaires and college graduates in history, and unprecedented gains in almost every economic rubric of professional and social progress. But on the other hand, the same post–civil rights era unfolds depressing levels of black urban despair, drug epidemics that affect blacks disproportionately, unimaginable levels of violence, and the largest proportion of an ethnic group imprisoned ever known to any Western nation.

Perhaps no recent work better articulates the lingering legacy of racial inequality than Michelle Alexander's (2010) tome *The New Jim Crow: Mass Incarceration in the Age of Colorblindness*. Alexander contends that American life in the post-soul era has restructured racial caste through the rigorous incarceration of black bodies as the result of a drug war waged almost entirely against poor people of color. Similarly, sociologist Eduardo Bonilla-Silva (2013) points to haunting discrepancies between Dr. King's dream for a more equitable society and the actual state of affairs, documenting how blacks trail whites in almost every measure of socioeconomic vitality. Bonilla-Silva explains how a new racial ideology of color blindness allows for social inequality to persist as a covert system of racial inequality in which whites justify racial discrepancies in ways that ignore structural realities on racial lines. Numerous other scholarly and journalistic works document the structural destitution African Americans face in this epoch of post–civil rights despair.

One of the earliest and most imaginative mainstream artistic representations of black socioeconomic hardship in the post-soul era is the sitcom *Good Times* (1974–1979). The show is television's first treatment of social issues like gentrification, school busing, and the racial dynamics of IQ tests, as well as the first show to engage in a serious conversation about communism, affirmative action policies, sexually transmitted diseases, and the dire state of affairs of black urban schools. The show is also the first to offer a semblance of voice to pimps and prostitutes, drug addicts and drug pushers, while also revealing the negligent power structures that perpetuate inequality.

Good Times reveals the tragic absurdities entailed in black ghetto life in the early years of the post-soul era. Situated in the South Side of Chicago in a high-rise project complex, the show focuses on how the Evans family negotiates a daily deluge of disappointments. Through

their battle with poverty and inequality, we gain a clearer vision of the vulnerability of black people in marginalized communities. For example, when the police arrest the tall, lanky elder son, JJ Evans, on suspicion of armed robbery because he purportedly fits the description of the perpetrator, we later learn he does not look anything like the short, chubby teen the police eventually apprehend for the crime. The Evans family does not have the five hundred dollars for bail, so JJ has to languish behind bars until the police finally capture their new suspect. They eventually release JJ but not before he loses his new job once the employer learns of his arrest via the emerging technology called the computer. In this way, *Good Times* anticipates Michelle Alexander's (2010) finding that being poor, black, and marginalized in the post–civil rights era makes one more susceptible to wrongful treatment by the criminal justice system. Tyler Perry echoes Alexander's judgment with Candy's disproportionate prison sentence as a result of prosecutorial misconduct (*Madea Goes to Jail*) and Monty's false imprisonment on trumped-up sexual assault charges (*Daddy's Little Girls*).

Good Times also exposes the discomforts and cramped conditions of ghetto life. Five family members live in a two-bedroom apartment and the two sons spend their entire childhood with no room of their own, sharing the couch as their bed. The family has no car, no savings, no health care coverage, no reliable refrigerator, and no air-conditioning for those hot Chicago summers. They navigate life's challenges with barely enough resources to get by while living in a crime-laden high-rise project complex. Each episode unfolds the instability and vulnerability of late-modern urban life, as the sitcom reminds us of the socioeconomic destitution that characterizes life for millions of African Americans in the post-soul era.

While *Good Times* focuses primarily on the vicissitudes of urban poverty, the pioneering television sitcom *The Jeffersons* (1975–1985) symbolizes the divergent ways blacks from humble beginnings respond to late-modern competitive capitalistic environs through its wealthy industrialist George Jefferson and his maid, Florence Johnston. George pulled himself up by his proverbial bootstraps in a manner not unlike transcendent Americans such as Benjamin Franklin, Madam C. J. Walker, and Booker T. Washington, to own a cleaners empire. In contrast, Florence cannot shake a poverty-stricken fate as a maid. By placing the excesses of black privilege and progress adjacent to the toil

and despair of black marginalized life, *The Jeffersons* offers its viewers both humor and tragic absurdity.

In the sitcom's pilot episode, after learning that her new black employers own the high-rise apartment in the Lower East Side of Manhattan, Florence responds, "Well, how come we overcame and nobody told me?" Florence's question cleverly alludes to the popular civil rights song and sentiment "We Shall Overcome," demonstrating that Florence (and the show's writers) perceive George and his wife Louise's privileged social standing as fulfilling civil rights promise—promise Florence has yet to see manifest in her own life. Hence, the pilot episode reveals Florence's mindfulness of the social gulf between those African Americans like the Jeffersons, who are fortunate enough to live out Dr. King's dream, and those like her living in utter economic despair. The sitcom often plays with the disparity between the opulence of the Jeffersons and Florence's underclass status and gloomy prospects. For example, in the episode "Florence's Problem," the maid plans to end her misery with suicide. George, Louise, and their privileged friends find out about Florence's plan and eventually dissuade her, not by presenting a convincing case that Florence has much to live for, but by imposing upon Florence the obligation of nursing their own angst about the effect her suicide would have on them. So their very success in talking Florence out of suicide betrays the lack of meaning and optimism in Florence's life. This episode and the entire series explore the farce of a working-class character like Florence living with people who are enjoying a bigger piece of the pie and who are constantly eating that pie right in front of her face. Tyler Perry picks up right where *The Jeffersons* leaves off, differentiating those African Americans in the post-soul era who are enjoying the American dream from those enduring the nightmare.

PERRY'S PORTRAYAL OF BLACK PRIVILEGE

Tyler Perry showcases an impressive constellation of black elites and professionals in his movies and an even more notable aesthetic curating of their privileged lives. He features more black female professional characters than any other contemporary mainstream artist, with the possible exception of Zane, who creates black female judges, politicians,

doctors, lawyers, and entrepreneurs in her erotic short stories and novels (Lee 2010). Perry's movies are showpieces for the late-modern strides that black women and men have made since Dr. King's monumental "I Have a Dream" speech.

Tyler Perry's poster child for post-soul progress is Abigail (Abby) Dexter, the corporate executive played by Robin Givens in *The Family That Preys*. Charlotte Cartwright, a white Southern aristocrat and controlling shareholder of the Cartwright Corporation, hires Abby Dexter to run her prestigious company. Abby has not only an MBA in finance but also a law degree from Yale and fifteen years of experience in the industry. So Abby, then, is no black token in a white world of privilege but a highly qualified and sought-after asset that Charlotte poaches from another powerful corporation that had been enjoying record profits under Abby's leadership. Abby leaving one privileged position to secure another is indicative of new opportunities for African Americans that rarely existed before the civil rights movement. And she immediately makes her presence known at the Cartwright Corporation as a business savant who is conversant with the legal, financial, and strategic inner workings of a large corporation.

Charlotte is giddy about hiring Abby even as it antagonizes her son, William Cartwright, who feels he deserves the position. Tyler Perry does not whitewash the kind of resistance a black female executive like Abby Dexter might experience as CEO of a large corporation in the South, as William Cartwright and some of the board members resist her new authority. But Abby takes on powerful white male aristocrats without flinching, even while she remains a perceptive and caring leader. In Abby Dexter we have Perry's idealized expression of post–civil rights black promise: the elite education and ascent up the corporate ranks through ability and hard work, along with the black woman's triumph over white male power. Abby is part of Perry's cautious capitalist optimism, demonstrating there are places at the table for talented African Americans who can prove their value to corporations.

The protagonist Wesley Deeds (played by Perry) in *Good Deeds* is another character manifesting post-soul socioeconomic promise. While Wesley's familial privilege precedes the civil rights movement, as he is able to trace his lineage through four generations of Ivy League graduates, his father's company exploded in success around the start of the post–civil rights era with "a little help from affirmative action because it

was very necessary," as Wesley reveals in his conversation with Lindsey at the pizza shop. With this important comment, Wesley links the success of his father's company to progressive policies that were intended to certify a higher percentage of blacks enjoying the American dream. Upon his father's death, the corporation was passed down to Wesley, who now functions as its thirty-eight-year-old CEO. Wesley and his brother Walt, a petulant and troubled but talented and hardnosed executive, are Gen X black men at the helm of their family's powerful corporate legacy.

When Wesley and Walt acquire the company of their father's greatest rival, Mr. Brunson, we see the powerful imagery of two black young businessmen out-leveraging a white baby boomer. It is not by accident that both brothers end up playing different but equally crucial roles in their corporate takeover of Brunson's company. Perry's representation of young black executives wielding power in corporate America is emblematic of post–civil rights black progress. And later in the same movie, the very fact that Wesley makes the decision to leave his corporation at the height of its success and pursue philanthropic adventures like traveling around the world digging water wells and helping the less fortunate, is indicative of the kind of intriguing possibilities that come with post-soul privilege. Wesley's lifestyle and choices would have been almost unimaginable for African Americans in pre–civil rights contexts.

In Perry's third film, *Daddy's Little Girls*, Gabrielle Union plays Julia, a senior partner at her father's prestigious law firm. Like Wesley Deeds, Julia comes from a family of privilege, attends an Ivy League university, and demonstrates that lineage and social stratification can expedite post–civil rights black progress. We learn that Julia's father pushed her to be the best lawyer she could be, and that she was the youngest person in the firm to make partner. With her father retired, the thirty-one-year-old daughter runs his firm with iron fists. Julia never loses cases, and court justices often immediately recognize her by name and reputation. Whereas her social life needs radical intervention, Julia's professionalism and power in the legal arena demonstrate the promise and taken-for-granted entitlement for Gen X African Americans. In Julia, Perry offers us another glimpse at a powerful black woman forging ahead with a new vision of twenty-first-century corporate leadership.

Whereas Wesley and Julia hail from black privilege, the elite attorney Charles McCarter comes from humble beginnings. In Perry's debut movie, *Diary of a Mad Black Woman*, the opening scene shows Charles honored as the Jacob Feinstein Attorney of the Year, an award bestowed upon him in a posh gala brimming with urban sophisticates and Atlanta powerbrokers. Charles built a respectable law firm from scratch, and the awards ceremony demonstrates his prominence in his profession and in the community (even as a later chapter discusses one of the compromises Charles makes to achieve such great success).

Why Did I Get Married? and its sequel *Why Did I Get Married Too?* also display Perry's proclivity for including highly accomplished Gen X characters. Both films feature four couples, and the professional careers of the characters are quite impressive. Gavin runs his own architectural firm and his wife, Patricia, is a psychotherapist and bestselling author. The first movie begins with Patricia guest-lecturing at a university on her most recent book and ends with her receiving the prestigious Psychology Digest Award. Dianne is the top litigator of a prominent law firm and her husband, Terry, is a pediatrician. Mike is a well-connected attorney who plays golf with the police commissioner. Sheila, Mike's wife in the first movie, doesn't work during her marriage to Mike, which is a sign of privilege even though it leaves her in a vulnerable position when Mike divorces her. Marcus was a pro football player before getting injured and goes from being a barber at his wife Angela's salon in the first movie to the host of a popular sports television show in the sequel. Angela majored in chemistry in college but was unable to get a job in the industry, so she started her own beauty salon, using her chemistry training to create hair products for African-American women.

We should pause and consider how Angela's entrepreneurial wizardry is emblematic of Tyler Perry's own emergence as a capitalist success story. Unable to land a job in her area of interest, Angela relied on her grit and resourcefulness to use her chemistry education to be of entrepreneurial service to black urban communities, combining technological progression with black aesthetic needs. So Angela's success is symbolic of Southern post-soul entrepreneurial transcendence, a window through which we can understand Perry's cautious but hopeful embrace of capitalism as well as his own escape from humble beginnings by similarly meeting the existential needs and tastes of black urban communities. Both Angela and Perry offer intriguing blends of black folk

culture and modern sophistication and point us to the ways in which the Southern capitalist frontier creates unique spaces for creative sojourners who harness their environments and connect with free-market needs and tastes.

Most of Perry's films showcase professional careers as signs of socio-economic arrival for post-soul African Americans. In *Madea's Family Reunion*, Carlos is a successful investment banker and Madea's nephew Brian is a lawyer. Natalie and Kimberly are real estate agents for luxury homes in *Good Deeds* and *Madea's Big Happy Family*, respectively. Will, the son of the animated alcoholic Vera in *Meet the Browns*, is a gynecologist. Andrea transcends humble beginnings to earn an MBA in finance and work in that capacity for the Cartwright Corporation in *The Family That Preys*. In *Daddy's Little Girls*, Brenda and Cynthia are Ivy League grads; Joshua and his fiancée, Linda, are successful attorneys in *Madea Goes to Jail*.

In addition to featuring accomplished black characters, Perry's cinematic efforts epitomize the aesthetic beauty and conspicuous consumption of late-modern black privilege. His camera offers a voyeuristic exploration of materialism and an ease of life that only come with abundant resources. Whether it is shopping in an expensive store in Denver or Jet Skiing and lounging on a beautiful Bahamian beach, *Why Did I Get Married?* and its sequel showcase the perks that come with black professional life. In *Good Deeds*, Wesley and Natalie's expensive condo in San Francisco includes a scenic view of the city's skyline. Wesley drives an expensive car, and the company's headquarters are in a presumably costly building in downtown San Francisco. Wesley and Natalie even announce their breakup in style in a posh gathering at a beautiful resort.

Madea's Family Reunion presents many scenes that exhibit the pomp and circumstance of black privilege. The film begins with a well-designed peace offering from investment banker Carlos to his battered fiancée, Lisa, in the form of a path of rose petals leading from the bedroom to the bathroom where Lisa meets an elegant string quartet playing live music while she soaks in their deluxe gemstone bathtub. A few scenes later, the troubled tween Nikki seems very impressed with the fact that Madea's nephew Brian, an attorney, drives a Mercedes, assuming only a drug dealer could afford such a nice ride. When Lisa meets with her mother, Victoria, for lunch it is in a classy restaurant

where Victoria has valet service for her beautiful convertible. Carlos and Lisa dine at a fancy spot with another couple, listening to great live jazz, while the dysfunction of the relationship comes into play as they do their best rendition of the tango. Carlos lives in a beautiful high-rise condo and drives a captivating silver Mercedes Benz convertible, but perhaps the greatest symbol of his wealth is the impressive diamond engagement ring his fiancée sports throughout the movie.

In *Diary of a Mad Black Woman*, Charles McCarter owns a mansion with beautiful furniture and exquisite interior design. In *Daddy's Little Girls*, Julia's law firm is in a high-rise building overlooking Atlanta's skyline. Julia has her own driver, and her condo is so big that Monty has to ask for directions to find the kitchen during his first visit. There is no doubt that Tyler Perry indulges in representing black urban sophistication and opulence. His films offer a panoramic exploration of the posh optics and ritzy life that Perry himself finally had access to after he made his break from obscurity with his successful plays and then films. As he reveals in his commentary for the DVD of *Diary of a Mad Black Woman*, Tyler Perry actually owned and lived in the mansion featured in his debut movie. If the filmmaker finds fault with blind ambition and existential deficiencies of black capitalists and aristocrats, as the next chapter reveals, his camera eye seems nonetheless enthralled by the aesthetic beauty and ease of life that black elites enjoy. Perry does more than any other filmmaker in American cinematic history to show that there are African Americans out there enjoying the perks of privilege, even as the very same movies juxtapose such privilege against black characters struggling to make ends meet.

Perry pushes us to consider how the civil rights era created a landscape more conducive to black progress, one in which the fathers of Wesley Deeds and Julia Rossmore could build a successful investment company and an elite law firm in *Good Deeds* and *Daddy's Little Girls*, respectively, and pass on the privilege to their offspring. Perry's films capture this post-soul epoch of black social mobility with characters like Charles (*Diary of a Mad Black Woman*), Brian (*Madea's Family Reunion*), Joshua (*Madea Goes to Jail*), and Angela (*Why Did I Get Married?*) transcending their humble beginnings to become prominent professionals and enjoy the perquisites of their earned status. If the aforementioned television series *The Jeffersons* offers an early post–civil rights vision of black promise, Perry expands that vision to portray more

black Ivy League characters and professionals getting their piece of the pie than any other mainstream artist. But we should also note that Tyler Perry more extensively delineates the social problems and vulnerabilities that paradoxically make our late-modern landscape concurrently replete with despair. And as a cinematic curator of black urban desolation, Perry often portrays the devastating impact of drugs in his movies.

DRUGS AND THEIR REPERCUSSIONS

Within the trajectory of social ills is carved out prominent space for the drug epidemics that decimated African-American communities and families during the post–civil rights era. Numerous movies depict the effect of drugs on black urban environs. *Coffy* (1973) is a revenge film in which the protagonist, Coffy, blows off a dealer's head in the opening moments and kills various people in the drug trade throughout the film. *Super Fly* (1972), *Foxy Brown* (1974), and countless other films in the 1970s represent the effects of drugs on the streets and in the lives of African Americans. *The Brother from Another Planet* (1984) features a shipwrecked black alien getting his introduction to the fatal effects of the drug epidemic in the harrowing streets of Harlem when he discovers the corpse of an overdosed black teenager lying in the alley with a needle sticking out of his vein. In *Poetic Justice* (1993), Lucky has to rescue his daughter from the negligent care of her freebasing mother. *Sugar Hill* (1994) presents an ambivalent drug kingpin, Roemello Skuggs, who runs the streets, takes care of his junkie father, and contemplates leaving the game, while meeting the requisite challenges of a rival crew trying to take over his turf.

The introduction of crack in the 1980s makes Nino Brown and his drug-dealing enterprise quite wealthy and powerful in the movie *New Jack City* (1991). The film opens with news reports detailing the bad economy, drug wars, and dangers of the city and then cuts to Nino Brown and his boys dropping a man from the Manhattan Bridge into the East River. The film shifts back to the news reports detailing the rise in the number of addicted infants born in Manhattan-area hospitals and how the cocaine epidemic has severely depleted resources for pediatric care. Whereas Roemello Skuggs in *Sugar Hill* is a man of contemplation, wrestling with moral pangs about his participation in the

rough and violent drug trade, Nino Brown in *New Jack City* is a man of action, contemplating only his booming opportunities afforded by this new drug called crack. As if he were presiding over a board meeting of Fortune 500 executives, Nino offers a stirring motivational speech to his colleagues on how to turn the misery and desperation of the Reagan era into exploding crack sales: "Times like these people are gonna want to get high, real high and real fast. And this is going to do it," showing his captive cronies a vial of crack as if it were a new invention like the computer chip. And at the height of his power Nino declares, "The world is mine! All mine!" *New Jack City* expressively captures three levels of desperation regarding the post–civil rights urban drug trade: that of Nino Brown and his crew to expand their market share, that of addicts to do whatever it takes to get their next fix, and that of law enforcement to curtail the burgeoning drug trade and the violence that ensues. The movie adequately represents how crack invaded multiple sectors of city life, thus situating itself among the countless other films that have addressed the impacts drug trade and abuse have had on cities and the families who live in them. Building on the urban flicks of the post-soul era, Tyler Perry explores multiple dimensions of how drug wars and addictions affect black families and communities.

The Drug Dealer

In Perry's third movie, *Daddy's Little Girls*, we see both a community and a particular family threatened by the terrifying reign of Joe, the drug kingpin who, like Nino Brown, wreaks havoc on those around him. Jennifer, the former girlfriend of the protagonist Monty and mother of Monty's three children, now dates Joe, and hence Joe's dealings impact both Monty's community and his three daughters, who eventually come to live under Joe's roof. Earlier in the plot we meet Jennifer's mother, Miss Katherine (Kate), who has custody over Monty and Jennifer's daughters and is dying of lung cancer. Miss Kate spends her last moments terrified by the prospect of Jennifer gaining custody of the girls after her death, primarily because her daughter is dating a drug dealer.

So with *Daddy's Little Girls*, Tyler Perry demonstrates drugs as a force powerful enough to terrorize a community and alienate a mother from her daughter. Perry invites us to imagine how painful it must have been for a deteriorating Miss Kate to dash over to child services and file

a recommendation that Monty receive custody of the girls, believing her own daughter would not make a suitable parent. It is this perceived act of betrayal that prompts Jennifer to remain resolute in winning custody over her daughters just to spite her deceased mother and Monty. After Jennifer gains custody, her boyfriend is able to inflict psychological and emotional trauma on Monty's girls, exemplifying the plight of many children who grow up under the tutelage of treacherous drug dealers. For example, the girls are horrified when they see Joe and Jennifer beat up one of their dealers right in their living room for coming up short.

The threat of the menacing drug dealer getting one of his boys to harm or kill Monty is present throughout *Daddy's Little Girls*. Joe is able to compel Monty's daughter Sierra to bring marijuana to school to sell to her peers because he threatens to kill her father if she refuses. And after Sierra gets caught in school with the marijuana and Monty and Joe scuffle in the principal's office, Joe warns Monty, "These are my streets. Do yourself a favor Monty, live!" reminding Monty that he can arrange things so that they won't even need a custody hearing because Monty will be dead. Similarly, Jennifer makes multiple threats to Monty that at her command, one of Joe's boys is ready to shut him down. The movie proffers the clear and ever-present threat of Joe's power to impose his will upon everyone around him, including Monty. With Joe and Monty's hostile relationship, Perry represents the antagonism that often exists between working-class men who work hard legally to pursue the promise of the American dream, and those like Joe who gain power and affluence through illegitimate means—with both sharing geographic and social space. Joe's ability to impose his will on Monty and his community is a recurring theme as Monty is left with few options to protect his daughters from the dealer's insidious influence, legion of lawyers, and battalion of thugs. We learn from Aunt Rita that Joe visits schools and recruits children to sell drugs to their peers, showing another vulnerable population affected by Joe's reign. Community residents are too fearful to testify against Joe to help legal authorities to make a case against him. Monty's act of defiance at the end of the film inspires his fellow residents to finally stand up against Joe and his goons and take back their community.

Jamison Jackson, the drug dealer in Perry's first movie, *Diary of a Mad Black Woman*, also represents a greedy urban conqueror willing to

protect his empire at all cost. The next chapter elaborates on Jamison's treachery and violence as a drug dealer. Both films remind us that ominous dealers like Joe and Jamison do exist and that their power has destructive influences on families and communities. But Perry's oeuvre is not limited to one-dimensional drug dealers. His movies also portray them more sympathetically as troubled young survivors facing bleak employment prospects.

In *Meet the Browns*, we encounter the protagonist, Brenda Brown, a struggling mother of three; her eighteen-year-old son, Michael Jr.; and his friend Calvin, a young drug dealer. Unlike Perry's aforementioned kingpins Joe and Jamison, who are driven by greed and power, Calvin chooses drug dealing as what he perceives as his only means of survival. Whereas Brenda is suspicious and hostile to Calvin, perceiving him as a threat, her son, Michael, has a rounder view of the context that shapes Calvin's decision to deal drugs. Calvin's mother dies when he is young and so dealing serves as Calvin's preferred way out of poverty, a fate Michael too pines to escape. And there is a point later in the plot when Michael, fed up with the pangs of his poverty-stricken plight, turns to Calvin to join his drug-dealing enterprise. The fact that Michael, an idealized and heroic young character within the movie, succumbs to the temptation of selling drugs is Perry's way of humanizing urban drug dealers, many of whom are black teens like Calvin and Michael facing paltry prospects for economic stability. If drugs are a rational response to insanity as Chon claims in Oliver Stone's movie *Savages* (2012), then Calvin and Michael might add to Chon's sentiment that selling drugs is a rational response to the depressing alternatives of black urban life.

Perry's treatment of Calvin as a troubled young survivor is round and penetrating. Early in the movie we see Michael playing in a basketball game for his school and struggling on the court trying to fix his beat-up tennis shoes, a shameful predicament that troubles his mother, Brenda, who can't afford to buy new ones. The camera cuts to Calvin seated in the bleachers watching his friend Michael work to fix the mishap. The troubled look on Calvin's face foreshadows the drug dealer's later decision to surprise his buddy with a new pair of tennis shoes. Even when Michael later reneges on dealing drugs with him, Calvin understands. Perry constructs Calvin as a young black man viewing drugs as his only lever to lift himself out of the reach of poverty and social inequality. But Perry refrains from romanticizing Calvin's precarious occupation. To-

ward the end of the movie, rival drug dealers attack Calvin, demonstrating the dangers inherent in such an occupation. Although Calvin escapes, Michael, who was not dealing drugs at the time, gets shot in the cross fire. Hence, even as Perry sympathizes with Calvin's plight, he doesn't whitewash the pitfalls that accompany dealing drugs.

Perry's later film *Madea's Big Happy Family* poignantly raises the question, what happens when a retired young drug dealer tries to get on with his life? The movie offers a quite sympathetic depiction of an eighteen-year-old former drug dealer named Byron who recently endured a two-year prison stint and is now resolved to stay out of trouble. Perry's treatment of Byron's post–drug dealing phase is true to Michelle Alexander's (2010) assessment that young ex-convicts are marginalized and stigmatized for life after their release from prison and face dim economic prospects. Byron makes only a thousand dollars a month at his warehouse job, and after giving his baby's mother, Sabrina, almost a third of his paycheck, he is left with only seven hundred dollars for a full month's expenses. His selfish girlfriend, Renee, constantly reminds him how his low wage stands in stark contrast to the money he once made selling drugs.

Byron negotiates both the oppressive demands of his toddler's mother, Sabrina, and the greed and selfishness of his girlfriend, Renee, while armed with meager resources. After Sabrina has him put in jail for running behind on child support payments, Byron loses his job and suddenly has no income. Angry with his mother for harboring a family secret about the identity of his true biological mother, and facing the pressure of supporting his son and girlfriend, Byron finds himself in a nihilistic tailspin regressing back to drug dealing. His mother's deathbed exhortation inspires Byron to take the right path, and the movie ends with him refusing to sell drugs, breaking up with his selfish girlfriend, and pledging to support his baby's mother.

So in *Madea's Big Happy Family*, Tyler Perry contextualizes a young man's flirtation with returning to dealing drugs even as the filmmaker's existential message points to Byron's agency to overcome the temptation and protect the best interests of himself and his son. Perry captures the limited prospects of a young black ex-convict without sacrificing his existential responsibilities. With Byron's struggles and progression, Perry reveals both why it is so tempting for young black men to resort to selling drugs and why young black men should make better choices to

secure better futures. Whereas hip-hop tracks often glorify urban drug dealers, while media outlets, politicians, and religious leaders often make dealers scapegoats for all urban problems, Tyler Perry's films represent the drug dealer archetype from both the perspective of the obtrusive power it wields through violence and intimidation, and that of the sympathy it generates for young urban poor people struggling to make ends meet with few prospects.

The Drug Addict

Perry also offers a panoramic view of how drug addiction impacts communities, families, and addicts. In Perry's first movie, *Diary of a Mad Black Woman*, Debrah becomes an addict, which tears apart her family. Perry refuses to sugarcoat the perils of addiction, as Debrah appears throughout the movie unkempt and living on the streets, while her husband, Brian, and their kids miss their wife and mother. In one touching scene, Brian allows Debrah back into the home for a meal but then kicks her out even though she has no place to go, reminding her of how his previous acts of kindness led to her abusing his trust. Debrah begs Brian to let her stay in their home, telling her husband that she can make him feel good. This quid pro quo overture captures the absurdity of addiction: a wife attempts to seduce her vulnerable husband to stay in their home, and the husband must refuse to let her stay in order to protect himself and his children.

In *I Can Do Bad All by Myself*, an unnamed daughter of Mama Rose died of a drug overdose before the start of the movie. In light of her daughter's death, Mama Rose had to take guardianship over her three grandchildren, Jennifer, Byron, and Manny. As the plot unfolds, we learn more about the trauma the three kids faced in earlier years having a mother as an addict. Their mother placed them in dangerous predicaments, including swapping Jennifer for drugs and almost putting Manny in the oven when he was a baby. Manny's diabetes and asthma and Byron's learning disability are attributed to their mother abusing drugs while pregnant with them. We also learn that Mama Rose was really too sickly and old to take care of three rambunctious children. Perry shows the sacrifices that thousands of weary grandparents like Mama Rose have to make to stand in the gap and raise their children's children, as well as revealing the physical and emotional scars of drug addiction on

the addict's offspring. Hence, Perry demonstrates not only how drug abuse destroys the life of the addict, but also how children, partners, grandparents, and residents of a community are casualties of its destructive reach.

In *Daddy's Little Girls*, crack addicts attack and stab the protagonist's mentor, Willie, while attempting to rob his auto repair shop, a traumatic straw that breaks the camel's back, so to speak, concerning Willie's resolve to fight against the destructive effects of drugs in his community. After the attack, Willie throws his hands in the air and rushes the sale of his shop to Monty to escape the urban madness that now plagues his community. In *Madea Goes to Jail*, two prostitutes, Candy and her friend Donna, try to break free from heroin's powerful hold on their lives. In one scene we see Candy shivering in a bed, and when Joshua volunteers to get her a blanket, Candy explains that her shakes aren't the kind you get from being cold. We later learn from a rambunctious minister named Ellen that she too was a prostitute and badly hooked on drugs in earlier years.

SEXUAL VULNERABILITY

Drug dealing and addiction are just part of the panoply of late-modern social predicaments Perry tackles in his movies. *Madea Goes to Jail* deals with a host of other social problems in addition to Candy and Donna's aforementioned drug addiction. Whereas Candy's childhood friend Joshua transcended their lower-class neighborhood to rise up to the ranks of black professional life as a lawyer, Candy's life made a tragic turn in college. Though they attended the same school, Candy and Joshua's collegiate experiences were drastically different. Joshua's status as an athlete on the football team proffered privileged social spaces, while his peers mistreated and rejected Candy because of her class status and humble appearance. Candy found herself vulnerable and disparaged on campus, and a catastrophic blow to her well-being occurred when football players plotted and executed a gang rape against her. The tragic assault led to a downward spiral of despondence in Candy's life to the point at which the movie begins with her as a drug-addicted prostitute.

Madea Goes to Jail also presents sex workers as susceptible to violence and sexual assault. A pimp physically assaults Donna and then kidnaps and (presumably) rapes Candy. Perry's earliest treatment of rape goes back to his second movie, *Madea's Family Reunion*, when we learn that Vanessa's stepfather heinously subjected Vanessa to sexual molestation cosigned by her own mother, Victoria, as a desperate attempt to preserve their privileged existence. In the very same scene, we learn that men subjected Victoria to sexual abuse as a child at the behest of her own mother. In *I Can Do Bad All by Myself*, Jennifer's troubled childhood involves her drug-addicted mother selling her off to men, an unfortunate reality that leaves the teenager despondent and distrustful. The movie also presents a rape attempt against Jennifer by her aunt's boyfriend, Randy. And in *Madea's Big Happy Family*, Madea reveals in a crucial scene that Kimberly's uncle raped Kimberly when she was a tween.

Perry also exposes the vulnerability of a black lower-class man being subjected to false claims of sexual assault. In *Daddy's Little Girls*, the protagonist, Monty, was accused of raping a young white teenager when he was a high school basketball star and the false accusation led to a conviction and eight-year prison sentence. So Perry supplements his unprecedented cinematic engagement of sexual assault by establishing the exposure of poor urban black boys like Monty to being wrongly imprisoned for such an offense. With his willingness to address the issue of sexual assault, Perry offers intriguing artistic crevices to explore darker social challenges within the context of post–civil rights despair.

HOUSING, CHILD CARE, AND SINGLE-PARENTING

Tyler Perry's role as curator of post–civil rights black despair exposes many of the challenges working-class families face. Perry not only explores the social, economic, and psychological toll of poverty but also the physical cost in the form of hungry bodies. In *Good Deeds*, Ariel's teacher questions her mother, Lindsey, concerning why Ariel comes to school so hungry. At another point, Ariel's stomach is growling so loudly that Wesley realizes she must be hungry and takes Ariel and Lindsey out to eat. Hence, we see Lindsey and her young daughter having to deal with hunger as part of their daily struggle. Similarly, in *Meet the*

Browns, Brenda and her three children often go without food, as Brenda's oldest daughter tells their Southern relatives. Her youngest daughter's babysitter, Miss Mildred, mentions how Brenda always brings the child to her house hungry. In one telling scene, Brenda only has a half a cup of oats left to make enough oatmeal for four people, so the mother lets her children eat and goes without breakfast. Lack of food is an ongoing reality that Brenda's family endures as part of the real physical consequences of poverty. Tyler Perry understands that hunger is a reality for many black families facing post–civil rights despair.

Perry's movies also expose how lack of affordable housing is a pressing problem for African Americans. In *Daddy's Little Girls*, Monty has to fight for custody of his three kids after their grandmother, Miss Kate, dies, but he only has a one-bedroom apartment. We see his three girls commandeering his bedroom and sharing a single bed when they visit him. In *Madea's Family Reunion*, Vanessa works at a bridal shop, a low-wage job that does not pay her enough to find affordable housing for her two children, so she has to live with her relative Madea. Vanessa's situation mirrors that of many single mothers who must live with a relative. And as a result of Madea's generosity, Vanessa's kids are able to enjoy the comforts of a large house rather than enduring the challenges of living in a low-income housing community, perhaps the only other option available to a low-wage earner with two children.

But in *Good Deeds*, Perry displays what it is like for a working-class single mother who does not have a Madea-like relative who can offer residence. The film begins with Lindsey trying to stall her landlord until she can receive her check, which she later finds out has been diminished because the IRS garnished funds to recoup back taxes owed. In perhaps the movie's most dramatic scene, Lindsey returns to her apartment and finds all of their possessions thrown out on the street for bystanders to pilfer through, including her savings hidden in a mattress. Lindsey can only retrieve a few garbage bags filled with their clothes and now has the difficult task of improvising their new living situation.

Ariel's school principal pressures Lindsey to get Ariel to class on time, while oblivious to the challenges Lindsey faces just to bring Ariel to campus every morning, such as washing up in a local gas station. Her supervisor seems somewhat cool concerning Lindsey's scheduling challenges, eventually putting Lindsey on the late shift even though she does not have anyone to watch Ariel. Even her new rich friend, Wesley,

tends to judge Lindsey's choices until he finds out more about her plight. *Good Deeds* shows how institutions and people are imperceptive about the harrowing challenges many poor parents endure as they negotiate the structural limitations imposed by their socioeconomic status. Lindsey's arduous attempts to make ends meet only enhance the empathy we feel for her housing situation. Perry goes the extra mile in dramatizing the scary challenges that a homeless family faces, including nights sleeping in Lindsey's minivan and fighting off an attack by a crazy man at a shelter. Lindsey has no perceivable bad habits, and the fact that her earlier efforts toward becoming a nurse were thwarted by the death of Ariel's father all the more highlights the vulnerability of the urban poor. *Good Deeds* shows how life's challenges can dramatically detour vulnerable populations striving for the American dream.

Monty, Lindsey, and Brenda are single parents who struggle with the issue of child care, another topic to which Perry gives attention within the context of post–civil rights struggles for black families. In *Daddy's Little Girls*, Monty loses custody of his children because while he is working a second job to earn extra income, one of his daughters accidentally starts a fire, which prompts child welfare services to grant custody of his girls to their unfit mother. Monty's situation unmasks a catch-22 in which low-wage earners often have to work second jobs to make ends meet but then in turn have to navigate the problem of child care during those work hours.

In *Good Deeds*, Lindsey has to keep Ariel in a closet while she works the late shift. The company CEO, Wesley, eventually finds Ariel hiding in the closet and scolds Lindsey for not placing her daughter in the care of a relative during her work hours. Lindsey informs Wesley that she obviously would have done so if that option were available to her. As mentioned earlier, *Madea's Family Reunion* provides a contrast from Monty and Lindsey's child-care dilemmas in that the single mother Vanessa's child-care situation is mediated by Madea's support. Vanessa is even able to go out on dates with her new beau, Frankie, because Madea watches the kids. We see Madea as a doting surrogate, making breakfast for the kids and spending time with them, thus demonstrating the crucial role familial sympathizers play in lending their support to single parents.

Perry explores child-care challenges even more thoroughly in *Meet the Browns*. The movie begins with Brenda, a single mother of three,

rushing her oldest daughter to the bus stop and then taking her youngest daughter to Miss Mildred, an elderly woman in the housing community who provides her own makeshift day-care center in her apartment. After dropping her daughter off to Miss Mildred, Brenda sprints to the bus stop to avoid being late for work. This opening scene exposes the manic pace of a single parent's morning before she even begins her workday. Brenda does not have a car and must get the girls where they need to go in the morning the best way she can and then take a long bus ride to work. Sociologists Sandra Barnes (2005) and William Julius Wilson (2009) explain how labor markets reflect the growing suburbanization of jobs, which then necessitates long commutes on public transportation for working-class women like Brenda. Tyler Perry brings to the forefront the single black parent's struggle for survival with paltry resources and limited support in an economically depleted neighborhood.

When Brenda arrives at work, she discovers her plant has moved to Mexico and thus she is now jobless and unable to pay for many things, including her child-care provider. Brenda tells Miss Mildred her story and the matronly mentor shows sympathy, agreeing to watch Brenda's youngest child without pay. Perry pushes us to ponder what kind of professional child care the Brendas of the world could afford if it were not for trustworthy women like Miss Mildred. With meager resources, poor single mothers cannot afford to be picky about the person in whose hands they leave their young child.

Perry's focus on single parents is a fitting example of the social realism that motivates his plots. The large majority of post–civil rights African Americans are born in female-headed households, and no filmmaker has more accurately calibrated his cast of characters to represent this late-modern reality than Perry. In doing so, Perry humanizes the single black female parent with multiple "baby daddies" in ways that have only been problematized in other movies and television shows before him. Vanessa in *Madea's Family Reunion* has two children with different fathers, and Brenda in *Meet the Browns* has three children by three different fathers, and yet both are dignified women heroically enduring the vicissitudes of their working-class conditions. And it is telling that both Vanessa and Brenda also come from broken homes and were raised by suspect parents. Brenda's mother was a prostitute who would do anything for money, and her father was a pimp whom she never met. Vanessa's mother was such a pathological parent that she

allowed Vanessa's stepfather to sexually abuse her daughter. Thus, Perry is one of the first filmmakers to link social stratification with romantic choices in detecting a cultural component to parental mechanics that reproduces social inequality in the next generation. But in doing so, Perry refuses to leave Vanessa and Brenda in hopeless despair; he taps into their agentive capacities to elevate their life expectancies, and he portrays them with integrity and dignity even as their life choices have residual effects on their socioeconomic status.

Perry's single parents often have to withstand the bourgeois gaze that imputes shame onto their situation. In this way, Brenda faces scrutiny by Miss Mildred and Vera for having so many kids with multiple fathers (*Meet the Browns*). Vanessa's own mother, Victoria, calls Vanessa's children bastards, when expressing her disinterest in seeing her grandchildren (*Madea's Family Reunion*). Wesley seems insensitive to Lindsey's plight as a single parent until his conservative criticisms are met with cogent retorts, allowing him to gain a clearer understanding of Lindsey's vulnerabilities (*Good Deeds*). Julia's friends look down on Monty for having multiple kids out of wedlock, and one of them disrespects Monty at the aquarium while he is with his daughters (*Daddy's Little Girls*). So not only are Brenda, Vanessa, Lindsey, and Monty met with economic challenges as working-class single parents trying to provide housing, food, and clothes for their children, they also have to endure the social sanctions imposed upon them by middle-class and elitist blacks who scoff at their nonnuclear families. Even as black elites place shame on Brenda, Vanessa, Lindsey, and Monty, Tyler Perry portrays these working-class characters as heroic, something rarely seen in mainstream art in relation to single black parents.

INTERCLASS SYNERGY

If Perry's movies signify a divide between post–civil rights economic promise and despair, they also establish how characters enjoying the promise can be of benefit to others enduring the vulnerabilities of despair. In *Daddy's Little Girls*, Monty flounders hopelessly in the courtroom trying to win custody of his girls, so much so that the presiding judge begins to get annoyed with the auto mechanic's lack of legal protocol. The corporate attorney Julia swoops into the courtroom and

saves the day when she takes over Monty's case. The Ivy League–trained attorney is able to lend her professional resources to a desperate working-class man in need. But it was only through their earlier interactions that Julia had become aware of the elements of Monty's vulnerability. In this way, Tyler Perry advocates for interclass engagement and dialogues in order for privileged individuals to become cognizant of the challenges that plague their less fortunate counterparts.

We see this pressing importance of interclass dialogue in *Good Deeds* when the privileged CEO Wesley learns about his janitor Lindsey's vulnerabilities through their heated debates and later uses that knowledge to help her. For example, when he finds out that Lindsey has no relative or surrogate to watch Ariel while she's working the evening shift, they have a feisty exchange over the matter that eventually pushes Wesley toward an empathetic understanding of the plight of working parents who cannot afford child care. This awareness leads the CEO to create a free child-care service for all of his employees. Similarly indicative of Wesley's support, when one of Ariel's teachers discovers that Ariel and Lindsey are homeless, the teacher reports it to child welfare services and a social worker removes Ariel from Lindsey's custody. Wesley responds to this new tragedy by providing Lindsey with an apartment so she can get Ariel back. Wesley's willingness to act upon hearing about Lindsey's vulnerabilities demonstrates Perry's vision for ongoing dialogues and symbiosis between poor and privileged African Americans to produce fruitful solutions that alleviate lower-class vulnerabilities.

Perry constructs Lindsey's dialogues with her rich and privileged Gen X counterpart, Wesley Deeds, such that Wesley often represents the kneejerk conservative retort to her plight followed by Lindsey articulating in convincing fashion her paltry options. Lindsey is mindful of their social distance and has to convince Wesley to come out of his privileged perspective to see life through her eyes. But it is within their fruitful exchanges that Lindsey persuades Wesley to confront the impediments of his own privilege. For example, she asks the CEO if he could tell her the cost of a gallon of milk. Wesley is unable to offer a guess, hence proving Lindsey's point that he is somewhat out of touch with the janitor's daily struggles.

But inspired by his verbal exchanges with Lindsey, Wesley not only learns the price of milk but he becomes a more concerned employer and friend to find ways in which his life of privilege can ease the pain of poverty's hold on his janitor. *Good Deeds* demonstrates that interclass empathetic engagement comes through dialogue, or even arguments. Lindsey wins all of their verbal exchanges and a more informed Wesley marshals his resources on behalf of Lindsey's vulnerabilities. Whether it's Julia lending her legal expertise to Monty (*Daddy's Little Girls*) or Wesley offering resources to Lindsey, Perry presumes that pressing modern problems rely on the active generous intervention of those abounding in professional and monetary resources to lend those resources to vulnerable populations.

CONCLUSION

While Perry has done much to bring attention to the triumphs and tragedies within our late-modern moment, his role as filmic curator does not presuppose we judge him by the standards to which we might hold sociologists, community organizers, or public policy analysts. For Perry does not offer a comprehensive program for societal reorganizing, policy initiatives on social reform, or legislative proposals to disabuse the structural and cultural mechanisms that reproduce racial inequality. Neither does Perry make any attempt to clarify the complex components of late-modern capitalism. But the filmmaker does do a surprisingly sophisticated job of offering art as an apparatus to explore the increasing bifurcation of privileged blacks and underclass blacks within our post–civil rights epoch. With no PhD in hand (or bachelor's degree for that matter) and no training as a social theorist or policy analyst, the filmmaker elucidates the power of social positioning in ways that could help conservative politicians understand that structural forces are always at play in the backdrop of individual decisions. While Perry places a high premium on human agency, he also offers a structural lens through which we can see an empathetic view of social problems. He shows how hardworking people are trapped in systems of inequality and require a helping hand. Perhaps Perry offers an intriguing balancing point between scholars and politicians who tug on either end of the structure-versus-agency continuum. Whether it is exposing the chal-

lenges of finding affordable housing, the difficulties of securing child care, the social shame imposed upon particular life choices, the precarious path poor people take toward self-actualization and progress, or the pragmatic realities of not being able to make ends meet with low-wage earnings, Perry gives voice to post–civil rights vulnerabilities.

And the voice that Perry projects for the struggling black single parent is not an obsequious or helpless one, but a strong, confident, and passionate voice articulating the inherent struggles and pitfalls concomitant within post-soul urban despair. Through Vanessa (*Madea's Family Reunion*) and Brenda (*Meet the Browns*), we hear a competent voice of resolve to provide their children with the kind of love and support the women themselves never received from their parents. Through Monty (*Daddy's Little Girls*), we hear a hopeful voice aspiring to run his own auto mechanic shop and be the best father he can be to his three daughters. In Lindsey (*Good Deeds*), we hear a confident voice that stands up to the CEO of a company, challenging him to walk a mile in her old tattered moccasins, so to speak.

Perry's movies capture the absurdity of black urban life synthesizing accomplishments related to late-modern promise, while simulating social conditions indicative of post–civil rights despair. He explores how more African Americans are enjoying the good life, receiving elite educations, and thriving in professions in our current epoch, but his movies also allude to the loss of manufacturing jobs in urban areas, working-class vulnerabilities like unaffordable housing and child care, as well as the costly toll of drugs on communities, families, addicts, and dealers. Perry measures the extent of working-class vulnerabilities juxtaposed against astonishing levels of socioeconomic privilege and demonstrates that modern progress generates both conquerors and urban casualties. His cinematic plots are all about leveraging the professional assets of post–civil rights black modern life to mitigate the susceptibilities of our postindustrial hyper-capitalist era. Perry presents working-class blacks as enveloped within particular needs and vulnerabilities, but as the next chapter explores, he also presents them as having great dignity and much to teach black elites about their own existential liabilities.

2

WANTING MORE

Perry's Populist Critique

In John Huston's riveting film noir *Key Largo* (1948), Johnny Rocco is a former mob boss whose control once "extended over beers, slot machines, the numbers racket and a dozen other forbidden enterprises," Humphrey Bogart's character, Frank McCloud, tells a room full of people held hostage by Rocco and his boys. Rocco affirms Frank's assessment of his early years and vows to return to the same level of dominance, bragging, "Thousands of guys got guns but there's only one Johnny Rocco." When an old man asks Rocco what makes him so sure of his inimitability, Frank chimes in, "He wants more! Don't you Rocco?" to which Rocco responds, "That's it, more! That's right, I want more!" The old man then asks Rocco if he will ever get enough. Rocco ponders the matter and finally answers no and then turns to Frank and asks, "Do you know what you want?" Frank tells the gangster he has given up his hopes, to which Rocco inquires, "Hopes for what?" Frank's retort is one of the most memorable lines of the movie: "A world in which there is no place for Johnny Rocco."

One of Tyler Perry's most compelling scenes involves a character cut from the same cloth as Johnny Rocco. It occurs in *Diary of a Mad Black Woman* when a ruthless drug dealer named Jamison Jackson makes a late-night call to his former attorney Charles McCarter, demanding to meet with him. Charles reluctantly relinquishes his warm bed to visit a dark abandoned warehouse, where Jamison admits he just shot an

undercover cop who was trying to run a sting operation on him. Distressed and confused, Jamison claims he needs both a lawyer and a judge, saying, "I got $300,000 in that bag; that ought to buy me both, right?" After Charles advises Jamison against attempting to bribe a judge he reminds the kingpin that he no longer deals with his kind. Understandably offended, Jamison responds, "My kind? Brotha, before you started defending all these rich white boys it was my kind that got you down," harking back to their complicated past when he ran so much cocaine through Charles that he practically bought Charles's mansion, adding, "I need you like you needed me back in the day to get all you got." Charles tells Jamison he needs another lawyer and forbids him to call him. Unmoved by Charles's directive, Jamison picks up his bag of money and throws it at Charles's feet and barks back, "You are my lawyer, you know where to find me," thus leaving the scene with the conclusive words on the matter because Charles does in fact take on Jamison's case.

Jamison's intense exchange with Charles is quite telling. The drug kingpin just shot (and presumably killed) a cop and yet is too preoccupied with attempting to purchase a judge and legal services to show a hint of remorse. But this late-night reunion is also striking regarding the conspicuous naïveté Jamison exhibits about the law and life. Armed with a bag of money, he supposes he can nullify his foul deed as easily as buying one of his pinstripe suits. And judging by the contents in his bag, Jamison appraises the value of a human life at $300,000. Perry cleverly creates this scene to mock the Jamison Jacksons of the world who so incautiously perceive money as an easy solution to their most pressing problems and who so abhorrently think protecting power and privilege is more important than preserving human lives.

Jamison Jackson is Johnny Rocco reinvented for the post-soul era. Both men thrive off illegal enterprises, both believe money and power rule the world, and both shoot a cop in cold blood to protect their undertakings. Simply put, Jamison Jackson and Johnny Rocco are two men perpetually wanting more at all cost. And if Jamison embodies Rocco's insatiability, then Perry reiterates Frank McCloud's desire to live in a world where there is no place for such people who are driven by ambition and acquisition. Perry's late-night exchange between Charles and Jamison and the unfortunate events that follow at the end

of Jamison's murder trial bring home Perry's populist critique of and cautionary tale against wanting more.

So then we see that Tyler Perry's oeuvre offers a rather ambivalent reaction to late-modern African-American aspirational cultures. On the one hand, as the previous chapter demonstrates, Perry's films present the post-soul era as a hopeful time for black capitalist progression and professional leadership, featuring black characters functioning at the helm of large corporations, running their own law firms, generating entrepreneurial success, while flaunting Ivy League educations, posh pads, and copious material accompaniments. But on the other hand, as Perry offers cinematic windows through which we can see the perks of black privilege and accomplishment, the filmmaker balances such delineations with a dual critique against arrant ambition and blind bourgeois aspirations. For Perry, this late-modern age offers both temptations and constraints in the foreground of living out the American dream. So if the previous chapter demonstrates how wealthy or professional blacks have much to offer by way of resources to alleviate working-class vulnerabilities, the other side of Perry's interclass synergy is to push ambitious professionals or privileged blacks toward positive connections with the working-class values that Perry believes have sustained black communities for generations. And it is within the backdrop of this symbiotic exchange that Perry often presents black elites or professionals as either greedy capitalists or will-less sails caught in the whirlwind of societal and familial expectations, flailing in desperate need of existential intervention by more prescient working-class guides.

CRITIQUES AGAINST BLACK AMBITION AND WEALTH

Perry's disputations against black aspirational advancement are not new. Few social thinkers have articulated more about the shortcomings of middle-class African Americans in the pre–civil rights era than sociologist E. Franklin Frazier. In his noted study *Black Bourgeoisie: The Rise of a New Middle Class in the United States* (1957), Frazier depicts middle-class blacks of the mid-twentieth century as confused and misguided sojourners, manifesting a delusional kind of sociocultural mindset, suffering from a deep-seated inferiority complex, and traversing a world of make-believe to escape the condescension of whites. Frazier

projects the small contingent of middle-class and elite blacks of his era as existentially deprived of the very same values and perspectives that sustained black masses for generations. A quote from Mitchell Duneier's groundbreaking ethnography *Slim's Table: Race, Respectability, and Masculinity* demonstrates that real-life working-class African Americans can be similarly suspicious of black privilege:

> It seems to Slim and his sitting buddies that younger middle-class blacks have achieved their lot without having to struggle and without developing any character. J.J., a plasterer, once said, "I look at the middle-class black as being wealthy. But emotionally, physically, and mentally he cannot compete with me." (Duneier 1992, 69)

Duneier's excerpt captures a working-class person's belief that something psychologically stabilizing is lost within newer generations of African Americans striving for status.

Race films of the early to mid-twentieth century addressed varying themes involving the pitfalls of black ambition. A great example is *Souls of Sin* (1949), which introduces three black roommates in a squalid one-bedroom basement apartment facing a crossroads as they endure the vicissitudes of poverty and disappointment. The overly ambitious roommate Bill decides that he is tired of living in poverty and begins to work for the local Harlem gangster "Bad Boy" George in order to raise his lot in life. Whether it is selling hot jewelry or transporting stolen furs, Bill succumbs to the lure of the underworld to achieve a modicum of prosperity and success. The other two roommates, Robert and Isaiah, choose more acceptable means of attainment through hard work and determination. The movie ends with Bill suffering fatal gunshots as a result of his fast dangerous life, while Robert and Isaiah flourish through their patience and grit. *Souls of Sin* offers an unambiguous message: African Americans taking shortcuts in reckless pursuit of money and power will suffer pernicious consequences, while African Americans working hard and patiently persisting through disappointment and disadvantage will eventually make their mark and achieve respectable success. Bill's destructive path has much in common with Tyler Perry's aforementioned characters Jamison and Charles, who take shortcuts to achieve money and power and end up sullied by both.

Spencer Williams's early race films engage similar themes concerning the corruptible forces of wealth and greed on black souls. *The Blood*

of Jesus (1941) presents money as a mechanism of temptation and worldly pleasure that can lead a young impressionable black woman away from the path of righteousness. Rufus Brown's promise of money is a vehicle to lure Martha's soul on the path to death, but she eventually heeds the words of the angel and leaves Brown's juke joint, rejoining the righteous path. Williams's later film *Go Down, Death!* (1944) portrays the damaging influence of avarice when crime boss Jim Bottoms goes to great lengths to discredit a preacher whose ministry is challenging Jim's financial base. The crime boss eventually kills his former caretaker as a last-ditch effort to protect his financial empire. Hence the movie is essentially a tragedy, explicating the ways in which money drives Jim Bottoms on a path of destruction.

The classic Senegalese film *Touki Bouki* (1973) also anticipates much that Tyler Perry would later unmask as aspirational culture run amok. Mory and Anta are attempting to secure enough money to escape their West African environs in hope of a better life in France. The two execute an ill-advised gambling venture, attempt to steal money from a national sporting event, and exploit a rich man out of his clothes, car, and resources with the hope of sailing off to a life of unmitigated splendor in Paris. Director Djibril Diop Mambéty's camera work generously captures the West African landscape as an unspoken rebuke against Mory and Anta's inability to appreciate the beauty and splendor of their current social location as they chase a modern illusion of wealth and happiness in Europe.

More recent films showcase cynicism or satire against black ambition, snobbery, or elitism. In Maya Angelou's film *Down in the Delta* (1998), Will Sinclair worked all of his life to achieve professional success and material attainments, yet after building a successful law firm and a large home for his wife and two kids, appears quite unfulfilled. It is only when he reconnects with the people of his humble hometown to inspire entrepreneurial activity after the chicken plant closes down that we finally see him come alive. Malcolm Lee's comedy *Welcome Home, Roscoe Jenkins* (2008) ends with the protagonist, R. J. Stevens, finally rejecting his vegan, uppity, über-competitive fiancée, Bianca Kittles, to head back to the more down-to-earth Southern family he almost rejected. In Bill Duke's *Not Easily Broken* (2009), Clarice Johnson is driven by ambition at the cost of her marital health and later learns to focus less time on conquering her career and give more attention to

nurturing her relationship with her husband. Scott Cherot's film *G* (2002), a black urban remake of *The Great Gatsby*, offers a salient cinematic sermon on how myopic movement toward success and financial prosperity can leave one existentially bankrupt and miserable in many of the more important measures of happiness. Salim Akil's *Jumping the Broom* (2011) is framed as "Uptown meets Downtown" when a black man from Brooklyn marries a black woman from a wealthy family from Martha's Vineyard. It showcases interclass conflicts that arise the weekend of the wedding, with the bourgeois pretension of Sabrina Watson providing a satirical spectacle throughout the film.

A few important television shows broach similar themes concerning the deficits of black aspiration or privilege compared to the existential strength of black humility. The short-lived 1967 series *A Time for Laughter: A Look at Negro Humor in America* satirizes the desire of Mr. Gramison and his wife to remain disconnected from the black masses. Their clever maid, Piola (played by legendary comic Moms Mabley), is the black working-class guide to put the uppity couple in their place. Later sitcoms like *227* (1985–1990) and *The Fresh Prince of Bel-Air* (1990–1996) recapture this clever juxtaposition of black working-class wit against the bourgeois posturing of Sandra Clark (*227*) and the out-of-touch privilege of the Banks family (*The Fresh Prince of Bel-Air*). But the most notable series capturing and critiquing African-American strivings for status and privilege is the aforementioned sitcom *The Jeffersons*.

While the groundbreaking show celebrates new opportunities for African Americans to excel in the post-soul era, it is television's first look at the negative consequences of black socioeconomic success in revealing how George Jefferson's myopic focus on economic progression causes him to neglect his marriage and health. The clever series presents George as a metaphor of the very same post–civil rights black aspirational myopia that Tyler Perry critiques in many of his films. George is a businessman with an ostensibly unhealthy focus on success. In the episode "George's First Vacation," Louise complains that she and George have not had a vacation in decades because George is a workaholic. In the same episode George reveals that he hates Sundays because that's the only day his stores are closed. George is always in perpetual motion, trying to wheel and deal and expand his influence. In an episode called "Rich Man's Disease," George deals with depression

and discovers that he has an ulcer, no doubt from pushing himself to the limits on his quest to expand his entrepreneurial empire. By the eighth season, the normally defiant George has succumbed to societal pressures to conform and is taking charm lessons in order to be more impressive to urban socialites.

Compared to his maid Florence's cool demeanor and folk spirituality, and Louise's maturity and depth, George often appears shallow and showy. An episode in the show's tenth season called "Otis" has a shoe shiner schooling George on the working-class dignity the dry-cleaning tycoon left behind when he emerged from his humbler life in Harlem. The sitcom's exposure of George's excesses offers a poignant critique against the immoderations of a capitalist society that focuses too much attention on money and success and not enough emphasis on living and being. If we may apply that same critique to the crucial scene in Tyler Perry's first movie that opens this chapter, the intimidating drug dealer who just shot an undercover cop resembles George Jefferson in wanting more.

So Perry's populist critique is part of a long-standing artistic tradition of assessing the excesses and drawbacks of black ambition. While scholars debate over the multivariate ways wealth and privilege impact the negotiation of black modern identities (Lacy 2007; Thompson 2009; Wilson 2009; Pattillo 2013), Tyler Perry goes a step further as an artist in representing what he perceives to be the delusional nature of black aspirational culture, explicating how excessive commitments to hyper-capitalist sensibilities and anxious capitulations to bourgeois constraints lead to what he portrays as deformation of the soul. In this way some scholars claim Perry is a cinematic heir to Frazier's critiques against blacks of higher status (C. Harris and Tassie 2012). But Perry's populist critique is not limited to the black bourgeoisie, as he also targets ambitious characters like Jamison Jackson. Nonetheless, his populist vision does often place professional or upper-status African Americans on either the cautionary or the satirical end of the equation when contrasted against working-class counterparts. Perry lampoons the extreme measures some of his characters are willing to take in pursuit of what they perceive as a better life. His films warn some African Americans not to get caught up in acquisition, and others not to let strivings for status stunt their existential growth and self-development.

CHARLES AND JAMISON

Turning again to the critical scene in *Diary of a Mad Black Woman* that begins this chapter, we notice that an attribute Jamison Jackson shares with George Jefferson is the assumption that one can create a happy ending to any narrative by using one's bank account. But at the start of his trial, the judge makes an evidentiary ruling against Jamison, allowing the video footage of him shooting the cop to be admissible, disproving the drug dealer's erroneous assumption that the judge is in his back pocket. In a heated exchange after the ruling, Charles explains to his client that the judge had no choice but to allow the video evidence against him, which does nothing to temper Jamison's unrealistic expectations, as he reminds Charles that he's made him a lot of money and paid him top dollar for this current case. Again, money is the focal issue at hand from Jamison's perspective. When Charles informs Jamison that a better legal strategy is to claim he pulled the trigger in self-defense, the naive client responds, "I told you to make this go away. Say it wasn't me. I wasn't there. How the hell do you use self-defense?" In other words, Jamison remains stubbornly committed to his confidence that money can make this serious problem evaporate.

Charles knows Jamison has little chance of an acquittal but must still go through the motions as Jamison's counsel because their fates were linked long ago when Charles made precarious sacrifices to secure the success of his burgeoning law practice. Similar to how Bill Burton sealed his doom when he joined forces with a gangster in the race film *Souls of Sin*, discussed earlier, Charles's early decision to align himself with a dangerous drug dealer like Jamison comes home to roost at the decisive moment when the jury announces its guilty ruling. Seconds before the foreman reads the verdict, Charles gives his legal assistant a disturbing look as if both men already know the bad news. And indeed, shortly after the guilty verdict is announced, Jamison's retaliation against Charles for failing to produce the acquittal he had so foolishly envisioned is to grab the gun from the court officer and shoot Charles several times.

With Jamison's impromptu courtroom vengeance against Charles and the successive sequences, Perry reveals how the lawyer's early aspirational decisions finally bite back, not only in the form of near fatal gunshot wounds, but also in that Charles has no familial support after

the tragic shooting. When we see Charles in critical condition at the hospital, and later helpless and wheelchair-bound in his mansion, we do not see any of his family members visiting or showing concern. Perry offers a tacit explanation in an earlier scene when the attorney's estranged wife, Helen, tells Madea that Charles was so focused on raising his status that he persuaded Helen to never look back to their humble beginnings. Perry makes it plain that Charles abandoned the security and nourishment of his roots to aspire toward a new kind of late-modern privilege and isolation. Now years later while recuperating from his gunshots, Charles finds himself desperate and sequestered from the nourishing social resources he needs most. Tyler Perry sums it up in his commentary for the DVD when discussing Charles's predicament: "He trusted in his money, his power, and who he was. He lost it all in an instant."

But Charles does eventually repent after a humbling stint under Helen's heavy hand of retribution. When he makes up with Helen and walks down the church aisle at the end of the movie, his appearance at the altar connotes more than just a spiritual reconnection; it is also a symbolic return to the modest origins he so misguidedly rejected in the early years of his marriage and career. Like the prodigal son in the New Testament parable, Charles's attendance at the church and his presence in the next scene at Madea's home imply that the once-arrogant attorney is finally returning "home," so to speak. And when he's dining at Madea's table, the very locality he had persuaded Helen to turn her back on early in their marriage under the foolish notion of not being bound by their humble past, Charles rectifies that mistake. Tyler Perry crafts the church and Madea's house as touchstones to reconnect Charles with his folk-cultural heritage.

While Madea is undoubtedly an over-the-top character, whose excesses and complexities are explored more fully in chapter 3, we should pause and consider how there is a sense in which all roads lead to Madea in many Tyler Perry films; how when people are in trouble, they go to her as a towering symbol of the comfort, power, and protection of black folk culture. When Vanessa needs a place to stay and her sister Lisa seeks refuge from her abusive fiancé in *Madea's Family Reunion*, they both go to Madea. In the same movie, when a troubled tween craves love and support, she becomes Madea's foster child. In *I Can Do Bad All by Myself*, when Jennifer and her brothers are desperate and

hungry, they fortuitously end up at Madea's house where they receive physical and existential nourishment; and when Jennifer is distraught at the news of her grandmother's death, she returns to Madea for comfort and guidance. In *Madea Goes to Jail*, when prison bully Big Sal picks on Candy, Madea comes to her rescue. In *Madea's Big Happy Family*, when Shirley needs to gather her rambunctious family for an important dinner to announce her bout with cancer, she turns to Madea for help.

And if we may return back to *Diary of a Mad Black Woman*, we can see that when crack addict Debrah is at her lowest moment, she comes to Madea for food and support, just as early in the movie when Charles kicks Helen out of the mansion, leaving her desperate with no place to go, Helen finds herself on her grandmother Madea's doorstep. People come to Madea for support when the rigors of the late-modern world seem unmanageable. But perhaps Perry quite intentionally puts privileged Gen X characters like Charles and Helen in predicaments where they have to return to Madea as a means of being absolved of their own aspirational sins since he props her up as a folk-cultural heroine. And so if Charles's presence at Madea's dinner table serves as the attorney's recompense, then the entire film documents in meticulous detail Helen's reintegration into working-class origins.

HELEN COMES FULL CIRCLE

Early in *Diary of a Mad Black Woman*, after Charles rather viciously drags his wife through the living room kicking and screaming and kicks her out of the house to move in his mistress, Brenda, an angry and confused Helen drives around Atlanta for hours until she finally finds herself at Madea's door. Madea is shocked to see Helen, reminding her granddaughter that she lives in a mansion on the other side of town, a subtle jab at Helen for being estranged from her family. Discerning that Helen's appearance betokens desperation rather than a mere social visit, however, Madea finally lets her in.

When Helen wakes up the next morning, she sees her grandmother offering a plate of food to her childhood friend Debrah. When the two reconnect we learn that Debrah and Helen as young girls would dream about being swept away into a new life of privilege through the promise of marriage. And while they eventually fulfill their fantasy by marrying

attorneys, both women now stand in Madea's kitchen miserably unful-
filled. Madea serves as a folk-cultural source of comfort and guidance
for both Debrah, who is wrestling with a drug addiction that plagues
her family, and her granddaughter, who needs to learn how to stand on
her own two feet after losing her sense of self in an insufferable mar-
riage to Charles. Helen must now reject the notion that her life revolves
around Charles and that she needs wealth and prestige in order to be
happy.

Visiting her mother, Myrtle, for the first time since her marital es-
trangement, Helen claims she is lost without Charles, an admission that
surprises Myrtle, leaving her wondering where she went wrong as a
parent. Helen tells her mother that she is not strong enough to make it
without Charles, to which Myrtle swiftly exhorts her daughter to trust in
God rather than a human being. Myrtle then reminds Helen that she
has yet to tap into the strength that has helped black women for genera-
tions to endure difficult situations with dignity. Tyler Perry uses this
scene to highlight his recurring populist lesson on how black aspiration-
al myopia leaves one disconnected from the existential resources incu-
bated within the rich legacy of African-American endurance. But it is
not Helen's saintly mother who ultimately impacts Helen's decisions; it
is Madea whose mentorship proves most useful.

One of the crucial moves Madea initiates within her mentorship is to
motivate her granddaughter to get a job. This form of tough love is not
Madea's way of demanding rent money from Helen, nor is it a means of
attaining revenge against Helen for turning her back on her family for
almost two decades. It's not even a reversion to some old-fashioned
commitment to labor. This push for employment is Madea's medicinal
imperative for Helen. Madea discerns that Helen cannot start on the
road of recovery until she learns how to support herself. Helen has
spent the last eighteen years without employment, depending entirely
on Charles, but under Madea's prompting she quickly lands a job as a
waitress. So the girl who dreamed of marrying a rich man and as a
woman fulfilled that dream in the form of a nightmare marriage is now
learning how to live and be happy as a working-class woman.

Not long after Helen begins waiting tables, she finds herself increas-
ingly content with the simple things in life. Helen learns that there is
life outside of Charles and the mansion, that standing on her own two
feet is more rewarding than enduring marital abuse to enjoy status and

wealth. Helen begins to apprehend that true contentment comes from the pride and exhilaration of charting her own course and embracing the simple values in a life of hard work and family. So there is a sense in which we see Helen progressively invigorated through her reconnection with her working-class roots. And it is through the process of supporting herself and starting a romance with a steel worker named Orlando that Helen is able to head down the path of reconciliation to her humble past and concomitant existential redemption. The arrant aspirational mind-set that had mistakenly disconnected Helen from the existential resources of her humble roots is slowly submerged by her reconnection to her family and working-class life.

Perry takes us through an important redemptive process by which Orlando wins her over and asserts himself within Helen's renewed identity as a working-class woman. On their first date, when Orlando picks up Helen from work and offers to take her out to eat, Helen underestimates the steel worker, rudely asking if their food and fellowship will occur at McDonald's. Orlando surprises Helen when he suggests they dine at a classy nightclub called Chandra's, one of her favorite hangout spots. Shortly after they enter and enjoy a drink at a secluded table, Orlando asks Helen to dance, inadvertently suggesting she put her new working-class identity on public display in the chic nightclub she once frequented as a privileged woman. Helen initially rejects Orlando's request, reminding him that she is in her work uniform. But a persistent Orlando tells Helen that he too is in his work uniform. Helen's eventual capitulation to Orlando's request is an important step toward rejecting the shackles of black aspirational culture where money, image, and status are benchmarks of one's worth. The two uniform-clad Gen X African Americans dance for all eyes to see, and with no shame.

From that important scene, Helen progresses as a new woman. She enjoys supporting herself while kindling the fires of a new romance with Orlando. She even tells the judge during a divorce arbitration meeting that Charles can have it all, the mansion, everything, that she doesn't want anything. In the very next scene Orlando proposes to Helen in his humble one-bedroom apartment, which seems to signal the culmination of Helen's full integration into working-class life. But before she accepts Orlando's proposal, Helen sees a news report on television revealing that Charles has been shot multiple times by his client. Helen

abruptly leaves Orlando's apartment to visit Charles in the hospital and decides to take a hiatus from her relationship with Orlando to support her husband.

Helen's return to the mansion seems quite complicated. When she first visits Charles in the hospital, it is clear that she is more concerned about his well-being than is his selfish fiancée, Brenda, who was willing to pull the plug on Charles so he wouldn't live like an invalid. But Helen's motives in returning to the mansion after Brenda abandons Charles are not reducible to a pious fulfillment of marital duty based on the technicality that their divorce is not yet finalized. Nor is her return initially motivated by revenge, even though retribution does occur quite rigorously and vigorously. To understand Helen's return to the mansion, we must consider how her earlier exit from the marriage did not come by her own volition: Charles crassly informed her that their marriage had run its course and replaced her with Brenda. But after Charles's near-death experience, the option of Helen returning to the mansion reappears as a possibility. The tables have turned and Helen now has newfound leverage. She thus faces a new crossroads where she must either reject the mansion in favor of her new working-class life, or seek to recapture the illusion that her life of privilege is somehow more fulfilling.

But upon Helen's return to check on Charles and help him recover, we learn that even near-fatal gunshot wounds, and the social isolation they initially reveal, have done nothing to temper Charles's disrespect for his wife. After experiencing Charles's recalcitrant contempt, Helen launches a physical onslaught against the man who had discharged systemic psychic torment against her for most of their marriage. As chapter 3 delineates in greater detail, Helen goes mad on Charles, but eventually calms down and helps him progress through his rehabilitative process. It is shortly after the two have reconciled that we have the emotional scene in the church where Charles answers the preacher's call and walks down the aisle soon to be accompanied by Helen. The church experience is followed by Sunday dinner at Madea's, where Charles and Helen seem to have reversed their uncoupling process.

With Charles and Helen peacefully reunited, most patrons probably guess the film will end with the two married happily ever after. Such a deduction makes sense when you consider Tyler Perry's own Christian faith that puts a high premium on marriage and frowns upon divorce.

Moreover, Charles has repented and changed. The man who once alienated Helen from her family and folk-cultural roots, the man who would have never given Madea the time of day, is now humbly dining at Madea's dinner table seated next to his wife. Charles appears as a new man, happily recommitted to the church and thankfully reconciled to the woman he once rejected. It is abundantly clear that the attorney is now ready to be a doting husband, and thus it is quite reasonable to suspect the movie will end shortly with Helen and Charles faithfully recommitted to each other until death do them part. But in an unexpected twist, Perry unfurls an entirely different windup.

Ironically enough, the moment when they appear most equipped to reconvene as a couple is the exact moment when Helen drops the bomb on Charles, telling her husband that she will always love him, but that she wants to proceed with the divorce because she is in love with another man. Helen exerts her newfound agentive capacities to revisit the issue of divorce because she is clear about one thing: that even though she has reconciled with her humbled husband, she loves another man more; she is happier with Orlando, a man who works twelve-hour days at a steel plant and resides in an unadorned one-bedroom apartment, not a mansion. To borrow a metaphor from a classic movie and memorable Elton John song, Helen finally decides that her future resides beyond the Yellow Brick Road. She runs back into the arms of her working-class beau, Orlando, which means she makes a permanent embrace of her own working-class identity.

If the precise motives behind Helen's earlier decision to break from a budding romance with Orlando and return to Charles and the mansion are somewhat ambiguous in the middle of the movie, Perry provides a clearer indication at the end when Helen leaves Charles at the dinner table and returns to Orlando. It is significant that Helen does not meet up with Orlando at his apartment, but at his place of work, the locus of his identity as a blue-collar man. Such a choice highlights the fact that class issues are at play in both their complicated separation and now with their momentous convergence. In this passionate scene, Helen frantically runs through the steel plant screaming Orlando's name in a moment reminiscent of Tracy Chambers appearing at Brian's political rally at the end of *Mahogany* (1975), a classic film that sheds great insight on *Diary of a Mad Black Woman*'s ending.

Earlier in *Mahogany*, Tracy denigrated Brian as a loser, and her ambitious drive for success and fame blinded her from realizing Brian's value, so her return to Brian's humble vocation is a form of repentance and acceptance of who he is as a struggling politician. When Tracy finally rejects her aspirational strivings, she craves the warmth and stability found in her earlier connection to Brian. The simple values she once scorned in her lover, she now covets, and hence the movie ends with her humble return to his place of work to affirm his identity and to pledge her life to him. Brian, while happy to see her, gives her a series of interrogations and conditions: Tracy is able to affirm all of his terms, and *Mahogany* ends with them pledging their lives to each other.

Similarly, *Diary of a Mad Black Woman* ends with Helen showing up at Orlando's place of work, having made up her mind that she will accept his earlier marriage proposal and her new life as the wife of a steel worker. And so her first words to Orlando when she finally sees him hard at work are, "I gave it all up. I just want you." Her short greeting to Orlando illuminates motives that might have seemed murky in the middle of the movie when she returned to the mansion. It is important to consider that what she does not tell Orlando is that she gave "him" up, referring to Charles; she uses the pronoun "it" to refer to all that comes with the illusion of her social standing as the wife of a powerful attorney living in a mansion. Helen's return to Orlando is not just the fulfillment of a love story but her full reintegration into a humbler social standing. Her statement to Orlando, "I just want you," means Helen understands and embraces her working-class existence. Helen indicates her final rupture from the mansion, the privilege, and the illusion that her life revolved around her social standing. That Helen has her *Mahogany* moment at Orlando's place of work undergirds her claim that she "gave it all up." She then asks Orlando to propose to her again, and the movie ends with the two engaged to be married. Helen chooses the blue-collar steel plant worker over the prestigious lawyer as the exclamation point in Perry's populist critique against aspirational strivings for status and celebration of black working-class status.

The symbolism behind Helen rejecting life at the mansion draws strong parallels with several timeless works of art, one of which is Elton John's masterwork "Goodbye Yellow Brick Road," which is a song about a man who leaves humble beginnings on the farm to live in a penthouse with a person of great wealth and status—only to discover that the new

life of privilege is not all he had imagined. The song's use of the "Yellow Brick Road" metaphor is an obvious allusion to *The Wizard of Oz* (1939), where Dorothy and her new friends are happily trekking toward a utopic totality of attainment. What Dorothy and her friends find out at the end of the Yellow Brick Road is that they already have everything they need within themselves. Elton John's protagonist comes to a similar realization, describing the penthouse as a place "where the dogs of society howl," perhaps alluding to the obtrusive expectations that pervade high society life with his new companion. The song's protagonist becomes disenchanted with that world and strongly desires to come back home to the farm.

Edith Wharton's groundbreaking novel *The House of Mirth*, first published in 1905, anticipates Elton John's provocative song by almost a century, offering a similarly scathing critique of the pressures and social dictates of high-society life. Wharton more specifically aims her line of attack against New York City at the turn of the twentieth century. Wharton presents a stifling world of petty privilege in which strict rules of propriety impose themselves on social agents with reckless ferocity. But more than exposing and lampooning the frivolous world of privilege, Wharton's novel perceptively exposes the will-less existence of a female protagonist named Lily Bart who gets lost in that world. While Elton John's protagonist escapes back to his previous life on the farm, trading in the howls of society dogs for the more refreshing hoot of the old owl in the woods, Edith Wharton's protagonist remains alienated and dejected in a downward trajectory that eventually leads to her tragic death from a drug overdose. Perhaps if Elton John's protagonist had stayed in the penthouse just a bit longer he too might have suffered a tragic demise like Lily Bart, who crashed down from her world of privilege and died poor in money and spirit.

Tyler Perry unwittingly borrows pages from Edith Wharton and Elton John in *Diary of a Mad Black Woman*. Helen goes back to Charles as one last attempt to assess life in the "penthouse," so to speak, to test her newfound agentive capacities against the draw of her old life's privilege. Like Lily Bart, Helen had already endured a miserable existence in her comfortable modern aristocratic lifestyle during her eighteen-year marriage to Charles. But unlike Lily, Helen had a folk-cultural refuge in Madea's house and escaped to retool and reemerge as a subjective force. So when she revisits the mansion, Helen is stronger and

wiser and hence eventually, like Elton John's protagonist, decides she prefers life on the "farm" after all. Helen's rejection of Charles, the mansion, and status for her embrace of Orlando and his working-class life indicates that she is no longer beholden to the illusion that money brings happiness or that socioeconomic success secures satisfaction.

And perhaps if Joshua (the protagonist of Perry's seventh film, *Madea Goes to Jail*) had not left his privileged fiancée, Linda, at the altar during their wedding ceremony, he too might have become exasperated with the howls of society hounds like Lily Bart in Edith Wharton's novel and Elton John's protagonist in "Goodbye Yellow Brick Road." Linda's family name is so influential that the mayor and governor attend their wedding ceremony. But Joshua abandons Linda before saying "I do" and heads off to Candy, the woman from his old working-class neighborhood. All throughout *Madea Goes to Jail*, Linda had been pushing Joshua to forget about his humble past, but finally it is Joshua who rejects the rich woman of privilege and chooses to be with Candy, a former prostitute, drug addict, and convict. And the film ends with Candy newly freed from prison juxtaposed to the privileged attorney Linda heading off to prison for prosecutorial misconduct, a populist reversal of fates that resonates with Perry's overall critique against blind ambition. Linda's myopic focus on acclaim and success leads her to pad cases and cheat the legal system. Joshua is saved from Linda's superficial world of privilege, status, and aspirational myopia through a reconnection to his troubled childhood friend Candy. Like Helen choosing working-class Orlando over Charles, Joshua rejects Linda's world of high status and blind ambition to return to his folk-cultural roots through a film-ending romance with Candy.

A major motif within Tyler Perry's oeuvre is to warn his contemporaries against the existentially depleting entrapments of modern privilege and ambition. Perry's lesson for African Americans ceaselessly striving for upward social mobility within this post-soul epoch is simple: all you need for success and happiness exists in abundant supply within the social geographies of your humble ancestral heritage. Such a message is not entirely antagonistic to capitalist progression or socioeconomic transcendence; it is simply a reminder that as one strives for success, one should be sure to stay connected to the humble orientations, spiritual values, and cultural commitments that the filmmaker believes can provide true happiness and a healthy sense of self. And this

message seems quite in line with what Julie Dash projects in her critically acclaimed film *Daughters of the Dust* (1991), when Nana pushes her younger family members to reconnect with the spiritual dynamism of their black folk-cultural heritage before trekking off to a new and complicated modern existence up North. Dash and Perry celebrate the sustaining power of black folk-cultural dynamism as a corrective against the Johnny Rocco syndrome, the insatiable thirst for more.

Perry's cautionary tale for African Americans in this post-soul age is that once they embark upon a blind quest for acquisition and status, disconnecting themselves from the existential resources that have nurtured and nourished black people for centuries, they then put themselves in vulnerable positions that may lead to their own demise. Charles and Jamison learned this the hard way in *Diary of a Mad Black Woman*, and the ruthless attorney Linda is Perry's signpost for the deficits of blind ambition and aspirational myopia in *Madea Goes to Jail*. Perry uses Myrtle to articulate this point even more explicitly during her passionate speech to her family in *Madea's Family Reunion*.

A TALE OF TWO DAUGHTERS

Helen is not the only family member who becomes disconnected from her family. In Perry's second movie, *Madea's Family Reunion*, Lisa is estranged from her own working-class sister, Vanessa, and is somewhat severed from the entire family, with the exception of her mother, Victoria. Lisa and Vanessa symbolize the duality between black privilege and black working-class life. Lisa had a wealthier father than Vanessa and hence enjoyed more of the comforts of life during her childhood. Vanessa's father was a starving artist whom Victoria abandoned because he could not support the family. Now as adults, Vanessa and her two children are living with Madea to make ends meet, while Lisa is the fiancée of an investment banker named Carlos and lives in his luxurious high-rise condo. So while Lisa and Vanessa are living in the same city, the two sisters exist within two different social geographies and have little to do with each other until the beginning of the movie when they vow to spend more time together.

Victoria frames Vanessa's choice to live at Madea's house as a tragic plight, and warns her more privileged and preferred daughter, Lisa,

against falling into such a fate. Instead of valuing Vanessa as a hard worker and loving mother, Victoria sees her through materialistic lenses. Like Charles and Jamison in Perry's first movie, Victoria's consciousness is drenched in arrant ambition. Decades earlier, Victoria had struggled to make ends meet until she married Lisa's father. But her successful new husband was no longer satisfied with Victoria and wanted to sleep with his stepdaughter Vanessa and gave Victoria an ultimatum to make it happen or he would abandon his family. To save her economic standing, Victoria allowed Lisa's father to take advantage of her oldest daughter, Vanessa.

Victoria's horrific transgression against Vanessa is Perry's way of emphasizing the absurd compromises people make in pursuit of life's comforts and status. Just like Charles is willing to connect his nascent law firm's future to Jamison's drug empire and Jamison is later willing to kill an undercover cop to preserve that empire (*Diary of a Mad Black Woman*), Victoria sells out her own daughter within her aspirational necessity to preserve wealth and high status. Ironically, the fact that decades later we see her daughter Vanessa working at a bridal shop and living with Madea to raise her two children is proof that Victoria had other options when faced with similar circumstances. Victoria could have left Lisa's father and all the privilege and social standing he afforded her and sought refuge with a family member like Madea. But we learn that Victoria's own mother had similarly leased Victoria out to other men for money and so, as if living out a generational curse, Victoria followed the same path with her oldest daughter when her rich husband desired Vanessa. But the generational curse ends with Vanessa, who taps into familial resources to preserve her children's health and well-being as a working-class parent. Throughout the movie we see Vanessa's kids cheerful and thriving, protected and loved, in contrast to the painful childhood Vanessa endured because of her mother's dreadful neglect.

As the plot unfolds we see that working-class Vanessa is actually the sister to envy, despite Lisa's posh living situation. The daughter of privilege is subjected to physical abuse from her wealthy fiancé, while the working-class daughter has a blue-collar beau named Frankie who treats her like a queen. Lisa never developed muscle memory for resistance, but Vanessa, in contrast, learned how to fight long ago, and as the movie unfolds she finally learns how to heal. As if to further advance the

contrast, Perry ends the movie with a twist of fates. After Lisa finally fights back against Carlos and calls off the wedding, Frankie makes a spontaneous marriage proposal to Vanessa, who gladly accepts. So the blue-collar couple celebrate their nuptials in the extravagant Parisian-themed wedding originally designed for the wealthy-yet-troubled couple Lisa and Carlos. *Madea's Family Reunion* is a salutation to black working-class dignity and vitality. Perry juxtaposes black aristocracy against black folk culture, and the former suffers an astounding defeat. Perry is also clear in showing the ways in which both Vanessa and Lisa's lives are enriched by the folk-cultural heroine Madea, both physically, in providing a place of shelter and sanctuary, and existentially, in providing a kind of redemptive encouragement and guidance to help both women live fulfilled lives.

Victoria's pit-bull tenacity toward securing the good life at all costs is a metaphor for what Perry perhaps finds most troubling about our late-modern moment replete with the Johnny Roccos of the world wanting more and more. Victoria's best advice to Lisa in the entire film is "Sit up straight dear," and her worst exhortation comes in the form of premarital counseling: "Just be a good wife, do what the man says, and you won't have any problems," advice that comes directly after learning Lisa's fiancé is beating her. Maintaining social standing and appearances is primary for Victoria—the apotheosis of late-modern black aspirational strivings run amok. In contrast, Vanessa and her love interest, Frankie, represent existential stability and well-being that Perry believes can be found most abundantly in black working-class life.

If the previous chapter discloses that Perry's movies capture the aesthetic beauty of black wealth and professional privilege, it is also important to note how Perry envelops the visual warmth of a working-class couple enjoying love and life through the blossoming relationship of Vanessa and Frankie. It is no accident that Perry chooses Frankie's place of employment at the helm of the number 9 bus as the setting for his first success in securing Vanessa's attention, a public conversation that elicits participation from other passengers. Initially Frankie is having little success at captivating her, but he finally fractures Vanessa's defensive wall by reciting a corny poem. With Frankie and Vanessa's back-and-forth exchange and the rhythmic interjections of other passengers, Perry turns a mundane bus ride into a warm folk-cultural experience. An older passenger chimes in to cosign for Frankie, urging Va-

nessa to give her bus driver a chance because he really is a good guy. Perry converts the bus into a creative improvisational space where community onlookers witness (and perhaps bless) the commencement of a beautiful relationship.

Vanessa and Frankie's first date confirms Perry's mantra that you do not need money to have happiness. They enjoy each other's company and soak in the landscape of one of Atlanta's most beautiful parks at no cost. Frankie's son plays with Vanessa's children as the two parents learn more about each other's past. We later see Frankie and Vanessa having a fun date that allows Vanessa to express herself through poetry, and Frankie to draw a spontaneous portrait of Vanessa in front of a supportive community of artists and patrons in a bohemian spot reminiscent of the lounge in the urban classic film *Love Jones* (1997). As their relationship blossoms, we see Vanessa and Frankie enjoying long walks, sharing each other's ice cream, relishing each other's company, and lying in each other's arms without having to spend much money to secure satisfaction and fulfillment. Through Vanessa and Frankie's explorations, Perry accentuates the aesthetic beauty and simplicity of black folk-cultural connections. Frankie is content as a bus driver, Vanessa is fulfilled as a working-class parent, and the two form a relationship that proves to be not only medicinal toward healing Vanessa from her troubled past but also redemptive in contrast to the dysfunction exhibited by Lisa and Charles's engagement. Both Vanessa and Frankie are artists and both are admitted Christians, which adds more layers to their black folk-cultural reserves. Perry uses multiple resources at his disposal to call our attention to black folk-cultural beauty as a repository of existential assets against the repulsive backdrop of black aspirational culture represented by ambitious African Americans like Victoria and Carlos. Black working-class humility and vitality are posited as redemptive alternatives to elitist arrogance and blind ambition.

Madea's Family Reunion offers a poignant scene that best summarizes Perry's populist message. When mayhem breaks out at the family reunion, Aunt Ruby starts ringing the bell near the old slave shack, which draws all of the family members toward the building. With multiple generations of her family a captive audience, Myrtle draws on the slave shack imagery to envision themselves as modern sojourners standing on the shoulders of strong black ancestors who survived the tragedies of slavery. Myrtle exhorts her family members to see them-

selves as part of a heritage of survival, a legacy of endurance. Myrtle pleads with the next generation not to lose hold of that legacy, but to remain curious and vigilant in understanding and extrapolating from its dynamism. Myrtle's speech alludes to an existential inheritance within black folk culture that she fears is in jeopardy of being lost in our late-modern moment, an essential motif in Julie Dash's aforementioned movie *Daughters of the Dust* as well as in Perry's oeuvre. Perry's movies warn against discarding the rich cultural resources that have nourished African Americans through the harshest conditions, and Myrtle's speech captures that exhortation quite touchingly.

THE CARTWRIGHTS AND THE PRATTS

Tyler Perry's film *The Family That Preys* offers another interclass contrast, but this time the dissimilarity is also interracial. The powerful white Southern aristocratic riches of the Cartwright family and corporation serve as the comparative backdrop to the lives and aspirations of black working-class sojourners like Alice, Chris, Ben, and Pam. But there are also intra-racial class conflicts in the movie. In the same way that *Madea's Family Reunion* uses two sisters as divergent symbols of black folk culture versus black privilege, *The Family That Preys* draws on contrasts between Alice Pratt's two daughters, Pam and Andrea. The sisters are married to best friends, Ben and Chris, construction workers attempting to start their own company. Pam is content and well-adjusted within her working-class identity, even as she encourages her husband, Ben, to self-actualize and pursue opportunities to enhance his career. In contrast, Andrea is ashamed of her mother's diner and her husband's blue-collar occupation. Instead of offering Chris support, she demeans him as inferior to her white privileged boss and lover, William Cartwright.

Pam works with Alice in the family diner and resents Andrea's air of superiority. Under Alice's folk-cultural apprenticeship, Pam learns how to treat Nick Blanchett, a man who is down on his luck and living in the streets, with dignity and respect while Andrea rudely scoffs at him. Through Andrea's eyes, Nick is nothing more than a smelly nuisance. In contrast, Alice and Pam offer the homeless man free meals, bathing opportunities, and fresh clothes. Alice goes a step further by engaging

Nick like a person of importance and even heeding his investment advice, which proves quite lucrative for Alice at the end of the movie. Perry positions Pam as following in her mother's footsteps in embodying the beauty and existential health of their humble status, while Andrea is trying to escape to a world of wealth and privilege.

Throughout much of *The Family That Preys*, Andrea indulges in the Cartwright family's aristocratic mystique as William Cartwright's lover. Andrea's aspirational delusion not only fuels constant tension with her sister, Pam, but makes her blind to the unlikelihood of a Southern aristocrat like William Cartwright leaving his white wife to ride off into the sunset with his black mistress. In their confrontations with Andrea about her affair, Pam, Alice, and William's wife, Jillian, all allude to race as a barrier against any realistic expectation of William starting a new life with her. But Andrea is so thirsty for social prestige that their warnings fall on deaf ears, as she is not able to establish realistic expectations with William.

Andrea's preoccupation with William Cartwright's privileged status precludes her from realizing that her husband is actually more courageous and praiseworthy than her lover. In this way, Andrea's declaration to Chris that he will never be William Cartwright is prescient beyond her intent to prop up William as an articulate Harvard grad and denigrate Chris as a stuttering construction worker. Whereas William is lost without familial privilege, Chris is forging his own path on his own terms. William inherits an aristocratic empire while Chris is building one from scratch, and the tenacity and courage the construction worker shows throughout the movie surpass anything William Cartwright's privileged arrangement allows him to accomplish. Andrea is too distracted by aspirational myopia and her thirst for the Cartwrights' aristocratic status to ascertain that she has it all wrong: it is William who could never be Chris.

It is important to point out that Chris and Ben's venture to start their company contradicts any indication that Perry's populism harbors anticapitalist sentiments. While Perry often uses plots to lampoon and deconstruct aristocratic arrogance and arrant ambition, Chris and Ben present Perry's more positive example of post-soul progress through hard work and a healthy respect for their humble roots. In contrast, William Cartwright's attempt to out-leverage his own mother from the helm of leadership in the company and his reckless spending of compa-

ny funds on his mistress, Andrea, demonstrate the deficits of capitalist ambition and bourgeois privilege. The fact that those illegal gifts to Andrea are what Chris uses to jump-start the new company is an ironic populist twist. Perhaps Perry uses Chris and Ben to inform us that he still believes in the American dream and post–civil rights black progress, notwithstanding his penchant for criticizing narrow-minded quests for riches and status. Most of Perry's movies strike a harmonious balance between celebrating post–civil rights capitalist courage while critiquing what he envisions as the damaging effects of black aspirational fury.

Perry also contrasts the film's two most successful African-American female characters, Abigail Dexter and Andrea Pratt. Both Gen X women are educated, competent, and work with William Cartwright, but that's where the similarities end. Abby Dexter secures her executive appointment solely through her accomplishments, whereas Andrea depends on her powerful lover's backing. Abby plays by the rules and Andrea breaks them, accepting illegal gifts from corporate accounts, fraternizing with William against company policy, and venturing off to have sexcapades in hotels on the company's time and dime. Abby Dexter is Perry's vision of post–civil rights black privilege in all of its promising potentialities, while Andrea is his cautionary tale to contemporary black women who would be tempted to take shortcuts on their way toward the promise.

Tyler Perry also alludes to aspirational dissipation through the arc of William's mother, the wealthy industrialist Charlotte Cartwright. The filmmaker offers redemption, however, through Charlotte's connection to her best friend, Alice Pratt. While Charlotte is a far more sympathetic character than her son, she is not far removed from the decadent world of capitalist striving. In fact, she reigns supreme in that world. If William's shortcomings are mostly attributable to his desire to be like his late father, as Charlotte claims, some of his deficits no doubt are connected to William being his mother's son. The movie is called *The Family That Preys* primarily because Charlotte's family legacy is mired in backstabbing and dueling. No comment better confirms this than when Charlotte informs Abby Dexter, "My family has been known to prey on the weak" to convey her almost clairvoyant suspicion that William one day will try to out-leverage his own mother from leadership of the Cartwright Corporation. Charlotte is able to presume William's

surreptitiousness because she raised him within a climate of cunning, calculation, and contention. She knows her son did not garner such a penchant to prey on the weak from the thin air.

Charlotte's guilt-ridden confessions to Alice throughout the movie lead us to presume that Charlotte did her fair share of strong-arm corporate politics and dismantling of her enemies to stay on top. Being the Cartwright matriarch and corporate conqueror no doubt left much blood on Charlotte's hands, so to speak—enough that she asks Alice early in the movie if God could actually forgive her for of all of her past sins. Alice answers affirmatively, but Charlotte appears incredulous that she is redeemable. It is through Alice that Charlotte learns to accept redemption. Charlotte's stains from operating so long within the muck and mire of corporate leveraging and Southern aristocratic familial politics are sanitized by her connection to the saintly black folk-cultural heroine Alice.

Perry offers us cinematic optics for this redemptive synergy during Charlotte and Alice's westward excursion when Alice stops the car and drags Charlotte to the river where a black pastor is baptizing his congregants. Initially hesitant, Charlotte relents to a spontaneous baptism, a symbolic gesture that serves the duel function of preparing Charlotte for her death (which occurs later in the film) and relieving Charlotte's concern that she is unredeemable. Her submersion in water does not symbolize a spiritual rebirth or conversion to religion as much as it offers Charlotte absolution from past sins and acceptance by God. The fact that Alice and the black pastor play crucial roles in Charlotte's redemptive ceremony further underscores Perry's cinematic insistence that black folk-cultural agents and resources can do much to alleviate the stains and stench of elitist misery and excess. All throughout the movie, Alice functions as Perry's existential device to bring black folk-cultural purity to Charlotte's patrician life.

If Abby Dexter is Perry's most polished and perfect cinematic character, the humble diner owner Alice Pratt is Perry's most honest. Alice embodies the spiritual and psychic assets Perry seems to believe are in jeopardy of extinction within late-modern mind-sets pining for more. Charlotte takes refuge from the rat race of industry and the cynical power plays of running a corporate empire through her friendship with Alice. Oddly enough, Perry not only has Alice serve as Charlotte's spiritual adviser and folk-cultural sage, but he also offers an opportunity for

Alice to help Charlotte overcome her son William's attempt to gain controlling shares of the company. By heeding Nick Blanchett's investment advice, Alice secretly secures enough shares in Charlotte's company to help her best friend out-leverage her son and fire him from the company. Perry allows Alice to rise above the ranks of the working-class diner to become independently wealthy, another confirmation of Perry's pro-capitalist propensities and another plot rotation that allows a black working-class sojourner to appear heroic.

As *The Family That Preys* draws to an end, Perry's populism is clearly evident in the way working-class peeps thrive while the blue-blood Cartwrights and aspiring grandee Andrea do not fare so grandly. Charlotte Cartwright dies while Alice commits herself to enjoying life completely on her own terms. The banished aristocrat William Cartwright appears lost without power, and we see him sadly existing in his tepid marriage to Jillian, while his working-class rival Chris finally gets his company off the ground and appears happy and hopeful. Alice's daughter Pam is content supporting her husband, Ben, in his new business venture with Chris, while Pam's ambitious sister, Andrea, is unemployed and estranged from any social network of comfort. *The Family That Preys* warns against the reckless pursuit of post–civil rights promise and against the impolitic practice of measuring success and fulfillment by status and privilege.

SHEILA'S REDEMPTION

Tyler Perry reiterates the redemptive power of working-class life in *Why Did I Get Married?* Sheila is devastated and depressed both emotionally and economically after her marriage dissolves when Mike decides to divorce her; ironically the decision is made on a marriage retreat with friends in Colorado. After the breakup, Mike wipes out their joint bank account, leaving Sheila with eighty dollars, and cuts off her cell phone. Sheila is left with few options and decides to stay in Colorado to work at Sheriff Troy Jackson's general store. Earlier in the movie, when Mike first meets Sheriff Troy, he mocks the lack of remuneration in Troy's profession, to which Troy responds that he works as a sheriff because it makes him happy. So with that early exchange, Perry presents a telling contrast between Shelia's then husband Mike as mate-

rialistic and superficial and her future working-class husband Troy, who is happy with his job.

When the friends of the newly divorced and destitute Sheila offer to give her money and a place to stay, Sheila refuses their help, admitting that she has been allowing people to take care of her all of her life and that it is now time for her to be self-sufficient. And the fact that Sheila stays in Colorado to work in a general store instead of going back to Atlanta further symbolizes her need to break free from her privileged environs and gain existential renewal within a new working-class identity. It is not surprising that her successful friends do not think much of Sheila's choice to work at a general store. Given that Sheila is college educated and was accustomed to economic security and comfort while married to Mike, it is not surprising that some people (and even Sheila herself) might consider her new employment a major setback. But in actuality, working at the general store sets Sheila on course toward a happier future, allowing her to regain her dignity and jump-start a new romance with a more supportive partner, Sheriff Troy.

Perry makes Sheila's efforts in reviving the once-defunct general store both redemptive and romantic. In the process of resuscitating the store, she resurrects her sense of self. Thus, embedded within Sheila's recovery from the psychic trauma that she experienced during her miserable marriage to Mike is a connection to the honor of black working-class life, not unlike the manner in which Helen gains fulfillment through working as a waitress in *Diary of a Mad Black Woman*. It is no accident that the heroic figure who helps restore Sheila's confidence is a working-class man like Troy, who is cut from the same cloth as the blue-collar heroes (Orlando and Frankie) of Perry's first two movies. Sheila's time at the general store gives her an appreciation for working with her hands and facilitates a connection with a working-class hero. Their relationship blossoms, she marries Troy, and she eventually reappears to her friends at the end of the movie looking healthy and fulfilled. In the sequel *Why Did I Get Married Too?* Sheila and Troy are struggling with money problems and face several tensions but still support each other and grow closer from the adversity, once again proving that money is not necessary for happiness.

INTOXICATION AND BOURGEOIS CONSTRAINT

Tyler Perry not only offers biting critiques against aspirational myopia, but also presents our late-modern moment as a vortex of corporate impositions, familial expectations, and status pressures. Within this matrix, Perry presents black elites and professionals as suffering from what Lauren Berlant (2011) describes as relations of cruel optimism, fantasies of the good life that ironically produce outcomes that inhibit the pursuer's success or well-being. Perry builds on this notion of cruel optimism in recognizing that post–civil rights black professionals and elites seek the good life through relentless pursuit of societal prestige, wealth, and respectability in a manner that ends up providing more restrictions and problems than freedom and empowerment. And so the filmmaker sometimes offers his black privileged characters timely respites from their meticulously manicured modern actualities through alcoholic indulgence. Perry teaches that if modern life entails an endless list of restrictions under bourgeois polity, intoxication opens the door for throwing out the playbook and listening to one's own voice and inner drives.

Julia Breaks Free

A prime example of this liberating effect of alcoholic buzz for black elitist angst is with Julia Rossmore in *Daddy's Little Girls*. When we first meet her, Julia is an irritable, bossy, anxious, selfish, almost soulless corporate attorney. Perhaps a more euphemistic way of describing her is that she is all business. In dramatic contrast, Monty is a fun-loving mechanic moonlighting as her driver. In their initial encounter, Monty tries to break the ice with his client, but Julia is cold and condescending to him.

Tyler Perry presents the attorney as a victim of cruel optimism, as buying into the social restrictions of her sequestered world of bourgeois status in ways that come back to constrain her life choices and impede her opportunities for the good life. For example, we see her in absolute bliss on a blind date with Chris because he too is a lawyer at a prestigious law firm. It does not matter that as the date commences Chris insults her father by referring to him as an old fart; the mere fact that he's part of her professional class is enough to pique her interest. Julia

acts as if she has met her dream man, simply because their upper-class pedigrees are congruent. But her bliss terminates at the end of the date when she discovers that Chris is very much unavailable. Up until bumping into Chris's wife, kid, and dog, Julia is ready to give the lawyer a chance, whereas she did not even consider the possibility of dating a more available and impressive potential partner in Monty simply because of his status as a mechanic and driver. Thus, cruel optimism appears in the guise of how Julia's commitment to guarding the snobbish borders of her status and social space prevents her from pursuing a potential connection with Monty.

While Julia suffers from the entrapments of her own elitist standards, Monty appears free to live by his own dictates. Julia's father pressured her into becoming a great attorney, whereas Monty's dream to operate an auto repair shop came from his own imagination. Everywhere Monty goes he is greeted by a supportive community of friends who like and respect him, whereas Julia's only friends are two women from college who seem more concerned about policing Julia's commitments to bourgeois respectability than with displaying genuine regard for her happiness. Monty never knew his father but has a supportive surrogate in his mentor, Willie, and the adoration of an army of friends in his community. Julia, in contrast, knows her father and yet offers no indication that they share any warmth or connection. She is successful at her job but miserable at life and does not even know how to let loose and have fun.

Finally, during a spontaneous venture out to a nightclub at Monty's urging to celebrate her birthday, Julia is able to break free from the respectability constraints of her bourgeois world through intoxication. The moment Julia swiftly consumes two shots of vodka she goes from uptight killjoy to sexy and fun. In her sober confined state she ignored the possibility of connecting romantically with blue-collar Monty because she worried about what her friends would think, but in her state of inebriation, romance with Monty is not only possible but also par for the course. The liberating capacities of intoxication offer Julia improvisational space to redirect her quest for personal happiness. As a sober woman, Julia lets her highborn commitments control her, but as an intoxicated woman, Julia is free to create in the moment to feed new hungers and satiate new desires. Empowered by her alcoholic buzz, she seduces Monty on the dance floor and later demands that he spend the

night in her luxurious condo. While their rendezvous ends prematurely when Julia regurgitates as the result of her night of intoxication, the buttons are already pushed and Julia and Monty are headed on course toward romance. Alcohol serves as an existential lever to lift Julia out of her sequestered world of privilege.

Natalie and Walter

Intoxication also plays a liberating role in Perry's later film *Good Deeds*. The protagonist Wesley and his fiancée, Natalie, coexist within a black aristocratic world of constraint and predictability. In the movie's opening scene, after we hear Wesley describe his prescriptive life, Natalie's narration offers step-by-step predictions of what Wesley will say and do to fulfill his morning routine. She knows what shirt he will wear, what complaint he will launch against the housekeeper, and what food he wants for breakfast because her fiancé is trapped in toeing the line to routine. Later in the movie Natalie's only reprieve from their carefully crafted world is through the liberating power of intoxication.

Natalie gets drunk on a night out with friends and comes home ready to challenge Wesley's mechanical life with a spontaneous act of erotic play. But she is unsuccessful in seducing him out of his comfort zone as he is too concerned with what the neighbors might think because their blinds just happen to be open when Natalie is making her moves. Wesley's inability to facilitate one spontaneous act sparks an already intoxicated Natalie to cry out in frustration against Wesley for living such a boring predictable life, for worrying too much about what others think. Wesley responds to Natalie's mad tongue-lashing with confusion, perhaps indicating he has never heard these complaints before. He is so caught up in conformity that he is not even aware of his gradual deformation into an existential zombie. Natalie is not only painfully aware of Wesley's rigidity but also suffers from quiet desperation as a prisoner within her own capitulations to familial pressures and societal expectations. It is finally through the power of inebriation that Natalie is able to voice her frustration against Wesley's recalcitrant commitment to convention. She offers her first agentive critique of his existential (and sexual) immobility under the influence of her inebriated state.

Another alcohol-induced episode of medicinal madness occurs later in *Good Deeds* when the drunken state of Wesley's brother, Walter, disrupts the company gala, prompting a brawl with Wesley in the elevator. Walt's disruption continues after the fight when they are stuck in the elevator with his mother and Lindsey as he mocks Wesley for living his father's dream. It took a drunk, beaten, and bellowing Walt to dispatch a biting critique against Wesley's absurd conformity to other people's demands on his life. Walt tells his brother, "Isn't it ironic? We're all stuck here. Just like you're stuck in a career you don't even want," before breaking out into mad laughter and then banging on the elevator buttons to get it moving again. In this intoxicated moment, Walt Deeds offers a poignant assessment of the tragic state of his sober brother's passive existence.

This is not to suggest that Perry valorizes alcoholic indulgence. For *Good Deeds* begins with Walt unable to drive his own car as the consequence of repeated offenses of driving while intoxicated, and Perry's earlier movies *Meet the Browns* and *Why Did I Get Married?* make a mockery of Vera's and Angela's alcoholism, respectively. But what Perry's use of intoxication does possibly suggest is that from Perry's perspective, sober life within this late-modern world of bourgeois civility can be so stifling as to require a radical rupture and existential clarity through intoxication. And there is no doubt that Vera and Angela are two of Perry's most agentive characters as strong black women who rarely if ever conform to the politics of respectability. In contrast, Wesley Deeds for much of the movie seems in great need of the kind of rupture (or reprieve) from his sterile conformity to the dictates of his bourgeois existence that can be facilitated by alcoholic buzz. If Perry's populist critique exposes how people lose themselves in status or in defining themselves by the dictates of others, then alcohol is a temporary antidote to help people find themselves for a change. In this way Perry recapitulates the Dionysian capacities of ancient Greek mythology in balancing out rational strivings with revelry in intoxication.

CONCLUSION

In contrast to the aforementioned classic film *Touki Bouki*, which features a young Senegalese couple aggressively making moves to secure

enough money to leave Africa behind in pursuit of a more modern existence in Europe, Tyler Perry ends *Good Deeds* with his rich protagonist Wesley Deeds absconding from his elite corporate existence for a more peaceful life in Africa with his new love interest, Lindsey. Perhaps one might contend that Perry's ending comes dangerously close to broaching the borders of escapism in a manner that resembles classic fictional and nonfictional diversions from past versions of modern mayhem. Washington Irving's protagonist Rip Van Winkle evaded a vastly changing colonial landscape with a twenty-year siesta. Decades later, Henry David Thoreau's real-life digression from the bustling life of antebellum New England occurred in the form of a minimalist experiment near Walden Pond. Likewise, Tyler Perry ends *Good Deeds* with his protagonist, Wesley, absconding the States to embrace a simpler life digging wells in Africa. Perhaps Perry, like Irving and Thoreau, came to understand that fleeing the hammering impositions of modern momentum is a far better option than resisting them.

But perhaps Wesley's escape to new continental shores reflects a tinge of pessimism in Perry's artistic quest to disabuse the excesses of post–civil rights black privilege. Perhaps Perry too pines for Africa as a metaphor of a less modern world in which he does not have to be bombarded with the pressures and demands of running a 200,000-square-foot film studio and production empire. Perhaps Perry read Henry David Thoreau's classic text *Walden* (1854) and became convinced that the simple things in life really are the most fulfilling. Or perhaps Perry had his own Elton John–inspired "Goodbye Yellow Brick Road" moment in mind when crafting cinematic critiques against black aspirational myopia and upper-class angst. Perhaps Perry finds his existence among the dogs of society exasperating like the protagonist in Elton John's classic song, and perceives that his simple and unadulterated life back on the farm was more fulfilling than his new privileged status in the penthouse. Perhaps the drug kingpin Jamison Jackson's silly presumption in *Diary of a Mad Black Woman* that a bag full of money could make all of his problems go away reflects the naïveté Perry now too often sees among his wealthy comrades who believe they can buy everything, including happiness and fulfillment. Perhaps Perry has wrestled with these tensions in negotiating his own aspirations and patterns of consumption as one of the wealthiest African Americans in the world, continually warding off temptations to think that he can pur-

chase happiness. So then perhaps Perry with his penetrating disputa-tions against blind ambition and bourgeois existential immobility is preaching to himself to avoid their persuasive entrapments.

Whatever Perry's motivations may be, his movies convey that while post–civil rights black privilege can provide useful resources to those in need, a synergistic connection to black folk-cultural guides and re-sources can help elite or professional blacks live more fulfilled and satisfying lives. As a dual citizen of both sides of the socioeconomic divide, Perry sees his humble working-class origins as the repository of existential resources to help his comrades of post-soul privilege develop new levels of muscular interiority.

In a world in which the poor are blithely dismissed as needing reme-dial cultivation, Perry's films advance the populist notion that black elites and professionals need cultural and existential recalibration and must sit at the feet of poorer, less privileged blacks for an existential rehabilitation process. While novelist Edith Wharton and vocalist Elton John had the luxury of offering scathing critiques of materialism and taking populist jabs at the hounds of high society, Perry's artistic repre-sentations of black elitist dysfunction and existential angst generate crit-icisms from scholars complaining the filmmaker demonizes middle-class and wealthy African Americans or is contributing to class warfare (C. Harris and Tassie 2012; Z. Robinson 2014). But unlike scholarly discourses on intra-racial complexities of black modern life that engage the black poor from a vantage point of victimization and condescension, Perry's movies flip the script by exhibiting condescension toward the upper classes and celebrating the existential equanimity of black work-ing-class sojourners. Perry's antidote for the excesses and entrapments of modern living is a reconnection with the simplicity of black folk-cultural traditions and values. In this fashion, Perry issues a populist rejoinder to modern blacks warning them not to overlook the rich exis-tential resources that have sustained African Americans for generations. Perry's movies not only are creative representations of cultural and structural developments within post–civil rights black lives and experi-ences, but more importantly serve as black folk-cultural revisionist pro-jects on what it means to be healthy and whole within our late-modern moment.

3

REDEMPTIVE MADNESS

Perry's Existential Superwomen

Whether Madea is destroying beautiful furniture with a chainsaw in *Diary of a Mad Black Woman* or driving her car through the walls of a fast food joint in *Madea's Big Happy Family*, her comic rebellion and aggression are sufficiently out of control to consider her a madwoman of sorts. And her madness is in full force in multiple scenes in Perry's seventh film, *Madea Goes to Jail*. When her brother Joe throws a party at her house without her consent, Madea sprays bullets from her semiautomatic weapon to put an abrupt end to the revelry. When Cora is driving home and another driver cuts her off, Madea urges Cora to retaliate, reminding her daughter she didn't raise a punk. When Cora refuses, Madea intervenes by stepping on the gas and grabbing hold of the steering wheel, forcing the driver who cut them off to crash into the sidewalk. And later when a woman steals her parking spot, Madea commandeers a forklift to remove and total the woman's expensive convertible. Even in prison, Madea remains a reckless force, as she gives Big Sal a vicious beating.

It only takes one act of perceived (or misperceived) injustice for Madea to respond with a furious burst of retaliatory energy. While there is no way to deny Madea's destructive tendencies, scholars often miss the redemptive components of her madness. Nicole Rousseau (2013, 19) classifies Madea as an "overbearing, overwhelming, hypercritical, desexualized, violent, masculine, often criminal Black matriar-

chal character, which denigrates Black womanhood and Black mother-
hood on several meaningful levels." Other scholars claim Madea per-
petuates harmful stereotypes about black women (Kopano and Ball
2013), functions as a minstrel appendage of sexism and racism (Larkin
2013), and represents "the most devastating depiction of the African
American woman to appear on the large or small screen from the silent
film era to the iPad" (Merritt and Cummings 2013, 194). While Madea
is no Clair Huxtable, scholars and critics who reduce her to just another
instance of the "angry black woman" stereotype overlook how Madea's
volatility has existential import.

This chapter offers a revisionist look at Perry's most misunderstood
character to explore how Perry situates Madea and her madness as a
calculated contrast to women who are vulnerable to bullying and domi-
nation by stronger characters, usually men. While not denying the slap-
stick value of madness, this chapter reveals how that madness is Ma-
dea's mechanism to harness her environment and impose her will on
her world as a subjective force. The chapter also explores how Perry
strategically utilizes Madea's madness on children to satirize modern
parental mechanics and to offer an old-school kind of tough love. The
chapter concludes by exploring other characters in Perry's films who
have exhibited one form or another of madness. But in discussing
Perry's method behind Madea's madness, it is important to consider
how the hot-blooded grandmother contributes to a longstanding artistic
tradition of heightened agentive capacities for women through varying
degrees and deployments of madness.

MADWOMEN IN ART

One of the greatest articulations of the subjective power of madness can
be found in Shakespeare's tragedy *Hamlet* with his character Ophelia,
the love interest of Hamlet and the daughter of Polonius. Throughout
much of the play, when Ophelia is sane she operates as a passive tool for
the interests of these two men who dominate her. Polonius wants his
daughter to spy on Hamlet, something that gives her great pause, and
Hamlet wants to treat her as a docile trophy, which Ophelia finds equal-
ly distressing. Ophelia is situated within a precarious context where
everything about her social structure reinforces female passivity and the

dominance of the male will. Ophelia remains relatively voiceless for much of the play, but things change when she suddenly goes mad. Madness is Shakespeare's lever to create greater spaces of subjectivity for a structurally depleted, powerless woman, as it is no coincidence that Ophelia's unexplained rupture into madness provides her most bountiful lines in the play. In other words, madness gives Ophelia voice. While Ophelia dies never having enjoyed the kind of empowered subjectivity her male counterparts enjoyed, her mad state offers her creative spaces to express her own desires and vent against patriarchal power in ways unavailable within the social architecture of her day.

Bertha Mason in Charlotte Brontë's (1847) classic novel *Jane Eyre* fights, bites, shows anger, and sets fires that cause serious injuries to men. Perhaps at some point Bertha realized that the only way she could free herself from her cramped, gendered captivity within Victorian patriarchy was to go mad. And her madness lets her function as a subjective force even though it ultimately causes her demise. Brontë uses Bertha Mason as an outward expression of the inward fire that resides within the soul of protagonist Jane Eyre and countless other oppressed women as they negotiate the confined spaces of patriarchal domination (Gilbert and Gubar 1979).

Gayl Jones's provocative 1976 novel *Eva's Man* offers a nihilistic rendition of madness, as Eva's lifelong subjugation to male power eventually propels her to an unexplained and equally absurd breaking point in which she turns on a lover and poisons him. As if killing him is not enough, Eva castrates her lover's corpse with her teeth. In Toni Morrison's *The Bluest Eye* (1970), the protagonist Pecola remains a passive presence until late in the novel when she is wandering around the edge of town, communicating with her imaginary friend, and marveling at her newly perceived beauty. Pecola's wish for blue eyes and for a more empowered subjectivity is finally actualized through her venture into madness. In Morrison's novel *Jazz* (1992), Violet's suppressed anguish from a difficult childhood and complicated marriage reaches a boil at the funeral of her husband's young lover, Dorcas, when Violet slashes the corpse with a knife.

Cinema, too, has its fair share of women who impose their will on their environment through various forms of madness. Katharine Hepburn's role as Countess Aurelia in *The Madwoman of Chaillot* (1969) offers a constructive display of the agentive power of madness as popu-

list subversion, while Joan Crawford playing Louise Howell in *Possessed*
(1947) abandons all sense of proportion and murders her former lover
David. The unnamed female protagonist in the silent film *The Goddess*
(1934) goes mad and kills a gangster with a brick after he takes advan-
tage of her and tries to steal her life savings. In the Italian new wave
film *Senso* (1954), the protagonist Livia learns of her lover Franz's
deceitful and exploitative disregard for her and goes mad, but in her
mad state she sets in motion Franz's execution as an act of retribution.
In *The Color Purple* (1985), Celie passively endures beatings from her
husband, Albert, as her wifely duty, until she finally goes mad and
shocks everyone at the dinner table by threatening to kill her oppressive
husband with a knife. In the Spanish comedy *Women on the Verge of a
Nervous Breakdown* (1988), Lucia fakes sanity in order to be released
from the mental ward so she may kill her former lover Ivan. On her
mad quest to kill Ivan, Lucia threatens a biker at gunpoint and rides on
the back of a Harley firing bullets at a taxicab.

Perhaps one of the most notorious madwomen in cinematic history
is Annie Wilkes, the nurse who saves author Paul Sheldon's life and
nurtures him back to health in the film *Misery* (1990). Annie is out of
her mind but actually quite mindful of her own mad agentive capacities,
leaving a trail of corpses as an indication of her willingness to eliminate
people who stand in the way of her agenda. In *Thelma and Louise*
(1991), their life on the run from the authorities converts Thelma from
a rather passive victim to a courageous conqueror. In one scene, the
duo recklessly blow up a tanker of crude oil to punish a truck driver who
was making crude sexual advances to them. The movie culminates with
the two mad heroines dying on their own terms rather than passively
submitting to the authorities. In *Waiting to Exhale* (1995), Bernadine
(Bernie) destroys her husband John's clothes and sets his car on fire
after he tells her he is leaving her for his accountant. As a faithful
spouse, Bernie spent their entire marriage suppressing her will and
aspirations in support of John's career and perspectives. Going mad
strategically gives Bernie voice and subjectivity to recognize that her
world does not have to revolve around John's dictates.

In *Opium: Diary of a Madwoman* (2007), madness leads asylum
patient Gizella into autoerotic indulgence and numerous freedoms of
self-expression, eventually one in the form of a sexual encounter with
Dr. Brenner, who sees beauty and purity in Gizella's madness, magnifi-

cence and agency that do not reside in his own sane and troubled life. Madness creates new spaces for self-expression for Gizella even as it makes her vulnerable to dehumanizing experimental treatments by doctors who don't understand her. In Daniel Gillies's film *Broken Kingdom* (2012), Serafina, a teenage prostitute in Colombia, forges a unique bond with Jason, an American writer on a self-imposed depressive furlough in that country. As the friendship progresses, Serafina refuses to let Jason relegate her to the role of his asexual muse, and her only way of articulating her intense feelings is through mad subversive acts.

As with Gayl Jones's aforementioned novel *Eva's Man*, castration appears in several important films as a madwoman's act to punish or put a man in his place. The Swedish classic film *I Am Curious (Yellow)* (1967) features a dream sequence in which Lena goes mad and ties up an entire soccer team; shoots her philandering lover, Bill; and then cuts off his penis. In *Coffy* (1973), we see the protagonist dispatch her own creative form of castration by blasting a man in the groin with a shotgun. *Foxy Brown* (1974) features a madwoman of sorts setting her abductors on fire, mutilating a man with an airplane propeller, pulling a gun out of her hair to shoot another foe in the head, and for her encore, utilizing the services of a large and sharp knife to castrate her enemy. As if castration is not punishment enough, Foxy places the severed penis in a pickle jar and returns it to her victim's lover, Katherine, as a madwoman's way of provoking shock and awe. In the highly controversial Japanese film *In the Realm of the Senses* (1976), a prostitute becomes fixated on her client and eventually strangles him and then castrates his corpse.

In the aforementioned artistic works, despite erratic, careless, and at times tragic consequences, female characters occupy greater subjective spaces when venturing into varying degrees and displays of madness. For some, madness offers safe spaces to reject male dominance, and for others, madness offers a reprieve from the meticulous management of female expectations. Madness allows cheating lovers to be punished or unrequited love to be avenged. As a willful heir to this artistic tradition, Tyler Perry explores madness as a medicinal apparatus to achieve female subjective empowerment, strike back against bullies, mock modern parental mechanics, and break free from bourgeois constraint.

The fact that Perry names his very first movie *Diary of a Mad Black Woman* confirms the thematic importance of madness within his cine-

matic oeuvre. His movies endorse an artistic sanctioning of madness as a means of subverting the social order as well as offering women greater spaces for willful living. In this way Madea is an existential heroine, a woman who refuses to bow down to the respectability codes, professionalization imperatives, societal contraptions, and even legal statutes of her late modern mechanized world. Madea makes up her own rules and thumbs her nose at legal and moral restrictions to her actualization. So while we must concede that Madea's mad antics are slapstick, quite reckless, and not easily valorized, we must also recognize that Madea's volatility operates as a crucial mechanism for self-empowerment. Under her mad mentorship, weak-willed women learn to enjoy a more muscular interiority.

MADEA AND HELEN

Right off the bat, Perry explores madness in his first movie, *Diary of a Mad Black Woman*, through the character arc of the protagonist Helen. The film unravels a profound contrast between the earlier sane Helen, as a weak-willed pushover, and the empowered subjectivity she later displays in going mad. Early on Helen's passivity allows her husband, Charles, to dominate her, but going mad allocates space for Helen to achieve retributive justice and existential awakening. Throughout their marriage, she is pampered in riches while pummeled by Charles's growing contempt, which reaches its boiling point when Charles kicks Helen out of the mansion and moves in Brenda, his longtime lover and mother of his two boys. This quite callous replacement of one person with another will have great consequences for Charles as the film unfolds.

Forcibly removed from her marriage and home, Helen now suffers from a severe case of what Billie Holiday calls "lost my man blues" in the ten-minute musical short *Symphony in Black: A Rhapsody of Negro Life* (1935). With no one else to turn to, Helen moves in with her grandmother Madea to recover and contemplate the next phase of her life. Helen has no personal assets and no visible means of support because her whole life revolved around her husband's success and control. Tyler Perry positions Helen at Madea's house in order to set the stage

for Madea's inimitable brand of mad mentorship—just what the doctor ordered for a weak-willed woman like Helen.

Helen's first lesson in madness comes when Madea brings her back to Charles's mansion to wreak havoc. Like a madwoman, Madea drives through the security checkpoint and as soon as they enter the premises, Madea begins to destroy some of Brenda's expensive clothes. She urges Helen to destroy an expensive gown, and Helen tries but is not strong enough to tear it so Madea grabs the gown and rips it apart with one try, perhaps symbolic of how Helen was not strong enough to assert her will and thus relied on Madea's strength. After the two engage in heated confrontations with Brenda and Charles, the scene ends with Madea using a chainsaw to destroy Charles's expensive furniture, landing herself and Helen in jail for trespassing and destruction of property.

While Madea's mad acts in Charles's mansion are excessive and reckless, the existential strength she exerts is instructional to Helen, who has not yet expressed justifiable anger for being so callously kicked out of her marriage and mansion. Madea's wild desire to assert her own will on the matter is a powerful lesson that shows Helen that she can fight back, that her will does not have to be in concert with Charles's will, and that it is not the end of the world if she momentarily loses her mind in order to gain agentive power. But Helen's evolution to a willful state takes more time. Shortly after being released from jail she visits her mother, Myrtle, and reveals how lost she is without Charles. Here is where it becomes clearer that the focal point of Perry's existential lesson in this movie is not Helen's broken heart but rather the deformation of her will, her state as a disempowered subject.

Helen's venture into madness occurs shortly after she leaves her new beau, Orlando, to return to the mansion to help a wheelchair-bound and partially paralyzed Charles recover from almost fatal gunshot injuries (as discussed in chapter 2). Instead of appreciating Helen's concern, especially since his fiancée, Brenda, has abandoned him, Charles offers Helen the same disrespect she received from him all throughout their marriage. In reaction to Charles's intractable derision, Helen finally reaches her breaking point and responds, "Let me explain something to you. Old Helen is gone and you will not talk to me like that. Now I came here to help you, but now I'm gonna get even!"

Helen commences torturous treatments of Charles. She slaps him, beats him, and leaves him helpless to sit in his own urine and defecation

for days. When she finally returns to the mansion to see her immobile husband sitting in his fecal waste, she complains about how bad he smells and unleashes her own version of CIA waterboarding torture techniques by rolling Charles into the Jacuzzi, mocking him while his immobile torso almost drowns. Her back-and-forth trips to the mansion involve daily torture sessions where she imposes her will upon her helpless husband and taunts him, starves him, beats him, and demeans him, thus revealing that Helen has, in fact, gone mad! But in occupying new volatile spaces, her evolution as an agentive force is complete. Charles had conquered Helen for eighteen years, and it is through an abrupt sequence of redemptive madness that Helen now conquers Charles. Helen's madness becomes the great equalizer in leveling the playing field against a man for whom she served as a sycophant for almost two decades.

A triadic exchange between Helen; her saintly mother, Myrtle; and her quite secular grandmother Madea confirms Madea's mad mentorship of Helen. This crucial scene occurs during the time Helen is secretly torturing Charles. When Myrtle inquires about her daughter's marriage, Madea clairvoyantly blurts out, "She's beating the hell out of him," much to Helen's surprise, because she has not revealed to Madea her incursions against Charles. Utterly shocked, Helen asks her grandmother, "How did you know?" to which Madea responds, "You been around me. I know something done rubbed off on you"—Tyler Perry's confirmation that Madea's mad mentorship is helping Helen become an agentive force.

After her existential cleansing process is complete, Helen takes her mother's advice and forgives Charles before returning to Orlando—but enacts both choices on her own terms as an empowered subject. We learn from Madea that Orlando had been calling the house incessantly while Helen was taking care of Charles, but Helen by then was on her own agentive timeline. She returns to Orlando at the precise moment when she becomes fully committed to a permanent future with the steel worker. Hence the movie unfolds the process of Helen gaining subjective empowerment. She learns how to impose herself on her environment and will her way to happiness, which is in stark contrast to her previous existence as Charles's docile wife. No man will ever impose his will on Helen again, not even a loving caring man like Orlando who had to wait until Helen was ready to accept his marriage proposal on her

terms. With Helen's character arc, Perry shows us both the absurdity and ecstasy of love, but more normatively offers the restorative journey of a woman gaining subjective empowerment.

MADEA AND LISA

If madness is a crucial existential device in the title and plot of Perry's first movie, it proves even more remedial and retributive in Perry's second film, *Madea's Family Reunion*. This time the weak-willed protagonist is Lisa, the daughter of Victoria and the half sister of Vanessa, Victoria's other daughter. Whereas Vanessa had a hard life and a contentious relationship with her mother for reasons discussed in chapter 2, Lisa enjoyed a pampered existence, admitting in an early scene that she's never had to fight for herself. At the movie's onset we realize that Lisa, for the first time, is finding herself in a real fight for her life.

Lisa is engaged to Carlos, an investment banker who is described as one of Atlanta's most eligible bachelors. The movie begins with Carlos creating a carefully orchestrated romantic moment for Lisa before he takes off for work. He has engaged a string quartet to play beautiful music as she takes a relaxing bath to ease her soreness, which presumably came from a beating she received the previous night. The film's first depiction of Carlos's physicality occurs later that day when Vanessa and Donna surprise Lisa with a makeshift bachelorette party. Carlos unexpectedly returns from work to find the three women and a chiseled male stripper in his living room. He pretends everything is okay until his first moment alone with Lisa when he surprises her with a vicious backhand slap that sends her flying into the wall.

When Lisa visits Vanessa at Madea's house and informs her sister about the ongoing physical abuse she has received since the day of her engagement, Vanessa immediately screams for Madea, knowing that in a tight pinch the person to draw strength from is their mad relative. Lisa, not wanting to disclose that she is the victim in peril, tells Madea a hypothetical story about a friend who is getting physically abused by her partner. Madea's facial expression reveals her suspicion that this "friend" is closer to home, but she plays along and advises that the victim throw a hot pot of grits on the perpetrator followed by a royal beating with an iron skillet. Madea's visual demonstration of how to

implement the attack lightens up the moment, sending the sisters into laughter, even as her message that the "friend" needs to be ready to act violently proves prophetic. Tyler Perry discusses this scene in the Director's Commentary for the film's DVD: "In this movie I thought it would be important for [Madea] to teach that some battles you have to fight on your own. So with this conversation about the grits and everything, that was about fighting your own battles and finding your own path." Perry's statement confirms Madea's mediation toward inspiring Lisa to fight her own battles. While at this early point in the movie Lisa is not ready to fight, she finds safety and strength in coming to Madea's house as a refuge from the abusive physicality of Carlos.

As the movie progresses, Lisa's small steps toward subjective empowerment inspire aggressive retaliations by Carlos. For example, when she stands up to him on the dance floor at a nightclub, Carlos responds by reminding her to not even think about leaving him because he is in their relationship until death do them part. And later when she tries to leave him, Carlos awakens before she exits the condo and forcibly drags her out on the balcony, threatening to throw her off until she relents and tells him she loves him.

The movie not only juxtaposes Lisa's weakness against Madea's strength but also positions Lisa in contrast to the confidence and power of her own problematic mother, Victoria. Victoria may have her share of character flaws, but passivity is not among them. In a scene in which Victoria and Carlos engage in a vicious exchange, Victoria shows no fear and repeatedly suggests that Carlos's aggression toward her daughter is directly correlated with his lack of penile girth. Carlos gives as good as he gets in their verbal contest, but never even considers the possibility of striking Victoria, the preferred manner in which he controls her daughter Lisa. Similarly, Lisa's sister, Vanessa, is presumably too strong a woman to ever allow a bully like Carlos to abuse her. Vanessa is a fighter and would find a way to put an abuser like Carlos in the hospital while she exits the relationship. But it is Lisa the coddled child of privilege who finds herself in a situation that, as Madea has so presciently pointed out, requires her to take decisive action.

When Lisa finally decides to fight back, it is not under the influence of Myrtle and May, the elderly spiritual sages at the family reunion who counsel Lisa about love and life. It is the mad anointing of Madea that motivates Lisa's decisive strike against Carlos's dominance. In this cru-

cial scene, there are no prayers or pleas for God's protection as Perry unfolds a quite carnal solution to Lisa's problem: that she has to go mad to break free, that Lisa has to become "Madea" and exhibit a strong sense of self. The fact that the critical moment happens at Madea's house is fitting since it is Madea's mentoring that ignites Lisa's breakthrough. When the rubber meets the road, Perry's prescription for a victim like Lisa enduring physical abuse is not longsuffering and saintly wisdom, but the brute force that a madwoman like Madea can inspire.

This crucial scene occurs after another nightly session of Carlos's physicality leads Lisa to flee once again to Madea's house. The next morning, Madea exhorts Lisa that it is time to fight back. When Carlos finally arrives to retrieve Lisa, Madea reminds Lisa that Carlos must be hungry and that there is a pot of hot grits on the stove to feed him (hint, hint). So Madea leaves the couple alone in her kitchen having done her part in providing both the retaliatory strategy (earlier in the movie) and the punitive instruments (grits and an iron skillet) for Lisa's coup de grâce.

Once Madea leaves, Carlos slaps Lisa for defying him. That violent strike is the match that ignites the burning fires of a mad moment to sever Carlos's power over Lisa for good. Lisa grabs the pot of hot grits and empties the contents on Carlos's face, causing him to scream in agony. Outside of the house on her way to her car, Madea offers a sadistic chuckle as she takes pleasure in hearing Carlos scream. The camera cuts back to the kitchen showing Lisa beating Carlos with an iron skillet, just as Madea had advised. In the next scene, Lisa goes to the church and announces to friends and family that she is not going to marry Carlos, revealing the daily abuse she endured and her unwillingness to tolerate it anymore. The movie ends with Lisa free from Carlos's brutal impositions over her life.

Though comical and somewhat slapstick, Lisa's mad act of violence is quite dangerous, as were Helen's torturous exchanges with Charles in *Diary of a Mad Black Woman*. Pouring hot grits on Carlos's face and beating him with an iron skillet is more brutal than anything Carlos ever did to her. Hot grits could scar a person's face for life and an iron skillet can easily give a person a concussion as well as extensive broken bones, so this was a serious beat down administered by Lisa. There is no denying that Lisa had more constructive and less dangerous options to put an end to Carlos's bullying. And so it is important to reiterate that

bouts of madness in Perry's movies often release reckless and lethal displays of physicality. Perhaps the ending of Perry's third movie, *Daddy's Little Girls*, with Monty's mad vehicular assault (discussed later), serves as the greatest example of the reckless nature of madness in Perry's oeuvre. Similarly destructive, Perry's first two movies feature weak-willed female protagonists dispatching retaliatory attacks that are dangerous and cruel. So we see that Perry condones violent retribution against powerful people who prey on the weak, and that those violent acts are as cathartic and empowering for the weak-willed subject as they are carelessly harmful to the object of mad fury. Under Madea's mad mentorship, Helen and Lisa become willful subjects and the courage and power they display in their new agentive capacity is quite redemptive and normative within Perry's existential treatment of madness, even if the anger they release is quite dangerous and seemingly disproportionate. Bullies are punished in decisive and damaging mad acts in Perry's movies.

MADEA AND CHILDREN

Madea's threats and physical attacks against petulant kids are legendary. In a country with severe laws against child abuse and sanctions to preserve the safety of children, Madea is unashamed to go ballistic on an unruly child. Perry often metes out Madea's madness to mock modern parental mechanics and satirize middle-class mores. The filmmaker creates scenes in which Madea dispenses brute force as a remedy for unruly children, as opposed to the timeouts and friendly negotiations they might get with modern disciplinary techniques. While subjectivity is one of Perry's highest values, Madea's normative vision for children is somewhat old-fashioned, requiring children to obey in order to be heard and giving them a rough hand from time to time to make sure they stay in line. So we can imagine that Madea is no fan of Benjamin Spock, whose monumental tome *The Common Sense Book of Baby and Child Care* (1946) became the late-modern bible for child rearing, impressing upon parents the necessity to negotiate with their children. Perry's movies showcase unruly children who take advantage of such lenient parental mechanics. Madea's corrective solution is to go mad on disorderly or disobedient children.

In *Madea's Big Happy Family*, we see perhaps the best example of Perry's satirical representation of modern disciplinary tactics with the antics of Harold Jr., better known as HJ, the snippy tween child of Harold Sr. and Tammy. HJ enjoys incredible liberties in expressing his mind to his parents and other adults. Tammy asks her son to wash dishes and HJ replies, "I don't feel like washing no plates. Come on Tammy, leave me alone." The incorrigible child repeatedly calls his father a punk ass. In their first cinematic scene together, HJ tells Madea that she looks like she's been fed at a zoo. Moments later, when Madea insists that Tammy and her family attend a family dinner at Shirley's house, HJ tells his mother, "I said I ain't going, Tammy!" to Madea's astonishment. When they are finally alone, HJ rudely asks Madea, "What you lookin' at old lady?" Madea by now has had enough and goes mad on HJ, slapping him no less than nine times in a vicious physical exchange. Under Madea's tutelage HJ begins to show his parents a newfound deference. From Madea's perspective, score one for the mad rod of correction over the patient modern parenting of Dr. Spock.

The earlier film *Madea's Family Reunion* offers Perry's first representation of Madea's tough love with children shortly after a judge orders her to assume guardianship over an unruly tween named Nikki who has been languishing in the foster care system. Madea and Nikki get off on the wrong foot when, departing from the courthouse in Brian's car, Nikki keeps making a popping sound with her gum while ignoring multiple commands from Madea to stop. Unimpressed by Madea's directives, Nikki starts taking off her earrings as if it were a prefight ritual, warning Madea, "You don't know me. I'll whip an old woman." Madea asks Nikki who she is talking to, and the tween responds, "I'm talking to you!" with a cocky look on her face, adding, "You think I'm playing?" Madea dives into the backseat and commences pounding on Nikki uncontrollably. So Madea does not even make it home from the courthouse before beating on her new foster child.

When Madea is not physically imposing her will on children, she is verbally doing the same. Her madness gives her space to say all sorts of abusive things to children that would make one cringe in our age of political correctness and child advocacy. Madea threatens to "pimp slap" Jennifer in *I Can Do Bad All by Myself* and to shove a telephone down an unnamed disobedient girl's throat in *Madea's Family Reunion*. While Madea's threats of physicality to children are almost always dis-

proportionate to their offenses, within these spaces of madness are not only poignant critiques against lax modern parental mechanics, but demonstrations of Madea's care and concern.

Truth be told, there is no greater children's advocate in Perry's movies than Madea. In *Diary of a Mad Black Woman*, when Brian's daughter Tiffany enters Madea's house expressing her desire to sing in the church choir, it is Madea who advocates on Tiffany's behalf and the movie ends with the girl offering a penetrating lead vocal performance. Similarly, Madea often babysits Vanessa's children in Perry's second movie, *Madea's Family Reunion*, doting on them. In the same movie, her new foster child, Nikki, comes to Madea despondent, rude, and unconfident after enduring neglect and verbal abuse in her previous foster family tours. With her biological mother in jail and father never in the picture, Nikki matriculated through the foster-care system fearful and despairing. Social scientist Loretta Brunious (1998) articulates how children in similar circumstances to Nikki are often recipients of adverse labeling practices and consequently suffer from low self-esteem and negative self-image. Madea gives tremendous love and support to the troubled tween, and even Madea's violent threats and insistence on following dictates are medicinal in how they offer Nikki the one thing she never received in the care of other foster parents: attention.

Nikki quickly learns that Madea is not going to ignore her because she cares about her, even if the old woman has a rough way of showing it. And Madea's excessive monitoring and meticulous attention to detail gets the recalcitrant tween on the right track. When Nikki tells Madea about kids bullying her on the school bus, Madea walks her to the bus and gives the young passengers a stern warning that any more bullying will be met with swift retaliation. A boy seated in the front tells Madea to shut up and she responds by pummeling him, demonstrating to the rest of Nikki's schoolmates what will happen to them if they continue to pick on her. Obviously, there were better ways for Madea to make her point, but Nikki's smile at Madea's mad attack on the school bus reveals the pride of a child who never had a parent stand up for her before.

Later, when Nikki skips school and comes home attempting to deceive Madea, her story falls apart when she discovers Madea already met with her teacher and ascertained her homework assignment. Going up to the school to stay on top of Nikki displays astute parental instincts on Madea's part. After Madea gives Nikki an old-fashioned spanking for

her truancy, she calms down and listens to Nikki articulate how her lack of confidence sparked her decision to cut class. Madea adjusts to the new information by giving Nikki a loving pep talk to build her confidence and then resolves the problem by connecting Nikki with a tutor. Nikki quickly emerges as a polite, happy, and whole girl, thriving in school under Madea's tutelage. Toward the movie's end we see Nikki proudly proclaiming she wants to be a lawyer, a goal that was incubated under Madea's watchful eye.

In *I Can Do Bad All by Myself*, Mama Rose's desperate and hungry grandchildren, Jennifer, Manny, and Byron, first meet Madea during their unsuccessful burglary attempt. Madea catches them in the act but oddly enough serves them a nice hot meal instead of calling the police. While she's feeding them and threatening them with violence, she's imparting her folk wisdom on good manners and teaching them how to show respect to elders. Rather than just preaching to them, Madea listens and learns that they have a rough life and that their attempt to burglarize her house was a means of survival. But even after learning they have been through a lot, Madea still sees in them the potential to self-actualize and become well-adjusted adults. So she makes demands on Jennifer, Manny, and Byron and expects them to take steps toward growth and maturity, which they do under her insistence. This is another example of how Madea never acts with pity or condescension toward children within her reach. She treats all children as if they are capable of overcoming tragedies and trials to become productive citizens.

Later in the movie, when Jennifer, Manny, and Byron work in Madea's house as propitiation for breaking her VCR during their burglary attempt, Madea convinces a despondent Jennifer that she is beautiful and has more to live for than she realizes. It is no coincidence that the first time we see the teen smile is after one of Madea's endearing pep talks. Later in the movie when Jennifer learns of her grandmother's death, she runs for comfort and support to Madea, the same woman who a few days earlier had threatened to pimp slap her. So Madea's mad physicality and threats of violence to kids should be seen in the totality of her overwhelming concern for them. Every child who has had considerable interaction with Madea has been empowered by the exchange. Madea goes mad on kids, but her madness is imbued with

loving concern and existential uplift. She inspires children to show re-
spect to adults and to become productive agentive citizens.

MADEA AND SHIRLEY

Perhaps both Madea's most efficacious display and Perry's most
psychotherapeutic engagement of madness occur in his later film *Ma-
dea's Big Happy Family*. Madea's favorite niece, Shirley, a middle-aged
woman played by Loretta Devine, is diagnosed with cancer and is given
a short time to live. Sensing her time is short, Shirley wants to announce
her sickness to her adult children and bring her family into a more
harmonious tenor, but after an initial attempt quickly ends in failure,
she lacks the muscle to marshal cooperation from her children, who are
distracted by their own problems. Much of the early plot revolves
around the challenge of bringing the family together. Madea comes to
the rescue, guaranteeing a family dinner with all of Shirley's children
present. Shirley marvels at Madea's assurance, and part of the film's
slapstick dynamism involves Madea visiting Shirley's offspring to im-
press upon them the importance of coming to their mother's dinner.
Through outlandish intimidations and impositions, Madea's madness is
in full effect to ensure her intended outcome. For example, she inter-
rupts real estate agent Kimberly's open house with clients, raising a
ruckus and ensuring repeated disruptions until Kimberly finally com-
mits to attend her mother's dinner. And Madea threatens Byron that he
will regret the day he was born if he does not attend Shirley's dinner.
The entire family shows up for Shirley's dinner just as Madea had
promised.

Understanding how the timing of *Madea's Big Happy Family* is re-
lated to an important event in Tyler Perry's life is vitally important
toward ascertaining the movie's existential celebration of Madea's vola-
tility. Tyler Perry's mother, Willie Maxine Perry, died in 2009. Less
than a year later, Perry writes and tours the play and in 2011 releases
the film. In the Special Features section of the film's DVD, Perry dis-
cusses how writing *Madea's Big Happy Family* helped him deal with his
mother's death and "get through my own grief." And it is difficult to
miss the parallels between his character Shirley and his real-life mother.
Shirley dies in the movie from a bout with cancer; Willie Maxine suc-

cumbed to diabetes. Shirley is a highly spiritual woman, a loving mother, and a tireless worker with a generous heart, traits that correspond with the ways Perry has described his mother throughout the years. But whereas actress Cassi Davis (who plays Aunt Bam in the movie) describes the film as Perry's tribute to his mother, I envision the movie more as Perry's psychotherapeutic assessment of his mother's existential immobility. From this vantage point, the movie captures how Shirley and Willie Maxine share another thing in common beyond their virtues: the way their passivity allowed for their children to suffer on their parental watch, and hence the manner in which both Shirley and Willie Maxine's Christian virtues and capacity for longsuffering stood as ineffectual contrasts to the redemptive and retributive capacities of Madea's madness.

Tyler Perry is quite vocal in interviews on how he and his siblings have physical and emotional scars from his father's bullying. During his October 2010 appearance on *Oprah*, with tears welling up in his eyes, Perry discusses being subject to vicious mind games as well as receiving a beating from his father so severe that he blacked out for three days. The ongoing brutality and psychological torture he recounts being subject to were in no way condoned by his mother, but were not prevented by her either. While Willie Maxine's special place in Tyler Perry's heart seems indisputable when considering the endearing comments he made before her death and those he continues to offer in her memory, the one attribute the filmmaker's mother lacked was a proclivity toward redemptive madness, the retributive means by which his father's alleged bullying would have been put to an aggressive and decisive end. Perhaps from young Tyler's perspective, his mother could have used a real-life mad mentor like Madea to help her rid herself of a daunting bully of a husband who allegedly terrorized the entire family for many years. Had such a madwoman actually existed, she might have mentored Willie Maxine into conjuring up enough strength to leave his father or put him in the hospital.

And so as a filmic eulogy of sorts for Perry's mother, *Madea's Big Happy Family* is both an indictment against passive Christianity and a celebration of the kind of agentive secularity exhibited by a madwoman like Madea. We see this throughout the film with its ongoing contrast of Shirley's sanctimony and inactiveness against Madea's madness and willful efficacy. Shirley appears as a woman of contemplation; Madea as

a woman of action. Shirley prays, Madea punches, and it is the threat of Madea's mad punching power rather than the execution of Shirley's prayers that restores order in the family. Madea intimidates, threatens, and harasses Shirley's kids throughout the movie, and while her tactics lack all sense of proportion, it is Madea's willful action, not Shirley's prayerful contemplation, that restores order in the family. And I believe Shirley's passivity is Perry's unspoken indictment against his mother's failure to act decisively in the face of familial challenges and strife. Both Willie Maxine and Shirley were endearing Christian mothers, but both were presumably paralyzed by Christian passivity. Perhaps Perry believes his mother and Shirley took the Bible too literally when it admonishes believers not to resist an evil person but instead to turn the other cheek (Matthew 5:39). Perry seems to maintain that both women hid behind their spiritual convictions and therefore lacked decisive action to restore order in their families and protect their children from harm. In contrast, Madea is an agentive force that gets things done and restores familial order and stability, even if she wreaks havoc along the way.

Hence, the heroine of *Madea's Big Happy Family* is not Shirley, the gentle and loving spiritual matriarch who dies, but an irreverent, irascible, and irrepressible secular madwoman named Madea who brings the family together by hook or by crook after Shirley's death. The fact that Shirley dies with her family in complete disarray and Madea wields a compelling presence to generate healing and order is crucial for understanding Perry's modern message for the film. *Madea's Big Happy Family* exposes the negligent tragedy of inactiveness and celebrates decisive action. A recurring line in the movie has Madea asserting that her favorite niece did the best she could, even while acknowledging that Shirley's family almost dissolved under her watch. Perhaps Perry feels the same way about his mother, Willie Maxine: that she did the best she could. But perhaps Perry also feels that doing the best you can is not good enough when it comes to keeping your children from harm's reach. Perhaps Perry believes that, like Shirley, his mother needed less prayer and contemplation and more recklessness to ward off his father's alleged brutality. And perhaps Perry detects something disabling about Christian piety and hence uses a secular madwoman to confirm an existential point that reverberates throughout all of his movies, that it is up to the individual to fight for herself and impose her will onto her

environment rather than to allow family, religion, or life to bully one into quiescent self-cancellation.

So Madea's success in bringing Shirley's family together, establishing order, and getting everyone on the right track is an impeachment against Shirley's (and Willie Maxine's) passivity. Madea is able to confront and disabuse more dysfunction and enact more constructive change in Shirley's family in one week than Shirley was able to generate in decades. What we learn from Perry's existential vision is that prayer and love are not enough, that perhaps a little madness is needed to exert one's own existential power as a woman of decisive action. Perry's movies are cautionary tales against the detrimental consequences of Christian inaction. From this we can presume that since Perry's own childhood lacked a volatile, gun-toting, quick-tempered woman of action to protect him from harm and systematic abuse, he had to create a fictional counterpart in Madea.

MADEA'S MAD COUNTERPARTS

Like Shakespeare and many contemporary writers and filmmakers, Perry employs madness as a subjective response to the deprivations of sanity within confined social spaces. In this way, Perry's redemptive use of madness resembles the instrumental use of psychopathology in Showtime's hit television drama *Dexter*. In the eighth season of *Dexter*, Dr. Evelyn Vogel, a psychiatrist who studies psychopathology, repeatedly claims that nature has good use for psychopaths and that human progress owes debts to psychopathological people who were willing to engage in cruelty when human progress demanded dispassionate detachment from civility. Similarly, Tyler Perry endorses a teleological respect for madness, especially when madness is employed to free women who face cramped spaces of subjectivity. Within Perry's cinematic universe there are times at which personal survival trumps civility, and madness offers the mechanism of willful exuberance to replace passive capitulation to abuse and bullying. In addition to Madea, other female characters outside of Madea's reach use madness as a mechanism to keep male power in check, punish bullies, and harness their environments.

Sheila Goes Mad

In a crucial scene in *Why Did I Get Married?* Sheila goes mad and knocks her husband, Mike, upside the head with a wine bottle. The force of the blow is so severe that Sheila thinks she killed him. And when she later finds out from Sheriff Troy that her concussive blow did more to bruise Mike's ego than cause serious injury to his person, she tells Troy, "I should have killed him." How did Sheila arrive at a state where she wishes death upon her spouse?

Earlier in the movie we see Sheila as a calmer, more passive Christian woman boarding an airplane with her husband, Mike, and her girlfriend Trina. The three are traveling from Atlanta to the mountains of Colorado to meet up with the couple's college friends for a yearly marital retreat. But before the plane takes off, the passenger seated next to Sheila complains to the flight attendant that Sheila's girth is invading his space. The flight attendant informs Sheila (played by a padded Jill Scott to appear larger) that it is the airline's policy for persons her size to purchase two seats but since the aircraft is already seated to full capacity, she will have to deplane. Sheila's husband could have easily rectified the situation by offering to switch seats with the man who complained, but instead chooses to mock his wife for being so big. Mike also prevents Trina from switching seats, and his compliance in Sheila's humiliating exit from the plane should have been enough of a red flag that their marriage was in trouble.

Only a weak-willed woman would endure such disgrace without putting up a fight, but at this point in her life, Sheila is all too accustomed to conforming to Mike's will, seeing it as her Christian duty to endure her husband's blatant contempt and disrespect. At the marriage retreat, Mike cheats on her with Trina and continues to be a callous bully, ridiculing Sheila's weight by comparing her to a cow. But the cold-hearted manner in which Mike proposes the terms for their divorce finally sparks the mad juices of retribution within Sheila, and so the normally passive Christian woman finally takes her first proactive step toward getting her life back by going mad and pummeling her tormentor with a wine bottle.

In the sequel *Why Did I Get Married Too?* the passivity from the first movie is long dissolved, and Sheila emerges as an agentive force. While we don't see her concussing anyone with a wine bottle, we do see

her vigilantly and proactively confronting and checking her new husband, Troy, every time he acts in a way that is unacceptable to her. If Sheila is guilty of passivity in the first movie, she goes overboard asserting her will at all costs in its sequel. The new Sheila keeps a bit of madness in her psyche as a reminder never to let anyone, not even a loving and caring new husband like Troy, invade the borders guarding her self-respect. The old Sheila let Mike bully her into passive conformity to his will. Like a person wielding no will of her own, the more Mike disrespected her, the more Sheila blamed herself for Mike's unhappiness. But her mad act of violence with the wine bottle was her first decisive break from a universe that revolved around Mike.

Cheryl, April, and Angela

In *Meet the Browns*, Sofia Vergara plays an endearing bipolar Latina named Cheryl who exerts Madea-like volatility throughout the film. In her very first scene she argues with a bus driver and prevents the bus from leaving until her best friend, Brenda, reaches the bus stop. Shortly after, Cheryl threatens to burn down the plant where she works when she finds out her employers closed it down to ship production overseas. Cheryl's willingness to impose her will onto her environment provides both slapstick exuberance and existential power as a defiant woman who refuses to be denied in any situation. When Miss Mildred demands money from Brenda for services rendered in the form of child care, Cheryl shows no deference to the elderly woman, threatening to report her for running an illegal day-care center. When Michael Sr., the uncaring, irresponsible father of Brenda's son, is verbally abusive to Brenda, Cheryl retaliates by throwing a brick at his back, knocking him to the ground. And later in the movie when Brenda starts spending time with her new love interest, Harry, it is Cheryl who threatens Harry to treat Brenda right or suffer violent reprisal. Throughout the movie, the protagonist Brenda's passivity is remarkably contrasted against Cheryl's subjectivity. In celebrating the kind of inward power that refuses to back down to anyone, women prone to mad displays of aggression like Cheryl seem to occupy a special place in Perry's imagination.

In *I Can Do Bad All by Myself*, the protagonist, April, has many faults but one of them is not being a weak-willed woman. April does what she wants when she wants, even in the face of criticisms by her

family, religious leaders, and friends. She carries on an affair with Randy, a married man, because she admits she is too selfish to devote herself to an available man who would demand more time from her. And later in the movie when Randy decides to make sexual advances against her teenage niece Jennifer, April initially acts calm and advises Randy to take a bath, as if she believes his claim of innocence. What Randy does not know is that April's tranquil temperament is the smoke-screen of a woman plotting revenge. After Randy draws the water and jumps into the bath, April electrocutes him by throwing an appliance into the tub. Randy survives, but not without feeling the high-voltage retaliation of a woman gone mad.

Angela in *Why Did I Get Married?* and its sequel *Why Did I Get Married Too?* may be the closest rival to Madea in embodying mad-woman swagger. Angela reps the hood, and her rough edges are ever present when she is imposing her will onto the world. She yells, screams, and threatens without any regard for Southern politics of re-spectability and bourgeois civility. Whether she is telling off passengers on a train, threatening to kick Trina's ass, or firing off bullets from her gun, Angela appears as a willful subject, refusing to be out-leveraged or overpowered in any exchange. Even in the bedroom Angela is the mad-woman in control, as her husband, Marcus, describes her proclivity for sexual conquest: "Angela is not the type to ask for it; she takes it!" Perhaps one of the funnier moments in the sequel is when Angela interrupts the live broadcast of her husband's television show to con-front and rebuke him when she suspects him of cheating. Within this exchange Marcus tells her, "You're like three crazy people!" and his assessment has merit. Angela's volatility may provide slapstick moments in both movies, but her madness exerts existential strength. She im-poses her will onto her environment in contrast to weaker-willed wom-en in Perry's movies who are easily bullied and manipulated.

MADMEN

Though madness in Perry's films is most often the mechanism used by women to consign bullies and abusers to their place, a few men also indulge in mad acts of retribution or, in the case of Gavin, madness as a medicinal act of release. There is no doubt that Perry's madmen pro-

vide some of the most troubling and perplexing uses of madness in his oeuvre, as characters find themselves able to fight back after enduring abuse or break free from the facades of bourgeois civility.

Monty and Chris

In *Daddy's Little Girls*, Monty loses custody of his three girls to their mother, Jennifer, the selfish parent who along with her drug dealer boyfriend Joe mistreats Monty's girls. The movie charts Monty's fight to win back custody of the children in court, while exposing the sad consequences of his daughters' lives under the tutelage of Jennifer and Joe. When the three girls run away from Joe's apartment at 3 a.m. to return to their father, exposing the bruises on the back of Monty's youngest daughter as the result of Joe's distorted disciplinary tactics, the upstanding Christian mechanic goes mad. Monty executes a premeditated vehicular assault against Joe and Jennifer at a dangerous speed, then drags the dazed and injured Joe from his car and gives him a vicious pummeling. Up until that point Joe's legion of thugs rendered him untouchable and feared by his community, but watching Monty punish Joe inspires Monty's community to join in the fight and go mad against Joe's support team, who are trying to rescue the drug kingpin from Monty. We see an elderly woman like Aunt Rita beating on a thug with a frying pan as other residents in the community go mad on Joe's boys. The melee sparks a series of fortuitous events that put Joe and Jennifer on course to be in prison for a long time.

So Monty's lethal act of madness not only goes unpunished; it is also the catalyst that provides the legal means through which the assistant district attorney can finally put drug dealer Joe in prison. Hence *Daddy's Little Girls* ends with violence as a redemptive means to overcome vicious bullying and win back the community. The community elders didn't pray; they punched. Monty's vehicular assault was commensurate with Madea's retaliatory measures as a move to restore order in the universe and put powerful bullies in check—another confirmation that Perry's movies condone violent paybacks to oppressors as powerful acts of redemption.

In *The Family That Preys*, the normally measured and quite passive construction worker Chris endures psychological bullying and disrespect from his wife all throughout the movie but finally snaps when she

reveals that she is having an affair with her boss, William Cartwright, and that their son might not be Chris's child but that of her lover. In a fit of rage, Chris slaps his wife hard enough to send her flying and has to be restrained by his best friend, Ben, and his sister-in-law, Pam. While some critics and activists might be troubled by this decisive display of spousal abuse, it is important to note that Perry respects women too much to impose a gender double standard that allows women to inflict violent acts against men in some movies but not the other way around. It is equally important to note that in the very next scene, Chris goes mad on his wife's lover, William Cartwright, with physicality more vicious than the slap to his wife.

Gavin Goes Mad

As one of four couples featured in Perry's two marriage films, Patricia and Gavin appear to form a successful loving union most people envy. Like many modern couples, Patricia and Gavin are so effective at concealing their resentments and presenting their union as healthy and strong that their peers are shocked when Patricia reveals that she and Gavin are getting a divorce in *Why Did I Get Married Too?* Patricia's declaration is ironic not only because she announces their decision to divorce at a retreat intended to produce stronger marriages, but also because Patricia and Gavin appear as the least likely of the four couples to have problems. As divorce proceedings unfold, we learn that their marriage existed for more than a decade in quiet desperation, while functioning under the facade of the black professional couple that has everything.

Tired of adhering to bourgeois decorum, the normally calm and confined architect finally releases his anger in a mad drunken fit. Gavin's intoxicated break is arguably the most passionate, disturbing, and bizarre sequence in Perry's oeuvre. The scene begins with Gavin walking in a room with a half-empty bottle of vodka in his hand, while announcing to Patricia that it might be best if he gets his things and moves out. Patricia's clinically calm agreement to the suggestion of their first separation in fourteen years triggers an alcohol-induced mad rupture in her husband. Gavin lets it all out concerning what he really thinks about his marriage. He laments their scrupulously managed public display of marital bliss, reducing their union to a fourteen-year farce.

He tries to hurt Patricia by bragging about her colleague Denise's ongoing flirtation with him. He yells and pours vodka on Patricia, and in a more hostile moment, pins her on the couch, lying on top of her with their faces so close in proximity that they would not have to extend their lips very far to kiss. But instead of locking lips, Gavin begins to "counsel" the psychotherapist, facetiously prodding her to purge, as she has no doubt instructed many of her clients to do. Gavin has gone mad and now has Patricia constrained against her will, forcing her to listen to his own purging. And hence, despite the fact that Perry doesn't idealize Gavin's reckless vodka-induced state, the filmmaker does nothing to conceal how it offers Gavin's most agentive moment in both marriage movies.

In this alarming scene, Patricia must now listen to Gavin's visceral rumbles and acerbic assessments of her performance as his wife. He asks her, why does she always have to be in control and why does she always have to be right? He screams at her, "You've got all this advice for everybody but you don't want to help yourself!" He even growls like an animal, and the growls confirm newfound feral freedom to purge within his mad state of intoxication. It is in this erratic scene that the veneer of bourgeois respectability is finally lifted and much is revealed about Gavin and Patricia's dysfunctional marriage. We learn about Gavin's disdain for the fact that Patricia never cried at their son Noah's funeral, that he wasn't happy in his entire fourteen years of marriage, and that he spent their entire partnership waiting for her to learn how to love him. So in all his primitive snarls and erratic antics, a scene that culminates with Gavin setting a reckless fire in the living room, intoxication brings out Gavin's most honest, raw feelings about his unhappy marriage. While his mad eruption is not medicinal in terms of healing an obviously doomed marriage, the scene nonetheless is therapeutic for Gavin. His alcohol-induced madness is the mechanism by which he steps out of the facade of modern civility and gains his greatest voice. Perhaps if the couple had had more mad moments to purge, they would not be heading toward divorce.

CONCLUSION

If Charlotte Brontë's protagonist in *Jane Eyre* represents a certain degree of conformity to modern bourgeois decorum, then Madea is Bertha Mason, the madwoman in the attack. But unlike Bertha, Madea cannot be confined; she is free to roam and impose her will onto her environment. Madea's madness produces disproportionately absurd retaliatory behavior that disturbs elitist notions of propriety as quickly as it undermines Kantian codes of respectability. Madea's wild antics provide much entertainment because they are unpredictable, shocking, and excessive. In this way, Perry taps into the American tradition of slapstick comedy through Madea's volatility, but utilizes it in an imaginative way to lift weak-willed characters up and over their oppressors.

Madea's madness is like a sauntering hip-hop track ready to provide shock and awe at the blink of an eye. Like hip-hop, Madea is disruptive to the very bureaucratic, professional, and judicial structures that organize modern life, as she ridicules modern parental mechanics with her incessant verbal threats and physical assaults against children. She violates law enforcement attempts to contain her volatility and laughs in the face of judicial restraint. Put a house arrest bracelet on her ankle and she'll eventually find a way to remove it. Madea rebuffs all impositions and forms of self-cancellation and even refuses to get her driving license renewed as a way of flaunting her wildcard status and defiance. No custom or spiritual precept can delimit Madea's erratic entanglements, as disruption and disproportion are crucial features of her madness. Madea is more than a clever slapstick appendage; she is a subjective force in the face of a mechanized late-modern landscape. Madea's madness is also strategically juxtaposed against the passivity of weak-willed women who need to stand up against aggressive bullies.

Mad violence is a reasonable means to punish bullies and balance the scales of justice in Perry's cinematic universe. In prison, Madea puts an end to the bullying of Big Sal with a vicious beating. Monty saves his community and wins back custody of his children through an act of vehicular madness (*Daddy's Little Girls*). Cheryl stands up for her friend Brenda by throwing a brick at the disrespectful father of Brenda's son (*Meet the Browns*). Chris puts an end to the psychological bullying of his wife and her lover through successive mad acts of physicality against both of them (*The Family That Preys*). April pays back her

lover for trying to rape her niece by electrocuting him (*I Can Do Bad All by Myself*).

Madness also represents Perry's existential release valve from sterile conformity to societal dictates and a rupture against crippling passivity and inaction. So much about our modern existence emphasizes containment and rational control, but Perry's oeuvre presents moments for letting go as a way to ensure existential health. When religious, familial, and personal scripts don't offer space for radical interrogation of being, for stepping outside of expected behavior, then madness offers the redemptive clarity to carve out new space, to confront, to protect, and to impose one's will on the world, rather than to acquiesce to the will of others. Perry's characters take a page from Madea's playbook when they realize that many of life's problems require less praying and more punching. For the woman whose passivity allows her to wallow in self-pity or endure long-term bullying, for the man of contemplation paralyzed within an abusive relationship that leads to expurgation of self, and for the growing numbers of black professional elites whose lives seem hopelessly deadlocked within a conformity to bourgeois dictates, familial pressures, and societal expectations, Perry offers an aggressive solution in the same manner in which Ophelia finally widens her agentive capacities in *Hamlet*, Celie finally stands up to Albert in *The Color Purple*, and Bernie finally strikes back against John in *Waiting to Exhale*: simply go mad!

Diary of a Mad Black Woman. Madea destroying Charles's furniture as payback for mistreating her granddaughter. Lionsgate/Photofest

Madea's Family Reunion. Carlos greeting his fiancée moments before she crowns him with a pot of hot grits, putting an end to his abuse and their relationship. Lionsgate/Photofest

Madea's Family Reunion. Tyler Perry sharing a moment on set with legendary cast members, the late Maya Angelou (left) and Cicely Tyson. Lionsgate/Photofest

Daddy's Little Girls. Monty comforting his daughters, Sierra, Lauryn, and China, after the abuse they suffered while living under their mother's custody. Lionsgate/Photofest

Meet the Browns. Brenda (left), with her best friend Cheryl, enjoying a well-needed reprieve from her recent struggles. Lionsgate/Photofest

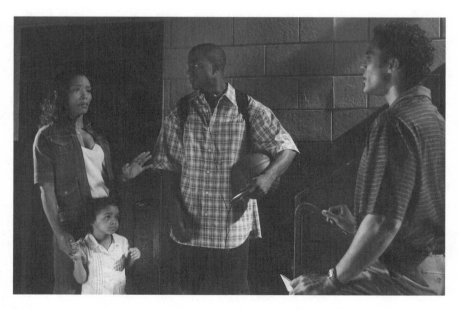

Meet the Browns. Brenda interrogates her future love interest Harry before letting him coach her son Michael. Lionsgate/Photofest

Why Did I Get Married? Dianne and her husband, Terry, attend an awards ceremony honoring their friend. Lionsgate/Photofest

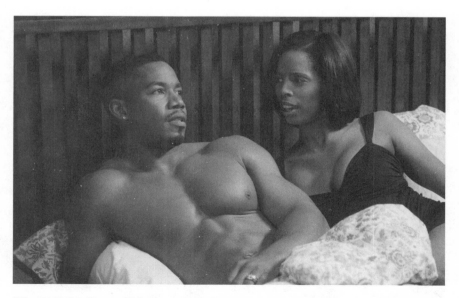

Why Did I Get Married? Marcus rebuffs Angela's romantic overtures to conceal the fact that he recently contracted a sexually transmitted disease. Lionsgate/Photofest

I Can Do Bad All by Myself. April angers Sandino by insinuating insulting motives for helping her niece and nephews. Lionsgate/Photofest

I Can Do Bad All by Myself. Pastor Brian leads his congregation in a song after delivering a passionate sermon. Lionsgate/Photofest

The Family That Preys. Alice (driving) and Charlotte on their cross-country excursion moments before Alice takes Charlotte to an outdoor service for Charlotte's surprise baptism. Lionsgate/Photofest

The Family That Preys. Tyler Perry discusses a scene with Kathy Bates on set. Lionsgate/Photofest

The Family That Preys. Pam (right) confronts her sister Andrea about her selfishness. Lionsgate/Photofest

Madea Goes to Jail. Madea commandeering a forklift to remove a woman's car from the parking spot Madea claimed for herself, an act that lands her in prison. Lionsgate/Photofest

Good Deeds. Lindsey surprising Wesley with a lunchtime adventure on a Harley. Lionsgate/Photofest

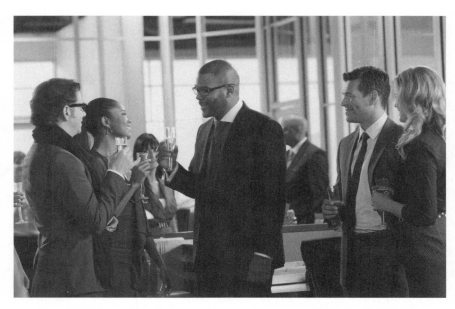

Good Deeds. CEO Wesley Deeds celebrating a corporate takeover with his fiancée, employees, and friends. Lionsgate/Photofest

4

RELATIONAL RELIGION

Perry's Folk-Modern Spirituality

Long before Tyler Perry treats Christian spirituality like a featured character in several of his movies, Spencer Williams does so in his very last film, *Juke Joint* (1947). After con artist "Bad News" Johnson prays over the dinner table (an ironic development itself), the Holiday family participates in a popular Protestant ritual practiced in many churches, Bible studies, and homes in which each person recites a scripture for everyone's spiritual edification. Mama Lou Holiday goes first and offers an improvised version of Psalm 31:1: "In thee, oh Lord, I put my trust. May I never be put to confusion," followed by her less holy husband, Sam, who blurts out a more recognizable Psalm: "The Lord is my shepherd, I shall not want" (23:1), not to be outdone by their worldly daughter Florida, who utters the shortest verse in the Bible: "Jesus wept" (John 11:35). Christian patrons familiar with the respected scriptural recitation ritual would have caught how Spencer Williams satirizes Sam and Florida's lack of spiritual depth by having them choose scriptures that even most heathens know. This scene in *Juke Joint* is just a small sample of how black directors have deftly incorporated religious culture in their race films.

Tyler Perry takes the deployment of Christian cultural tools within the textures of secular movies to entirely new levels. Part of his widespread appeal among post–civil rights African Americans resides in the fact that his artistry is birthed and inspired by the rhythms of black

spirituality. If intellectuals and scholars like Greg Tate (1992), Joan Morgan (1999), Bakari Kitwana (2002), Mark Anthony Neal (2002), and Nelson George (2004) attempt to chart the changing contours of black life since the 1970s, adding provocative insights toward understanding post-soul aesthetics, they all omit the cadences of black Southern spirituality and gospel music from their thoughtful delineations. Thus a component missing from scholarly explorations of post-soul transformations is space held by traces and tones of black spiritual identities and contemporary changes in Protestant Christianity. Black worship services and gospel music are themselves intriguing innovations because they incubate folk energies from slave religion while adapting to modern technologies, new sounds, and burgeoning themes.

Like Sunday services at many black mega churches, Tyler Perry's artistry helps scholars fill in the gaps concerning how nostalgic connections to black folk-religion converge with technological change, worldly savvy, and professional decorum to shape what it means to be black and modern in our post-soul epoch. Perry's filmic representations of spirituality feature upbeat and nondogmatic forms of religion that resonate with the wide-ranging tastes of many "post-soul babies," who grew up frequenting black mega churches, who came of age in the Oprah era, and who enjoy the eclectic aroma of urban neo-soul singers like Erykah Badu and Jill Scott. Hence, Perry's religious cinematic vision is an important touchstone for examining what it means to be black, Christian, Southern, and chic for many African-American people in the post-soul era. Perry's nuanced portrayal of religious cultural tools offers an artistic lens through which to explore the changing contours of contemporary American Protestantism as well as the extensive expressions of black spiritual empowerment.

An important theme that reverberates throughout this work is that Tyler Perry goes beyond the role of cinematic custodian of contemporary changes, continuities, and contradictions of black modern lives to function as an existential healer of modern woes. In such a capacity, Perry not only offers dazzling cultural displays of black spirituality and theological reflection but also accentuates the therapeutic dimensions of religion. And within some of his modern negotiations (or renegotiations) with religion appear the celebratory embrace and radical critique of some of the filmmaker's own Christian traditions. So Perry's folk-modern syntheses are quite complex when religion is the site for the

filmic interconnection of tradition and change. But long before Perry began to capture how religious identity and tradition navigate the torrential currents of modern momentum, Jewish identity films were brokering folk-modern collocations in divergent ways.

JEWISH IDENTITY FILMS

Jewish identity films depict protagonists contesting issues regarding Jewish religious and ethnic identities in the context of assimilation and modernization. One of the first filmic treatments of the tensions between Jewish tradition and modern change is Alan Crosland's *The Jazz Singer* (1927). The protagonist, Jakie Rabinowitz, is the son of a Jewish cantor, which is a musician and singer who leads a synagogue in songs and prayers. Cantor Rabinowitz expects his son Jakie to follow in the family tradition that has produced cantors extending back five generations, but Jakie ventures West in pursuit of his dream of being a jazz singer. The fact that he changes his name from Jakie Rabinowitz to Jack Robin signals his eagerness to assimilate to an American modern identity.

When Jack returns to New York and visits his family, his father rebukes him for playing jazz tunes on their piano, reminding his son, "I taught you to sing the songs of Israel, to take my place in the synagogue." Jack's response to his father's rebuke is significant concerning the way the movie strategically positions Jewish tradition against jazz and American culture as symbols of modern change. He tells his father, "You're of the old world! If you were born here, you'd feel the same as I do. Tradition is all right, but this is another day! I'll live my life as I see fit." So it is clear that as a second-generation Jewish American, Jack makes peace with modern American identity in ways that his more traditional and devoutly first-generation Jewish father will never accept. But against the advice of his producer, Jack chooses to fill in for his gravely ill father in the synagogue so Cantor Rabinowitz can die with a smile on his face having heard his son sing the songs of Zion. Hence, the movie ends with Jack resolving the tradition versus modern conflict by affirming both identities on his own terms. He refuses to deny his Jewish identity and yet continues on as a modern jazz singer.

A similar negotiation between Jewish identity and modern change can be seen in Jeremy Kagan's film *The Chosen* (1981), which is set toward the end of World War II. The film contrasts Reform and Orthodox Jewish-American identities through the friendship of two Jewish-American teenagers: Danny, whose father is a Hasidic rabbi, and Reuven, whose father is a liberal professor. *The Chosen* is an even more deliberate delineation of the disparity between Jews adhering to strict folk traditions (Danny's father) and Jews striving to become more modern (Reuven's father). At the movie's end, both sons strike intriguing resolutions with their career choices to broker what it means to be Jewish and modern. Reuven decides to become a Reform rabbi, and Danny pursues a career as a researcher and scholar; each son becomes a retrofitted version of his friend's father in a way that reconciles tradition with modern change. Hence, *The Chosen* (like *The Jazz Singer*) posits that every Jewish person has to construct his or her own identity utilizing cultural tools from both Jewish and modern toolkits.

Eli Cohen's *The Quarrel* (1991) offers an even more contentious dichotomy between tradition and modernity but offers nothing remotely close to a resolution like those posited in the preceding Jewish identity films. The central characters Chaim, a secular Yiddish writer, and Hersh, a conservative Rabbi, were best friends before the Holocaust as Yeshiva students, until Chaim's break with his faith sparked a breach in their friendship. Twenty years later they encounter each other in a park on Rosh Hashanah, each surprised to see the other, believing the other had died in the Holocaust. Their reunion provides the context for a penetrating dialogue about their vast religious disagreements. Hersh believes Chaim will remain spiritually crippled and wounded because he traded in the serenity of their Jewish faith for lusts he will never satisfy, and Chaim believes Hersh is intellectually thwarted by his unrelenting trust in a silent God and a lack of engagement with secular social spheres like art. The movie offers Jewish identity as a contested site between tradition and modern change as Hersh leans on tradition and looks suspiciously at modern reasoning, believing "if people followed their reason, it would lead to disaster," while Chaim looks suspiciously at Jewish tradition, supposing a secular and cosmopolitan life is the only way to be free. Hersh considers the Torah and God as crucial for Jewish survival, and Chaim believes reason and freedom should supplant faith and tradition. At the movie's end, Rabbi Hersh offers an

anecdote that best summarizes the contentious divide over Jewish tradi-
tion within the context of assimilation and modern change:

> You know, Chaim. I was on a train recently. A lady was sitting next to
> me. She was Jewish and she was dressed, I guess you would say,
> modern. And I noticed that for some reason she seemed very agitat-
> ed. We traveled along for a little while and I noticed she's getting
> more and more angry. And finally she leans over to me in a voice that
> only I could hear, "I don't know who you are mister but I just want
> you to know how embarrassed I get whenever I see Jews dressed like
> you; from another century. You make the rest of us look ridiculous. If
> you have to dress like this, the least you could do is stay at home."

Chaim and Hersh leave each other reconciled in friendship yet hope-
lessly deadlocked in beliefs concerning what each perceives as the best
path for Jewish identity.

Joan Micklin Silver's *Hester Street* (1975) goes to greater lengths in
conveying an impassable breach between Jewish identity and modern
change. Set in late-nineteenth-century New York, the protagonist, Yan-
kel Bogovnik, is a Russian Jew who immigrates to the United States
three years earlier than his wife and son and within that interim does
everything in his power to assimilate to American cultural values. Con-
sidering himself a proud Yankee, he changes his name to Jake and dates
a secular Jewish dancer named Mamie until his wife, Gitl, and son
arrive in New York and confront his assimilated identity. In contrast to
Jake, Gitl is unyielding in her adherence to and exhibition of traditional
Jewish religious, cultural, and aesthetic values. Their marriage becomes
ground zero of the conflict between the old and the new. Jake wants
Gitl to be Americanized and modern like his mistress, Mamie, and Gitl
wants her preassimilated husband back. Gitl soon seeks comfort from
Jake's coworker, Mr. Bernstein, an educated traditionalist who too re-
grets the cultural costs of leaving the homeland, telling Gitl, "When you
get on the boat, you should say, 'Goodbye, O Lord, I'm going to Ameri-
ca.'" The movie ends with Jake and Gitl getting a divorce so that Jake
can marry his more assimilated love interest, Mamie, and Gitl can mar-
ry the more traditional Jewish friend, Mr. Bernstein.

Whereas *The Jazz Singer* and *The Chosen* involve negotiation and
compromise, *The Quarrel* and *Hester Street* suggest that integration is
futile, that an irreparable fissure is the outcome of a clash between

Jewish tradition and modernity. But another approach presents Jewish identity and modernity as if there is no problem to be resolved. In Roman Polanski's critically acclaimed biographical film *The Pianist* (2002), the protagonist and his middle-class family wrestle with no theological or traditional Jewish interpretations and appear no different culturally or spiritually than the protagonist's circle of influential gentile musicians and professionals who eventually help him escape the Holocaust. Even as Jewish people suffer and die in large numbers in *The Pianist*, they do it without calling on God or showing discontent at being deprived of practicing any traditional Jewish customs or rites. Similarly devoid of serious engagement with Jewish traditions, Woody Allen's *Crimes and Misdemeanors* (1989) presents a fully assimilated and privileged American-Jewish doctor who orders the execution of his mistress and eventually comes to the rather modern conclusion that the notion of justice is socially constructed, even as that conclusion is in tension with the traditional Jewish values of his childhood.

If Roman Polanski's *The Pianist* treats Jewish tradition as invisible and Woody Allen's *Crimes and Misdemeanors* presents it as antiquated, the Coen brothers' film *A Serious Man* (2009) goes a step further, treating Jewish religion as incompetent and inefficacious. The protagonist's son Danny performs his Bar Mitzvah scriptural reading while high on marijuana, and no one notices, not even the purportedly perceptive Rabbi Nachtner. Similarly undiscerning, other rabbis in this film offer useless counsel to the protagonist, Larry, who is in search of meaning as his life unravels. The movie depicts Jewish faith and tradition as absurdly incapable of helping Larry cope with his complicated existence, raising profound questions as to the relevance of Jewish faith and tradition in a modern world.

So Jewish identity films offer varying perspectives on Jewish faith and ethnic identity as sites for the negotiation of tradition and modern change. Some strike a harmonious balance, while others present tradition and modern change as irreconcilable variants, and some, such as *Crimes and Misdemeanors* and *A Serious Man*, even mock traditional Jewish religious practices and practitioners. Within the rich expressions of African-American identities in cinema exist similar constructions of religion as sites for the battle of tradition against modernity. Like their Jewish counterparts, black identity films raise important questions con-

cerning a minority group's struggle against oppression and what it means to survive and thrive in a secular changing world.

BLACK RELIGIOUS REPRESENTATION AND MODERN CHANGE

Whereas Jewish identity films negotiate religious traditions against the backdrop of the Holocaust, ethnic oppression, and the requisite tensions of Jewish Americans assimilating into modern societies, African-American filmic negotiations of religion often unfold in the form of confrontations that are particularly relevant in matters regarding the historical legacy of slavery and the concomitant struggle for racial progress in an increasingly modern society. These movies offer intriguing representations of black experiences, conflicts, aspirations, and contradictions in light of exploring what it means to be black and modern, keenly featuring religion's role in answering that question and disabusing modern woes. When filmic protagonists challenge traditional black religion, it is often in the form of a social critique pointing out its irrelevance or inability to help African Americans progress toward a more promising future.

Support for Modern Change

Oscar Micheaux's *Within Our Gates* (1920) tactically contrasts regressive forms of black religion against more modern depictions with his representations of black clergy. Old Ned the preacher is Micheaux's caricature of "old-time" black religion. Ned dispenses emotional messages of eternal bliss to his black congregants while leaving the white supremacist power structure intact, promising God will balance out the scales of inequity in the afterlife. Micheaux uses Ned to suggest that a kind of fiery folk-religious fervor is regressive and detrimental to the cause of black progress. In contrast, Micheaux's educated ministers in the film appear as politically conscious and modern. For example, in the scene when Dr. Vivian is reading a magazine, Micheaux gives us a close-up of a posting that features the politically progressive cleric Rev. Thurston:

Rev. Thurston has begun an active campaign for the education of the black race. He asks that the federal government contribute significantly so that Negro children in all of the United States can receive proper instruction. He has called on a number of senators and congressmen with the goal of . . .

While the posting ends abruptly, we see enough to envision Rev. Thurston in stark contrast to a preacher like Old Ned, who at one point in the film assures two powerful white men that he'll disabuse the mounting pressure from blacks demanding suffrage. Micheaux depicts another progressive contrast to Old Ned in the form of Rev. Wilson Jacobs, an educator described as working tirelessly for the cause to uplift his race. So *Within Our Gates* depicts Rev. Thurston and Rev. Jacobs as modern, smart, conscious, concerned clerics, against images of Old Ned offering otherworldly and harmful messages to African Americans. Micheaux's point is imminently clear: a modern form of socially progressive religious intervention is efficacious for the black struggle while traditional black religion serves as an impediment to black progress.

Whereas Micheaux contrasts the politically inefficacious cleric Old Ned to more progressive-minded clerics, Michael Roemer's film *Nothing But a Man* (1964) contrasts a traditional black preacher against his nonreligious son-in-law, the protagonist Duff Anderson. Dawson is the local preacher in a small city in Alabama who counsels Duff to try to get along better with the white power structure of the city. The film offers an "Old Ned" moment when the city's white superintendent visits Dawson's home and makes his exit not without a stern reminder that he's counting on the preacher's support to dissuade his people from issuing a lawsuit. Duff was surprised to see his father-in-law compromise with the superintendent instead of fighting him, and even the preacher's own daughter, Josie, later acknowledges that her father has done nothing to ameliorate the oppressive conditions of black residents in the city. Earlier in the movie we see Rev. Dawson's small church indulge in fiery preaching and traditional hymns, demonstrating a kind of old-time religion that Michael Roemer positions as nonconfrontational and hence complicit with the white racist hegemony that dominates blacks in all sectors of society.

Spike Lee recapitulates Micheaux and Roemer's depictions of traditional black religion as socially irrelevant and ineffectual in the context of black racial progress with his film *Red Hook Summer* (2012), which

presents a dying black Baptist church in a struggling Red Hook project community in Brooklyn. The church appears unable to offer any kind of reaction to the vast challenges this urban community faces: children are perishing from preventable conditions, a gang terrorizes the residents, and the forces of social stratification and structural inequality seem irrepressible. Spike Lee's controversial movie depicts the traditional black church as unable to offer healing and restoration in the context of modern woes of black urban life.

Elia Kazan's film *Pinky* (1949) in more subtle ways depicts a traditional kind of black religion that can't keep up with the demands of black progress and social change. The illiterate laundress Dicey is a well-meaning grandmother whose deep religious commitments offer no meaningful critique of black oppression and social inequality. For example, while Dicey makes her granddaughter, Pinky, get on her knees and ask God for forgiveness for the sinful practice of passing as a white person, Dicey's Christian verisimilitude offers nothing by way of radical critique against the racist power structure that makes life miserable enough to motivate Pinky to pretend that she is white. Like Old Ned, Dicey's folk spirituality is not interested in challenging the white racist hegemony and is equally powerless to question why Dicey herself is illiterate and destitute within the Southern segregationist system of racial domination and exploitation. The movie subtly challenges the relevance of black religious efficacy in the context of social change. Pinky, the more secular, modern character, is the heroine of the film and demonstrates how to speak truth to power without uttering one religious sentiment.

Steven Spielberg's *The Color Purple* (1985) offers a clever contrast between the traditional Christianity of Celie, which keeps her bound and does nothing to challenge her husband Albert's cruel domination over her, and the more modern and efficacious spirituality of Shug Avery, which eventually offers Celie existential liberation. There is nothing within the traditional black church experience that infuses Celie with power and confidence to perceive her life and body as worthy of beauty and pleasure. Celie's subjective rebirth does not happen until Shug teaches her that she can love and feel loved, and that her body and mind can be powerful sites of tremendous pleasure. Shug mentors Celie toward a pantheistic understanding of God's efficacy that helps Celie not only notice the beauty of her own life, but also of nature and

of the world where God's presence can be found in everything. In short, Celie is humanized through the modern spirituality of a blues woman like Shug Avery, not the Protestant Christian religion she was exposed to in her ongoing engagement in the traditional black church worship experience.

Dee Rees's film *Pariah* (2011) portrays black religion as somewhat enveloped within a contrast between traditional and modern responses to the seventeen-year-old lesbian protagonist Alike's sexuality and value as a human being. Alike receives support and encouragement from her high school English teacher, Mrs. Alvarado, who pushes her to express her pain in her poetry. But Alike's Christian mother, Audrey, violently attacks Alike after she finally admits she is a lesbian. *Pariah* presents black religion as a stumbling block to a mother affirming her daughter's humanity. Alike's teacher, Mrs. Alvarado, symbolically replaces the Christian mother by exhibiting tolerance and affirmation to Alike just like any mother should—a modern rebuke against her real mother's Christian bigotry. At the end of the movie, Alike appears quite fulfilled in her affirmation of her own personal value and open-ended quest to self-actualize, while her mother remains recalcitrant in her conservative way of thinking and treating her daughter.

Support for Traditional Black Religion

Whereas the preceding black identity films problematize traditional black religion by presenting it in one way or another as unable to assuage black challenges and oppressive conditions, an opposite theme within black religious representation and cinema problematizes modern life as a stumbling block against the safety and spiritual resilience that can be found in traditional black religion. In this way traditional black religion, most notably black Christian faith, serves as the ark of safety for African-American sojourners in an increasingly unpredictable urban world where modern entertainments and complexities are threats to their health and survival. One of the earliest treatments of this theme is Eloyce and James Gist's silent film *Hellbound Train* (1929). The movie is a cinematic sermon on how dancing, drinking, and secular enticements lead to the destruction of one's soul. Each coach on the train contains a variation of sinful secular living that Eloyce and James Gist believe leads to death and destruction. The movie serves as their evan-

gelistic tool to draw patrons away from carnality and toward traditional Christian faith and righteous living.

Bud Pollard's *The Black King* (1932) offers the first indictment against the alleged promise of a more modern and socially relevant black religious expression. The movie begins with a board meeting at Rise and Shine Baptist Church with the chairman leading a coup to oust the current pastor, Elder Jones, on the grounds that he is too old to lead the church in this modern age. Elder Jones humbly submits to their decision even though he is obviously disappointed in the way they are ousting him from leadership. To stake his claim as the new leader, Elder Jones's younger rival, Deacon Johnson, offers a mini sermon strategically alluding to modern technology and change in the context of expressing his new vision for the church and then promises "to reach down and emancipate this church from the shackles of its superstitions and old-time doctrine and fight to new days when all the black brothers and black sisters can walk with their heads high in the air, proud as a peacock, independent of the mortars of white folks' hate." So Deacon Johnson uses rhetoric of modern change and racial uplift against what he posits as the passivity and inefficacy of traditional black religion in all its superstitions.

The deacon strikes a powerful chord with the congregation, which unanimously votes to replace Elder Jones with his younger rival. But as *The Black King* unfolds, we learn that Deacon Johnson is more interested in securing power than advocating for spiritual and social change. His depraved intentions become increasingly apparent; thus the film exhorts black Christians not to be so ready to abandon the tested touchstones of religious tradition in light of persuasive modern religious alternatives that in the end will lead them astray. Whereas Oscar Micheaux's *Within Our Gates* affirms the nexus of black religion and social action, *The Black King* criticizes the amalgamation of black spiritual leadership and political mobilization. The explicit warning in this film is that there is a risk in losing the power of the gospel message when black religion is circumnavigated to address sociopolitical concerns. The film calls black Christians to be distrustful of slick-talking modern preachers who espouse racial uplift and political empowerment.

Spencer Williams also puts to use the theme that black modern life presents pitfalls that are only remedied through a return to the simple values of the traditional Christian faith. In Williams's film *The Blood of*

Jesus (1941), Ras and Martha Jackson have been married for three months and Martha appears serious about spiritual things in contrast to Ras, who is more preoccupied by distractions. Shortly after her baptismal ceremony (which Ras misses because he would rather hunt rabbits than sit through a spiritual event), Martha asks her husband, "Ras, why don't you pray and try to get religion? We could be so much happier if you would." Ras agrees to at least try, but shortly afterward he accidentally shoots Martha. The rest of the movie depicts Martha's body in an unconscious state, while her soul ventures off on a journey in the spiritual realm. As Martha's physical fate lies in question, members of her Christian community gather around her bed to pray and sing spiritual songs, including the popular song "Give Me That Old-Time Religion," as an obvious grounding of spiritual stability in the sanctity of tradition. In the spiritual realm, Martha's soul is tested against the enticements of money and pleasure. In this movie, Spencer Williams presents city life and nightclubs as libidinal spaces, modern sites of temptation that Martha's soul eventually rejects and instead chooses the straight and narrow path to righteousness. After she heads toward the right path, her soul unites with her body and Martha recovers from the injury. The movie showcases a juncture between two roads: one pointing to Zion and godliness, and the other replete with modern stumbling blocks to faith.

While another Spencer Williams film, *Dirty Gertie from Harlem, USA* (1946), does much to lampoon black religious sanctimony in the form of two Christian missionaries who sublimate their lust for the beautiful protagonist, Gertie LaRue, with pious attempts to rein in her seductive power, the movie does in fact support the notion that venturing too far off from the ark of safety of black religious tradition can lead to dangerous repercussions. Gertie is a dancer who indulges in worldly pleasures of drinking, partying, and using men for her own self-aggrandizement. She has no interest in pursuing spiritual matters, even as Mr. Christian, one of the sanctimonious missionaries, warns her that her worldly living is leading her on a path to destruction. While the film offers much to cast doubt on Mr. Christian's motives, since he too seems somewhat caught under Gertie's seductive spell, it ends with one of Gertie's scorned former lovers killing her. Hence, the movie is a cautionary tale against people who carelessly forsake the things of God to indulge in the modern accompaniments of urban life.

While the preceding legacy of black filmic representation locates religion as a site of conflict between traditional religion and modern change, Todd Graff's *Joyful Noise* (2012) offers an intriguing compromise that comes much closer to Tyler Perry's synergistic integration of the two. The film features a choir from a racially integrated Southern church aspiring to win a national choir competition. Randy, a fun-loving young musician, embodies the energies and competencies that could transform this choir to be more competitive on the national level. While many members of the choir desire to display a more contemporary style of singing and choreography, and hence welcome Randy's innovations in music technology, their old-school black pastor is initially reluctant to change, clinging to the traditional songs of the past. The pastor eventually relents and the choir integrates new musical arrangements and choreographic movements, while still appreciating traditional hymns of old-time religion. This fusion of the old with the modern forms a dynamic spiritual experiment that helps the choir win the national competition.

As a clever filmic byline on gospel music's cultural influences, an unexpected twist toward the end of *Joyful Noise* features an energetic coterie of black tweens performing at the national competition. At a crucial juncture during their electrifying rendition, the kids gather in a circle reminiscent of the "ring shout" of slave religion and the lead singer starts praying in tongues and then seamlessly reverts back to singing the song. Hence, in this provocative scene, the choir simulates the most distinctive element of Pentecostal experience (praying in another language under the unction of the Holy Spirit), while choreographing the rhythms and spacing of one of the most memorable cultural artifacts of slave religion (the ring shout). With this surprising interlude, the movie cleverly pays homage to the kinetic origins of gospel music vitality—slave religion and Pentecostal worship services—while the young tweens proceed to indulge in the most modern sounds and movements gospel music has to offer, once again celebrating a synthesis between black folk-religious culture and modern momentum.

Joyful Noise trenchantly confirms that gospel music itself remains a vibrant and popular expression because it is inextricably both folk and modern (M. Harris 1992; Sanders 1996; Best 2005; Lee 2005). The dazzling gospel music that is featured in *Joyful Noise* as well as in many of Tyler Perry's cinematic soundtracks had its earlier formations during

the Great Migration when African Americans were struggling with the very same question concerning what it meant to embrace elements of the spiritual past while surging onward to accept modern ingenuity. Gospel music was one of the earliest compromises between holding on to the folk-cultural and rhythmic energies of slave religion and modernizing and becoming more urban (Harris 1992; Best 2005). Such a clever incorporation of the old and the new yields insights as to why so many contemporary African Americans enjoy Tyler Perry's synthesis of nostalgic appreciation for tradition and pulsating rhythms amenable to modern change.

TYLER PERRY'S FILMIC SPIRITUALITY

Like Todd Graff's movie *Joyful Noise*, Tyler Perry offers a smoother synthesis between religion and modern change than can be seen in most religious identity films. Perry uses cinema as a site for the nostalgic recapitulation of folk-cultural propensities of slave religion's past, while explicating how contemporary black religion and culture have changed. His depictions of black spirituality within the framework of undoubtedly secular unfolding plots are microcosms of that custodial process. In other words, Perry's role as a cinematic overseer of the post-soul epoch is to endorse a symbiotic negotiation of a black folk-religious past with contemporary innovation and sophistication.

Tyler Perry came of age within a neo-Pentecostal church culture that continues to captivate millions of congregants nationwide. Rather than attending college or film school, Perry matriculated within a church environment celebrating Holy Spirit power and worship exuberance packaged in a sophisticated urban mainline experience, and the gospel music he participated in as a member of the choir is the offspring of that folk-modern synergy. Perry's hometown church, Greater St. Stephen, like many neo-Pentecostal black mega churches, was quite proficient in its use of technology, quite impressive in its intricate organizational structure, quite resourceful in its ability to capitalize on the best of modern advancements, and yet equally acquiescent to the call-and-response rhythmic dynamism of slave religion. So Perry's spiritual and artistic imaginations were birthed within the ministry of a visionary leader like Bishop Paul Morton, who taught young Tyler every Sunday

through example how to be proud of his roots while at the same time striving for the highest levels of professional excellence and modern accomplishments. The filmmaker's artistic imagination and spiritual worldview were incubated within an intriguing folk-modern synthesis that would later diffuse into his own creative work as a curator of post-soul religious sensibilities. Simply put, Perry's ability to speak to the question of what it means to be black and modern in the post-soul age is inspired by his early Christian identity that seamlessly blended the folk with the modern.

So when Perry left New Orleans in his early twenties to embark upon a career as a playwright, his early theatrical productions were imbued with folk-modern synergies. Perry became a bridge between black mainstream art and neo-Pentecostal folk-modern vitality, and gospel music is the medium that brings those integrations into their sharpest focus. Perry became the artistic personification of the very gospel music he sang in church, first as a playwright and later as a filmmaker who offers an upbeat and exciting representation of black spirituality. The riveting gospel music scores that appear in so many of his movies are the sounds of modern momentum in the backdrop of black folk-religious vitality. To understand gospel music as an intriguing folk-modern experiment (Best 2005) is to understand an integral part of Perry's appeal.

Music and Preaching

Tyler Perry's most distinct cinematic contribution is a profound engagement with riveting gospel music, preaching, worship experiences, spiritual themes, and Christian tropes. The filmmaker does not just seamlessly blend cultural tools from reservoirs of black spirituality; he showcases them as important filmic characters. Perry jumps right out of the gate with vivid displays of black spirituality with his debut movie, *Diary of a Mad Black Woman*. The protagonist, Helen, is a Christian woman and her mother, Myrtle, is even more devout as she spars over spiritual matters with Myrtle's carnal mother-in-law, Madea. While the film is quite secular in its themes, characters, and plot, it seamlessly features pulsating scenes in a black church where a choir offers passionate songs extolling the virtues of Jesus and ends with a sermonic sequence, song, and invitation to congregants to come to the front of the church as a

symbolic demonstration of desiring a special connection with God, the kind of "altar call" you would find in many black churches. What is most striking about this church scene is not only Perry's ability to capture the passion and theology of a contemporary worship experience with the choir's song and the preacher's energetic allusions to Old and New Testament passages, but also the amount of time Perry devotes to pursuit of such authenticity. In his commentary for the DVD of *Diary of a Mad Black Woman*, Perry discusses how his goal was not to "perform church" but to "have church" and that the cast members weren't just acting but sensed the presence of God when performing the church scenes. So Perry does not see a clear divide between traditional Christian worship and its depiction in a modern medium like film; he sees a smooth integration of the two.

In Tyler Perry's movie *The Family That Preys*, we have a rare cinematic moment in which a white Southern aristocrat named Charlotte is deeply moved by a black gospel choir's song. Charlotte sits in the back of the church as she listens to her best friend Alice's choir rehearse a jazzy rendition of the popular song "Jesus Loves Me." Perry captures the subtle touches of a choir rehearsal, not only with the vibrant intonations of the lead singer, but also with the choir's saxophonist clad in work scrubs as if he came straight from his job at a hospital to make it on time. Perry's real-life experience as a young member of a choir no doubt offered him opportunities to see many men and women coming to rehearsals in work uniforms. When the song is over and Alice reconvenes with her friend in the back of the church, Charlotte tells Alice, "I've never heard anything so beautiful in all my days." Perry's cinematic choice to present a white blueblood being brought to tears by a black choir's song creates a rare cinematic event, just as a powerful gospel music interpolation within the textures of a quite secular film filled with adultery, familial contempt, and backbiting is an equally infrequent occurrence. And the fact that within this exchange Alice explains to Charlotte that Jesus died so she can be forgiven for her sins further points to the glaring reality that Tyler Perry's inimitable take on evangelical Christianity infuses his films with dynamic cultural import.

In *Daddy's Little Girls*, Perry offers a prolonged sermonic sequence that encourages the protagonist, Monty, to endure his difficult dilemma of regaining custody of his girls. And the actor who preaches to Monty's congregation is no Hollywood thespian; he is Bishop Eddie Long, who

at the time of the movie's release was one of the most noted African-American clerics of the day, his reputation not yet shattered by more recent controversies. We learn in Perry's commentary for the DVD of *Daddy's Little Girls* that Bishop Long's sermon was not scripted but the result of Perry commissioning the bishop to preach as if he were at a Sunday service. It is easy to detect the symmetry between the themes in Bishop Long's ministry and the sentiments expressed in the preacher's sermon sequence in the middle of the film. Once again Perry crafts a scene with the intent to "have church" not "perform church."

Perry's film *I Can Do Bad All by Myself* contains the same kind of effervescent gospel music tracks and vocal inflections Perry must have heard quite often as a young member of Greater St. Stephen. Key cinematic characters like Pastor Brian and his faithful assistant, Wilma, dole out wisdom and belt out extraordinary vocal performances in this movie. Casting two music icons like Marvin Winans and Gladys Knight to play Pastor Brian and Wilma is a poignant indication of Perry's savvy at making connections with both Christian and secular audiences. While it is easy to see the drawing power of a secular music legend like Gladys Knight, I would imagine that fewer film industry execs are cognizant of the intergalactic dynamism of Marvin Winans. Hence, most movie producers would have recruited a professional actor to play the role of Pastor Brian, the same way Spike Lee tapped veteran thespian Clarke Peters for the role of Bishop Enoch Rouse in his aforementioned film *Red Hook Summer*. But Tyler Perry is the rare cinematic powerbroker whose lifelong connections to black churches show up in his artistic choices.

Marvin Winans is in fact a celebrity in his own right as a popular neo-Pentecostal pastor and a delegate of one of the most distinguished gospel music families in history. Gospel music enthusiasts have been listening to the lively tunes of Marvin, BeBe and CeCe, Angie and Debbie, and other siblings of the famed Winans clan for decades. While many Hollywood filmmakers and powerbrokers might not have heard of Marvin Winans or might not recognize the cachet of his family name, many more black Christian patrons no doubt recognize and appreciate Perry's casting choice. Perry also cashed in on Marvin Winans's own pastoral credibility and singing facility in his construction of Pastor Brian's ministerial duties and musical performances. *I Can Do Bad All by Myself* utilizes the vocal expertise of Marvin Winans and Gladys

Knight to offer the kind of gospel music vitality and energetic worship services many African Americans enjoy in churches nationwide.

Worldly Christians and Pragmatic Spirituality

In addition to producing stirring cinematic moments within black church worship cultures and the best of contemporary gospel music, Perry's folk-modern religious synthesis involves an endorsement of a less intrusive and more inclusive relational form of religion. Perry's protagonists embody the diversity and tensions of believers living out their faith while making sense of the hustle and bustle of their late-modern world. Notwithstanding the more doctrinal demonstrations of religiosity we see in Myrtle (*Diary of a Mad Black Woman*) and Alice (*The Family That Preys*), and the passive and otherworldly spirituality exhibited by Shirley (*Madea's Big Happy Family*), the large majority of Perry's Christian characters display seamless blends of spirituality and worldliness. Perry most often taps into the wellspring of Christian cultural tools, tropes, and perspectives without falling into traps of exclusivity and dogmatism that often alienate non-Christian patrons.

In *Diary of a Mad Black Woman*, Helen and Orlando claim at different junctures of the film to pray for each other every day as a sign of their mutual love and devotion, but we don't see them ever preaching to each other or anyone else about codes of Christian conduct. Instead we see them enjoying good music and having good times and quite aware of their sensual dynamism. And when Helen documents in her diary an early night with Orlando where they did not have sex, Helen does not quote a scripture or a sanctimonious commitment to celibacy to explicate their restraint, but rather clarifies that Orlando gave her something "even better," which is intimacy, as they cuddled for most of the night. Helen admits that the two wanted to make love so she affirms their libidinal capacities. And the language of "even better" does not imply that had they chosen to make love, it would have been a grave sin or regrettable act of letting God down. In other words, Helen's discussion of sexual conduct is not framed in the context of biblical stipulations but rather in principles of romantic tenderness and healthy living. Later in the movie when Helen spends a night over at Orlando's place, Perry leaves it open to interpretation whether they consummate the relationship.

Similarly, in *Madea's Family Reunion*, Frankie and Vanessa are Christians who aren't sitting around attending Bible studies all week; instead, we see them enjoy a date in a bohemian artistic lounge as well as romantic walks in the park. Even as Vanessa informs Frankie early on of her commitment to celibacy, she does not indicate that her hiatus from sex has anything to do with Pauline prescriptions for holy living. She frames it as a practical choice rather than as perfunctory submission to a biblical command. If the New Testament warns that friendship with the world is enmity against God (James 4:4), Perry advocates a less alienating Christian presence that seems quite comfortable with carnality. *Madea's Big Happy Family* presents Bam as an older Christian woman who is addicted to marijuana and tries to make sexual moves on her younger doctor. Similarly, we see Monty (*Daddy's Little Girls*) hang out in a nightclub with sultry music, slow dancing, and alcoholic beverages and voice no commitment to celibacy when Julia invites him to spend the night. Both Bam and Monty are fun-loving Christians who enjoy worldly pleasures.

Other Christian characters seem similarly at peace with the ways of the world and quite modern in their thinking. In *Why Did I Get Married?* Terry appears heavenly minded when he tells Gavin that he was praying for him to win the architectural project on which Gavin placed a bid, but seems far more secular only moments later when Marcus reveals he received an STD while cheating on his wife. Terry is more disturbed that Marcus had unprotected sex than with the fact that Marcus violated biblical mandates against adultery. In the same movie when Mike questions Gavin and Terry about their abstinence from adultery, neither character appeals to biblical injunctions against infidelity as their motivation. Instead, both men offer pragmatic reasons for abstaining from infidelity that are rooted in their desire to avoid the unwanted consequences of unfaithfulness. Similarly in *The Family That Preys* even the super-spiritual Christian character Alice never draws upon biblical injunctions against adultery when she confronts her daughter's extra-marital affair with William Cartwright. Alice voices concern only at the pragmatic consequences of the affair, and not at her daughter's violation of biblical proscriptions against adultery.

It is worth noting that a bevy of Perry's Christian characters especially enjoy "spirited" drinks. Early in *Diary of a Mad Black Woman*, Helen downs an entire bottle of wine waiting for Charles to come home in an

attempt to kick-start a romantic night in celebration of their eighteenth anniversary, and later in the movie we see multiple occasions with Helen and Orlando setting the ambiance for their romantic encounters with glasses of wine in hand. As mentioned earlier, In Daddy's Little Girls, Monty takes Julia to his favorite nightclub and helps her get drunk, seemingly perceiving that alcoholic indulgence was just what the doctor ordered to remedy Julia's starchy elitist inhibitions. In Meet the Browns, Vera claims to love Jesus, but loves liquor equally, and appears intoxicated throughout the movie. At the end of Why Did I Get Married? when the bartender of an establishment phones Gavin to tell him that his buddies are getting drunk, Gavin, the tacit "daddy" of the group, rushes to the bar not to stop his mentees from drinking but to buy his obviously intoxicated friends Mike and Terry another drink to help them wallow in self-pity. In the same movie, even the overtly spiritual Christian character Sheila enjoys her wine as much as she enjoys her gospel music, and it is no accident that the very object she uses to concuss her wayward husband is a bottle of wine. And in the beginning of Why Did I Get Married Too? the first thing we see in Sheila's hand as she and her new husband, Troy, enjoy the beauty of the Bahamian landscape is an alcoholic beverage.

So it is clear that Perry presents Christian spirituality as imbued with worldly flair. His characters draw strength from their faith, but also pursue their lives in ways that resemble non-Christian contemporaries who have fun, experience the world, and voice no compunction against alcoholic and sensual indulgence. Perry brokers a worldly vision with Christian sentimentality and pragmatic improvisation rather than mechanical adherence to biblical stipulations. Perhaps we should perceive him as the first cinematic architect of post-soul Christian cool. The filmmaker's aesthetic presentation of hip, fun-loving Christians challenges the common narrative on religious people as bland and out of touch. Stylistically, characters like Frankie and Vanessa (Madea's Family Reunion) exhibit idealistic components of the filmmaker's inimitable brand of post-soul Christianity as urban and chic. They sport trendy outfits, and there is nothing churchy about them. Their moral compasses are not steered by sanctimonious moral codes but by more internal and practical mechanisms as they willfully embrace principles of healthy and fun living. And hence perhaps we should consider Perry's decision to go in a different direction in his portrayal of Christianity by

the self-righteous character Sarah in *Temptation: Confessions of a Marriage Counselor* (2013) as an aberration that only highlights his appreciation for more measured and worldly Christian equanimity. As the plot unfolds, Sarah's dogmatism and fire-and-brimstone spirituality is tainted by the hypocrisy of her own worldly secrets. Perry's worldly flavorings portray Christianity as redemptive, exhilarating, and pleasurable. He attempts to apply spiritual vitality to the changing contours of what some deem a post-Christian era, endorsing a relational kind of religious vitality that appeals to the needs and tastes of their late-modern worlds.

PERRY'S CHALLENGES TO TRADITIONAL CHRISTIANS

We have discussed how Perry's movies are firmly entrenched within conventional Christian codes, contexts, and worship cultures, offering perhaps the most comprehensive filmic engagement with Christian sentiments and cultural tools from black church experiences. We have also considered Perry's seamless blend of those cultural tapestries within the textures of his filmic plots. But it is equally important to explore how Perry's pragmatic brand of Protestantism often presents aspects of Christianity in unconventional or even controversial ways. While Perry gives aesthetic attention to the rhythms of black worship experiences, his movies at times offer subversive takes on topics that could leave more conservative Christians simmering with righteous indignation against Perry's pragmatic liberties.

Clergy and Spiritual Leaders

Perry is quite creative in the way he constructs ministerial characters. The most radical example is Ellen, the rambunctious minister played by Viola Davis in *Madea Goes to Jail*. The fact that she is a female cleric is alone somewhat of a subversive act when you consider the heated debates that still persist within black mainline churches concerning whether God even calls women to clerical leadership (Lincoln and Mamiya 1990; Gilkes 2001; Lee 2005; Pitt 2012). But Ellen is more than your everyday preacher; her church convenes in the streets and prison and her congregants are sex workers and convicts. Perry constructs

Ellen as an in-your-face spiritual advocate who is so preoccupied with the practical comportment of vulnerable populations that she is willing to break the law (in Georgia) by passing out drug needles on the streets. Ellen also distributes condoms to sex workers like Donna and Candy. Whereas some conservative Christian voices might accuse the minister of aiding and abetting drug abuse and fornication, Ellen sees passing out needles and condoms as a greater good because it contributes to the retrenchment of new cases of HIV/AIDS. In one artistic swoop, Perry demonstrates how his pragmatic approach to religion has both political and theological implications, as Ellen's proactive approach challenges rule-based dogmatism in both the law and the Bible. Later in the film we learn that Ellen, too, in her past life was a sex worker who wrestled with drug addiction, which adds another layer of complexity to her Christian witness and urgency to her practical ministry.

Pastor Brian in *I Can Do Bad All by Myself* is less controversial than Ellen, but also embodies a strand of relational religion that is light in proselytizing and heavy in hands-on engagement with the people in his community. The way his congregants and everyone else address him by his first name is quite contrary to asymmetrical formalities that dominate many black churches. Pastor Brian is very hands-on and attentive to the needs of people around him, in contrast to the sort of untouchable superstar pastor who presides over many powerful black churches. He is a respected leader in his community and his influence is impactful throughout the movie. For example, early in the movie Pastor Brian decides to connect Sandino, a Latin American newcomer to his neighborhood, with April, the daughter of one of his members, recognizing that each has what the other needs—April can offer food and lodging, and Sandino can offer handyman skills for much-needed repairs to April's house. So a cleric orchestrates an unmarried man and woman to live under the same roof for pragmatic purposes, an act that would no doubt seem scandalous to many traditional pastors and congregants. But the symbiotic living arrangement culminates in April and Sandino's wedding at the end of the movie, so their romantic triumph is a direct result of Pastor Brian's insightful introduction.

Throughout the movie, Pastor Brian appears more concerned with April's psychological well-being than with saving the alcoholic's troubled soul. And when Pastor Brian and his faithful Christian helper Wilma offer constructive criticism to April, it is out of concern for the

immediate harm her decisions might generate, not out of any sense that April is violating biblical mandates. No one can accuse Pastor Brian and Wilma of being sanctimonious. Instead of offering her scriptures and spiritual aphorisms, Pastor Brian and Wilma offer the troubled protagonist warmth and concern and eventually (with the help of Sandino) lure April back to church and a more stable life. Pastor Brian is Perry's throwback to the motif of the black pastor as village chief, the flexible yet durable fulcrum who holds things together in the midst of chaos in an urban community.

While Wilma is a highly regarded member of their church, she agrees to sing in a nightclub after the host recognizes her in the audience. In spite of the fact that her purpose for being in the nightclub is solely to check in on April, Wilma does not perceive her secular environs as being beneath her spiritual gifts and accepts the host's offer to sing. Wilma does not even protest when the host comically cuts her off from testifying, restricting the terms of his invitation to musical performance. Wilma's singing touches many hearts in that sultry nightclub. Later in the movie we hear Wilma offer riveting vocals in her church, so in having Wilma sing in both secular and spiritual localities, Perry assesses that "church" begins and ends wherever there are people in need. Wilma's vocal gifts seem to have the same effect of encouraging people, whether in front of the congregation or center stage at a nightclub.

With Ellen, Pastor Brian, and Wilma, we see Christian ministry extending far beyond the walls of the church and people reaching out to the unholiest of targets to demonstrate charity and concern. Perry fashions his spiritual leaders in ways that are for the most part unpretentious and deeply concerned; they roll up their sleeves to help and provide encouragement and comfort instead of using their words to chastise and condemn. Even Alice, the devout Christian character played by Alfre Woodard in *The Family That Preys*, balances out her super-spiritual moments of being a holier-than-thou party pooper (like throwing holy water on a male exotic dancer) by exhibiting the kind of relational religion indicative of Perry's pragmatic corrective for evangelical Christianity. Alice is endearing and inclusive; she brings people in and does not tear people down. She is unassuming and attentive, as we see her providing food, clothes, comfort, and conversation to a homeless man. And if Alice appears as Perry's most devout Christian character in the

beginning of *The Family That Preys*, she ends the movie critiquing her own religious excesses, while committing herself to enjoy living the good life like her recently deceased best friend, Charlotte. It is in this way that Perry allows Charlotte to mentor the super-spiritual Alice toward a more worldly spirituality.

Divorce

Perry's pragmatic treatment of divorce offers another potentially controversial depiction of Christianity. In the Gospel of Mark (10:12) as well as in other New Testament passages, Jesus voices rather strong prohibitions against divorce. Because biblical proscriptions against divorce are unambiguous, one would be hard pressed to find a prominent Christian minister or leader publicly endorsing divorce as a means to achieve a healthier life, unless such a clerical figure functions within a theologically liberal Christian community that does not take the Bible literally or seriously. So the fact that Perry comes from a theologically conservative religious tradition makes it all the more striking that he offers a relational religion that is very sympathetic to divorce.

Perry not only offers divorce as a reasonable solution; in *Diary of a Mad Black Woman*, he raises the possibility of it being a blessing from God. Newly estranged from her husband, Helen discusses with her friend Brian the dissolution of her marriage: "I always thought that if I did all I could, God would bless my marriage." And Brian responds with a stern look on his face, "It takes a lot more than you doing all you can." To which he then adds, "And who's to say this is not your blessing?" Brian also tells Helen, "Sometimes we hold on to the things that God Himself is trying to tear apart." This notion of God's endorsement on divorce stands in contrast to the Christians who might have counseled Helen to wait on God to change her husband's heart. In the Special Features section for the DVD of *Diary of a Mad Black Woman*, Perry describes Brian's statement "And who's to say this is not your blessing?" as the filmmaker's favorite line in the entire movie.

Brian's consideration of God's endorsement of divorce is reiterated in Perry's later movie *Why Did I Get Married?* Sheila's spirituality and her desire to save her marriage are contrasted against the ever-increasing reality that her relationship with her husband, Mike, is on a downward spiral. Early in the movie, Perry depicts Sheila as a Christian

woman who remains in a state of denial about the breakdown of her marriage. We see Sheila trusting God to save their union, while Mike expresses nothing but contempt for his wife. There is a heartrending scene with Sheila driving in her car, blasting gospel music, and reciting her faith in God to restore her marriage. But later in the movie Mike initiates the conversation to terminate their marriage in the most callous way, angering Sheila enough to strike him in the head with a bottle of wine.

Perry pits Sheila's faith in God's restorative power against Mike's marital contempt and the latter wins, suggesting that even God can't save a bad marriage if one of the partners has already checked out. The lesson Perry offers his audience is that the best such an abandoned marital partner can do, rather than praying for change while enduring more abuse, is to start over and find someone new. Mike and Sheila eventually get divorced, and Sheila begins a new relationship with a supportive partner named Troy, who is also divorced. Sheila later tells her friends that to receive God's blessing in the form of a new suitable partner like Troy, she had to give up her dysfunctional marriage to Mike, suggesting not only divine approval but also a teleological appropriation of marital termination.

With Sheila's story, Perry's message to Christian women suffering in bad marriages is that it is easier for God to bring them new loving partners than it is for God to change the hearts of husbands who have already checked out of their marriages. And perhaps this was the message Perry was trying to preach to his mother with the movie—that it is easier for God to bless her with another man than to change his father's heart. If Perry's reports about his father's incessant bullying of all the family members are true, then his Christian mother may have endured a troubled marriage and abuse not unlike what her son's character Sheila suffered. And Sheila's Christian optimism that God would bless her marriage and change her husband's heart might have been inspired by Mrs. Perry's interminable trust in God's delivering power. Hence, it is not unimaginable that Perry's own sympathetic view of divorce was birthed out of his concern for his mother. Perhaps watching his mother suffer in her marriage prompted Perry to replace the traditional Christian view of divorce as something tragic, with a more pragmatic and instrumental use of divorce as a mechanism toward achieving a healthier union with a better partner. And while rebranding divorce, Perry also

offers a clarion call for partners in abusive relationships not to underestimate the power of free will.

Both Helen and Sheila thrive in new healthy relationships as a result
of the dissolution of their dysfunctional marriages. Helen begins her
new romance with Orlando before her divorce is even finalized. And
her choice to divorce Charles is even more striking because it occurs at
the very moment he appears repentant and devoted to being a loving
Christian husband. In the case of Sheila, Perry presents divorce as a
means to escape abuse, but in Helen's case the divorce certificate is
simply a ticket to secure greater happiness and satisfaction. Both divorces tacitly critique the motif of the suffering spouse who faithfully
endures an unhealthy or unhappy marriage as part of her Christian duty
or familial responsibility. Perry presents divorce as a divinely endorsed
blueprint for redemption—and simply the smart thing to do.

Madea's Irreverence

If Tyler Perry's movies offer an unprecedented representation of Christian spirituality and culture, his most famous character, Madea, is an
affront to those hallmarks. Madea is defiant in her irreverence as
Perry's sole secular heroine. For example, she refuses to attend the
funeral of her favorite niece, Shirley, simply because she does not want
to set foot in a church (*Madea's Big Happy Family*). And earlier in the
same movie, Madea makes God seem quite petty when she claims that
God doesn't like her. In *Madea Goes to Jail*, when her Christian daughter Cora shows Madea her WWJD bracelet, Madea jokingly responds
asking if the initials stand for What's Wrong with Jermaine Dupri, rather than acknowledging its true message: What Would Jesus Do? Madea
mocks Jesus for talking too much (*Diary of a Mad Black Woman*), and
derides Christians for being passive and weak (*Madea's Big Happy
Family*), insisting on the necessity for Christians to learn the difference
between the time to pray and the time to punch.

But a more surprising element of Madea's secularity involves her
creative utilizations of spirituality. Madea often feigns spirituality in
order to get out of tight spots, reducing Christianity to a repertoire of
performances to pull the wool over someone's eyes. For example, in
Madea Goes to Jail, she acts spiritual when she is pleading her case in
court to Judge Mablean: "I feed the homeless and help the hungry. I'm

going out to the highways and byways doin' what the Lord told me to do. Praise him. Thank ya Jesus!" And later in the movie after Madea beats up prison bully Big Sal in the laundry room, a correctional officer comes in wondering what all the noise is about and Madea acts like she's just doing laundry while worshipping, and then walks by the correctional officer mock-praying in tongues.

Madea uses scripture and spirituality not only as devices to get out of trouble but also as justifications for her profane perspectives. For example, in *Madea's Big Happy Family* when Shirley asks for Madea's help to gather her rambunctious family members together, Madea promises to have everyone present by 6 p.m. Shirley is quite surprised at Madea's guarantee and asks how she will accomplish this daunting task. Madea responds by reminding Shirley of the scripture, "Let the redeemed of the Lord say so" (Psalms 107:2), and then offers her interpretation:

> That's right so if you've been redeemed by the Lord and somebody does something to you that you don't like, even your kids, you can beat the hell out of them and just say, "so." So that's what I'ma do, I'ma beat the hell out of 'em and say "so" and I'ma bring 'em over here 'cause you've been redeemed.

Madea's madcap hermeneutics justifies her violence against Shirley's children if such violence is necessary to achieve her objective.

Madea's strategic deployment of spirituality is part of her resourcefulness as an empowered subject. She may hate church but if acting religious or quoting a popular scripture will prove beneficial toward staving off trouble or supporting her agenda, she is all game. In this way, Madea is perhaps Perry's most modern character, deploying all available assets at her disposal to harness her environment. Madea is the ultimate unrestricted free agent: a trickster of sorts who conjures up religious cultural tools based on their instrumentality rather than their presumed authenticity. In other words, Madea reduces Christianity to a set of useful performances by which to accomplish one's agenda rather than as the outward manifestation of one's inward experience and lifestyle. Such a profane and strategic use of religion might be offputtingly received by some traditional Christians. It is also radical in how it inadvertently pushes the onlooker to question how much of spirituality in general might be performed rather than disingenuously. And perhaps Oscar Micheaux is raising a similar point in *Body and Soul* (1925) with his

criminal character Rev. Isaiah Jenkins, who uses religion initially to escape the law and later for his own self-aggrandizement. Madea treats religion and spirituality as collections of signs and representations, inadvertently reminding us of the epistemological challenge of deciphering the "real" from the "performed" when it comes to religious sentiments and actions.

As Perry's secular heroine, Madea is quite caustic in her critiques of what she perceives as religious excesses, perhaps allowing Perry to evaluate the dissipations of his own Christian perspectives and black religious folk-cultural traditions without appearing antagonistic to them. Madea's subversive secularity often appears in particular scenes after Perry has given voice to Christian truths and perspectives through saintly characters. In such exchanges, Madea's secular intuition upstages the expressed Christian sentiment. A great example of this upstaging comes in *Diary of a Mad Black Woman* with a clever conversation between Myrtle and Madea that positions Myrtle's Christian perspective on revenge against Madea's carnal opinion on the issue. When Myrtle recites the statement "peace be still" from the pastor's sermon, Madea replies with a playful pun, claiming, "Peace is always still around me cause I keeps me what they call a piece of steel." When Myrtle insists it is better to leave retribution in the hands of God, Madea responds by suggesting that God takes too long to secure revenge and that her enemies need to "get got" with no delay. So Madea pits herself up against God, judging herself as better at securing revenge in a timely manner. In contrast to Myrtle, who trusts in divine retribution, Madea evokes more confidence in her Glock than in God to deal with enemies.

When considering Perry's claim that his father bullied his family for years, we can imagine the Christian filmmaker, like Madea, is somewhat ambivalent about God's retributive capacity, having yet to see his father get struck down by God's wrath. And so perhaps Perry chooses to articulate such misgivings through his secular heroine Madea, who does not wait around for God to act but instead chooses to rely on immediate physicality. And we should note that it is Madea's heavy hand of justice, not Myrtle's trust in divine justice, that guides the protagonist Helen's brutal torture sessions against Charles. Similarly, Monty chooses to take matters into his own hands at the end of *Daddy's Little Girls* when he recklessly crashes his car into his enemies, a vehicular assault that actually ends up solving all of his problems. Monty grew tired of waiting for

God because his enemies needed to "get got" in a more timely fashion. Perhaps Perry still feels the same way about his father.

GOD, SUFFERING, AND EVIL

Tyler Perry's most subversive cinematic challenges against cherished Christian beliefs involve subtle yet poignant treatments of the problem of evil, the conundrum of why bad things happen to good people without God intervening. While characters in Perry's movies sometimes give lip service to the notion of God's sovereign control over the universe, his plots unfold in a manner in which humans are left to their own devices to solve problems or suffer pain. Part of the imaginative folk-modern paradoxical synthesis that makes up Perry's religious cinematic perspective is that despite his preponderance of Christian characters and riveting scenes with preaching and gospel music, when problems are settled, God never plays a tangible role in the resolution. The myriad conflicts and setbacks in Perry's movies are worked out by rational and courageous decisions on the part of human actors. Simply put, Perry's plots unravel pressing problems with modern solutions. God functions as a cosmic cheerleader, sequestered to the sidelines, while humans step on the field to play the game of life.

The problem of evil complicates Perry's cinematic theology, as life is systematically wearisome for some characters, while others get sick, become injured, or die on God's watch without a hint of intervention. In *Daddy's Little Girls* when Monty hears about Miss Katherine's (Kate's) lung cancer, he does not offer the prayer of faith on Miss Kate's behalf, only a trite rejoinder that everything is going to be all right, to which Miss Kate replies in the most solemn voice she can muster up, "Everything is not going to be all right!" And her warning was quite prophetic, for in the very next scene we see Monty and others leaving Miss Kate's funeral. Miss Kate's death proves quite tragic for Monty's children because the loss of their caretaker positions them to suffer under the custody of their unfit parent, Jennifer, and her treacherous partner, Joe. So when considering the notion of a God who controls the universe and has ultimate reign over human events, one might wonder why such a God neglected to heal Miss Kate in order to prevent the foreseeable trauma to children that would come as a result of her death.

Similarly, one might question why God does not intervene to stop a toddler's death in an automobile accident due to the preventable error of his mother, Patricia, failing to secure her child's car seat in *Why Did I Get Married?* or why God does not keep Noah's father, Gavin, from dying in an easily preventable car accident in the sequel *Why Did I Get Married Too?* Bam cleverly raises the issue concerning the problem of evil in *Madea's Big Happy Family* when she wonders why a loving and hardworking person like Shirley suffers from a fatal illness like cancer, commenting, "She works like a horse, she treats people nice, it's just not good to get sick and you treat people nice. That just don't ever seem fair to me. But it's okay I guess. You know the Lord just moves in mysterious ways." Bam ends her statement with an allusion to God's mysterious ways as a euphemistic commentary on God's inscrutability and the universe's perceivable lack of governance. The movie pushes the patron to consider the inscrutability of a weed-smoking lustful woman like Bam and a scoundrel like Madea both enjoying perfect health, while a saintly Christian woman like Shirley suffers a fatal bout with cancer. Bam even brags that she never has been sick one day in her life, which might not seem fair in a universe governed by divine justice, when considering Shirley's multiple battles with cancer, the last one taking her life.

And when Shirley is on her deathbed, her daughter Tammy pleads with her mother to pray for God to heal her, but Shirley explains that her healing will come on the other side of heaven and dies shortly after. While Shirley remains resolute in her faith in God's salvific capacities and that her eternal resting place is heaven, two battles with cancer stripped her of any hope that God will miraculously intervene on her behalf to heal her. Tammy's plea is rooted in Christian optimism and biblical discourse that emphasizes God's miraculous tendencies to come through in a pinch for believers in distress, but Shirley lying on her deathbed seems as sure as Miss Kate was to Monty concerning her imminent death.

Perry's movies flirt with theological solutions to problems while unfolding quite modern resolutions. In *Meet the Browns*, Brenda, a struggling mother of three who often goes hungry and barely makes ends meet, tells Miss Mildred that she prays or at least tries to pray, but her prayers don't seem useful at changing her longtime struggle with the effects of poverty. Later in the film, it is finally through human achievement (her son Michael's basketball contract) not divine intervention

that the family makes its permanent break from years of deprivation. Perry brings the problem of evil and suffering into play in other movies where God allows Candy to be preyed on by her stepfather, gang-raped by football players, and abducted and presumably raped by a pimp (*Madea Goes to Jail*); Vanessa's stepfather to molest her with her mother's consent (*Madea's Family Reunion*); and Mama Rose's crack addict daughter to rent out Jennifer to horny men in exchange for money to purchase more drugs (*I Can Do Bad All by Myself*). In Perry's movies, struggling mothers and children go without food, and communities get terrorized, as nothing seems to balance the scales of justice until brave individuals act in decisive ways on their own behalf.

Even when Perry's characters allude to God's interventionist propensities, we see a failure of the movie to follow through on those very same claims. For example, in the aforementioned sermon sequence in *Daddy's Little Girls*, the preacher promises his congregants that God is about to bring a breakthrough in their lives, a message that encourages Monty during his battle with Jennifer and Joe over custody of his children. Monty leaves the church service with confidence that God will come through for him. But as the plot unfolds, nothing seems to happen to Monty's enemies, and the only people who seem to suffer are Monty's daughters at the hands of Jennifer and Joe. At the end of the movie, Monty stops waiting on God and rather recklessly takes matters in his own hands through vehicular assault against Jennifer and Joe followed by administering a vicious beating against Joe. And the fact that Monty suffers no harmful consequences for his brutality but the movie ends with him hailed as a hero all the more highlights the efficacy of human initiative over the promise of divine intervention.

An even more poignant example of an unfulfilled claim for God's intervention occurs near the ending of *Diary of a Mad Black Woman* during a church service when a choir sings an original song written by Perry called "Father Can You Hear Me?" While the lyrics exert an ambivalent spectrum from unrelenting confidence in God's presence to desperate pleas for divine awareness of human struggle, the lyrics do posit an active God who intervenes in time and space to comfort and alleviate suffering and pain. And the sermon segment that precedes the choir's rendition of the song does even more to endorse a God who intervenes in time and space to help humans. The young preacher cites biblical examples of God's power to resurrect a valley of bones and heal

lame people, and promises his congregants that the same miracle-work-ing God functions today, that God can deliver them out of any situation, including drug addiction.

So the first sermon sequence of Tyler Perry's cinematic career offers a tribute to God's supernatural power to resurrect corpses and deliver people out of distressful situations, including drug addiction. And the strategic timing of the preacher's assertion about God's ability to deliver a person from drug addiction foreshadows the surprise entrance of crack addict Debrah sauntering into the church singing and looking healthy and whole for the first time in the movie. The congregants look on in amazement at Debrah's stunning new state, as her husband and daughter embrace her, forming a powerful moment of restoration. So one might be tempted to believe that Debrah struts into the church as a timely confirmation of the preacher's prophetic claim of God's super-natural power to intervene.

But before we accept Debrah's stunning transformation as a fulfill-ment of God's supernatural intervention, we must revisit an earlier montage to see the crack addict enter a drug rehabilitation center, receive professional care for her addiction, and suffer through painful withdrawal symptoms as a result of the detoxification process. And so by the time Debrah promenades down the church aisle, she has already been "delivered" from her addiction through modern therapy rather than the hand of God. While some might point out that God can heal through human methods, the preacher's assertion of God's ability to raise dead bones, heal lame bodies, and deliver a person from drug addiction is never fulfilled. In contrast to the preacher's assertions, God does nothing miraculous in this movie or indeed in any of Perry's con-tributions. In the filmmaker's first cinematic sermon, a young preacher writes a supernatural check that Tyler Perry's entire oeuvre has yet to cash.

There is in fact far more paranormal activity in two scenes of Penny Marshall's film *The Preacher's Wife* (1996) than in all of Perry's movies. Dudley, the charming angel (played by Denzel Washington), deploys supernatural capabilities to add a siren to a kid's toy truck and spook business mogul Joe Hamilton by making his piano play music with no pianist. *The Preacher's Wife* proposes a Christian religion that can transcend the laws of nature. Perry, in contrast, presents Christianity as a folk-cultural safety net and set of useful ideals, offering no direct

engagement with transcendent possibilities. Similarly, there is more supernatural activity in one brief moment at the end of Lars von Trier's provocative film *Breaking the Waves* (1996), when heavenly bells ring from the sky to signify Bess's successful entry to heaven, than in all of Perry's films. Perry chooses to focus on the human capacities rather than divine interventionist possibilities when resolving the pressing dilemmas black people face. It is almost as if Perry goes out of his way to juxtapose two conflicting worldviews: one in which the universe is governed by God who intervenes to help distressed believers in times of struggle; and the other more dominant reality in his plot resolutions in which an absence of God is implied, suggesting that when the rubber meets the road and when the spotlight shines on crucial moments deciding one's fate, it is human initiative that secures the outcome.

Tyler Perry's movies navigate the tensions between God's divine blessings and human suffering—a tension that neo-Pentecostalism and prosperity gospel contingents of Protestant Christianity often fail to acknowledge, focusing far more attention on God's supernatural power to bless (Harrison 2005; Lee and Sinitiere 2009) than on the problem of theodicy: why God allows bad things to happen to good people. And hence, it is in this way that Perry's cinematic universe veers away from the optimistic preaching of his hometown pastor Paul Morton and that of his good friend Bishop T. D. Jakes by simulating God's silence in matters of human suffering. In other words, Perry's movies offer an abundance of spirituality alongside a profound absence of God's supernatural intervention. His plots remind us that no simple theological or teleological formulation about God's intercession can erase people's struggles.

Perry does not make an attempt to resolve the theodicy question. Nor does he put God on trial for black misery. Nor does he provide a theological answer to questions pertaining to the origin of evil. Nor does he attempt to answer how a loving God could preside over socioeconomic inequality and racial injustice. But what his cinematic vision does offer is an existential message of uplift that puts the onus on humans to solve their own problems. Hence, an essential aspect of Tyler Perry's modern imagination promotes willful existence in the face of black suffering and such an endorsement resonates less with the neo-Pentecostal preaching of Paul Morton and T. D. Jakes and more with the modern perspective of noted humanist scholar Anthony Pinn (1995, 2002).

CONCLUSION

Whereas many Jewish identity films and race movies present religion as a site of confrontation between tradition and modern change, Perry's movies offer a seamless blend of the folk with the modern via a less confrontational and more relational brand of religious representation. Such a modern mitigation of religion in the form of inclusive and worldlier spiritual identities reflects Perry's vision as an overseer of the burgeoning sensibilities of many post–civil rights Christians. Had Tyler Perry come of age in a traditional Protestant church where dogma and doctrine reigned supreme and where the church saw itself as engaged in a war with the secular world, then the filmmaker might have been more inclined to represent a rigid brand of Christian dogmatism that endorses a more fervent rejection of the ways of the world. But Perry grew up in a neo-Pentecostal church that brokered a peaceful negotiation with the ways of the world, and many of his Christian characters exhibit that seamless blend in their lives. So even though at rare moments one of his characters may appear quite dogmatic in her Christian commitments (Alice in *The Family That Preys*; Sarah in *Temptation: Confessions of a Marriage Counselor*), Perry ends the first movie with Alice toning down her hyper-spirituality and embracing a more worldly perspective, and the other with Sarah using excessive spirituality to hide her own demons.

Tyler Perry's strategic deployment of gospel music and worship expressivities as major components of unfolding themes and plots situates the filmmaker as a spokesperson for a new generation of black Christians who hold sentimental connections with the slave religion of the past, while embracing the changing contours of modern technology and perspectives. Perry continues to disprove those Hollywood executives who claimed that black people who go to church don't go to movies, as black churches continue to transport busloads of congregants to opening nights of Perry's films. Perry shows that black Christians, like any other patrons, will see movies over and over again if those movies are able to appeal to their needs and tastes. But Perry would not have achieved the vast popularity he enjoys if the Christian filmmaker's works were trite depictions of evangelical dogma and religious sanctimony. Instead his movies are simultaneously spiritual and worldly, and that duality fuels his ability to draw an impressive African-American

patronage as well as his ability to expose us to new dimensions of black post-soul life.

While Perry's movies offer an unprecedented cinematic engagement with black evangelical cultural tools, they strip those cultural tools of their supernatural vitality. In this way, his quite secular character Wesley Deeds seems more efficient than God at meeting people's needs. In *Good Deeds*, whenever Wesley discovers a problem his employee Lindsey faces, he offers an immediate solution, wielding his power and resources in rational ways to alleviate Lindsey's pain. In contrast, God seems less inclined to intervene on behalf of suffering servants with such immediacy and efficacy in Perry's cinematic universe. God does not intervene to remove pain and misery, nor does God transcend the crushing forces of social stratification and inequality. God permits drug dealers to intimidate residents of a community and allows Perry's characters to suffer, to get sexually abused, gang-raped, wrongly imprisoned, neglected, and exploited in what appears to be an unjust universe. Human initiative and discovery are celebrated over divine intervention in providing functional solutions to pressing problems. To put it more crassly in pugilistic terms, Perry's plots first feint spiritual jabs and then unleash humanist haymakers.

We should pause and consider that perhaps the Christian filmmaker is not very different from most contemporary evangelical preachers who may endorse supernatural potentialities in theory, but in actuality put more trust in personal responsibility and modern ingenuity. For clerics in the most theologically conservative churches seek modern solutions to pressing problems, like assigning marriage counseling to the domain of credentialed specialists not spiritual savants (Lee and Sinitiere 2009). So to suggest that Perry's movies relegate God to the sidelines as a cosmic cheerleader of sorts while more active humans do all the heavy lifting is not a slight against the filmmaker for not living up to some idealized evangelical standard. Nor does it suggest that Perry's lack of supernatural activity in his films reveals a selling out of his faith. But what it does reveal is Perry's unique ability to harness spiritual expectations within the range of pragmatic realities. We should interpret Perry's strategic deism as his passive way of negotiating the pressing questions of theodicy: How can a loving God and human suffering coexist? How can modern Christians make sense of this coexistence without rejecting God? Why does God allow the most heinous actions

against good people to take place, while scoundrels are often spared from similar heartache and suffering? Perry's cinematic answer to all three questions comes tacitly in the form of a modern recalibration of God's responsibilities in which God remains on the sidelines while humans compete in the game of life.

Thus, Perry's cinematic vision is endurably Christian, indisputably spiritual, and indubitably modern. Despite all its vibrant gospel music soundtracks, riveting worship services, and creative preaching moments, Perry's cinematic spirituality is more concerned with providing pragmatic benefits that empower self-actualization and far less concerned with weighing Christians down with dogmatic constrictions or adhering to legalistic traditions. His movies celebrate human freedom, eschew theological explanations for the origin and perpetuation of evil and black suffering, and rarely make overt claims on where God stands in all the madness that humans create and perpetuate. And perhaps this is where Perry makes his break from the creative Christian kinship he shares with the legendary twentieth-century artist C. S. Lewis, who, in spite of his joyous portrayal of Christian living, was clear to point out how doctrinal truths and divine revelation undergird and hold accountable human rationality. Religion for Perry serves as a creative repository of folk-cultural resources to empower his members toward greater subjectivity, not as an accountability device to still the tides of a kind of moral subjectivism that Friedrich Nietzsche (1887) preached about and C. S. Lewis challenged in his seminal apologetic tome *Mere Christianity* (1960). For I would argue that Perry would find much more that is nourishing about Nietzsche's perspectivism than C. S. Lewis ever imagined, and that Perry is far more of an existential pragmatist than Lewis can ever be conceived as. Tyler Perry's representation of spirituality does not call for an apologetic breach from the ways of the world, but rather is often seen sailing the hammering surges of modern momentum.

5

PRAGMATIST CINEMA

Perry's Five Functions of Art

Whether Madea is trading barbs with her obnoxious brother Joe or threatening to pimp slap Jennifer, her zany antics and indelicate humor appear all throughout *I Can Do Bad All by Myself*. But when Jennifer reaches out to Madea for spiritual guidance and comfort shortly after learning about her grandmother's death, we see Madea's utility extend beyond levity. This scene features Jennifer sitting on Madea's porch asking the irreligious woman to teach her how to pray. In her strange attempt to comply with the teen's request, Madea simulates a prayer that makes a mockery of Christian theology, transposes Old Testament characters into New Testament contexts, and confuses contemporary pop stars like Mary J. Blige with biblical characters, ostensibly offering a slapstick interlude for a painful moment in Jennifer's young life. But Perry purposefully pivots Madea's misguided prayer into a powerful existential message for Jennifer and for his patronage.

After Madea finally admits to Jennifer what most of Perry's fans already know, that the elderly woman is profoundly unsuited to this task, she informs the teen that no one can teach her how to pray and that all she needs to do is to speak to God straight from her heart with her own words and sentiments. Madea exhorts Jennifer to envision prayer as simple and honest communication with God requiring no mediation. Such an approach demystifies prayer from something sacrosanct and ritualized to something intimate and accessible. Madea en-

courages Jennifer to drop all pretenses and talk to God honestly just like she would talk to anyone else. The Protestant reformer Martin Luther could not have expressed this notion of the priesthood of all believers any more effectively than Madea does in this clever improvisational moment.

There is no doubt that Jennifer's visit to Madea's house infuses a light moment after the morose sequence that unfolds around the news of Mama Rose's death. But in a dialogue in which Madea demonstrates a vaudeville disruption of biblical narratives, she also offers a pragmatic lesson on prayer that recapitulates the teachings of Søren Kierkegaard (1843), a noted nineteenth-century Danish philosopher and theologian. Similar to how Kierkegaard rejected a stale conformity to dictates of the Danish church of his day and admonished his fellow Christians to learn how to commune with God in their own creative ways, Madea uses her botched tutorial on prayer to teach Jennifer (and Perry's audience) that conforming to church strictures and conventions won't help a dis-traught teenager deal with tragedy. Kierkegaard and Madea both em-phasize the agentive capacities of human engagement with the divine. Jennifer learns from Madea to offer honest communication to God about her pain without the help of elders, religious elites, or anybody else. So in the most madcap moment of *I Can Do Bad All by Myself*, we see Madea offering the movie's most powerful teaching moment: that if you're going to pray, you must do it on your own terms and in your own language and talk to God as you would a friend.

Madea's improvisational lesson poignantly demonstrates that Perry's cinematic artistry has pragmatic import. Madea's zany wit not only bal-ances out Perry's treatment of heavy social themes like sexual assault, drug addiction, capitalist greed, homelessness, and spousal abuse; it also offers practical instruction and existential mentorship. Madea plays a crucial role as Tyler Perry's folk-cultural conqueror, providing layers of sagacity and secularity within the filmmaker's overall pragmatic com-plexity.

Tyler Perry is heir to a pragmatist tradition that respects art's effica-cy and transformational capacities, insisting that the relevance of art transcend the ivory towers to enrich the everyday lives of the populace. The philosopher and aesthetician John Dewey (1934) is perhaps the architect of this tradition, contending that art's effectiveness comes within its relation to other modes of human experience and its ability to

help social actors interpret their own worlds. The pioneer director of race films, Spencer Williams is an advocate of this pragmatist perspective, and his cinematic artistry functions as a dispenser of moral enlightenment and a viable instrument of Christian education (Weisenfeld 2007). Similarly, Perry redefines the ontological possibilities of cinematic art, envisaging his movies as both the direct function of lived experience and as the creative means to challenge and transcend that lived experience.

What Tyler Perry's numerous critics often fail to recognize in their blithe dismissals of his movies is that Perry's cinematic appeal among contemporary African Americans is in direct relation to the ways in which his films provide pragmatic assets and deploy cultural tools rarely engaged in American cinema. For Perry, cinema provides tools of self-therapy through which both the filmmaker and audience can revisit and understand their past and press toward a more promising future. Perry envisions his cinematic craft as safe space to commemorate and critique deeply held beliefs and sensibilities within our late-modern moment as a platform to disabuse social ills, inspire personal healing, and provide existential enlightenment, even as it entertains. Perry creates movies as artistic mechanisms to enlighten our comprehension concerning the two most fundamental existential questions: Who are we? What can we become? Rather than judging Perry's artistic methods on the standards of activists, womanist ethics, or other political projects that impose expectations onto art, this book is curious about Perry's own teleological imagination about art's pragmatic import. Hence, it is helpful to locate five indispensable functions of art that drive Perry's cinematic imagination.

ART'S TEACHABLE MOMENTS

The first and most crucial utility of art we can derive from the filmmaker's work is a normative function. Simply put, Tyler Perry believes that art teaches something about life. In this way Perry participates in the cinematic normativity of pioneer black filmmakers like Oscar Micheaux, whose movies provide lessons about Jim Crow and racial inequality, and Spencer Williams, whose films feature spiritual enlightenment and filmic entertainment as enthusiastically symphonic. And Perry's cinematic

pragmatism has a lot in common with more recent black filmmakers like Bishop T. D. Jakes, whose first two movies, *Woman Thou Art Loosed* (2004) and *Not Easily Broken* (2009), teach much about emotional healing, forgiveness, and how to sustain healthy relationships; Dee Rees, whose breakout movie, *Pariah*, teaches about intolerance and self-transcendence; and Rees's mentor Spike Lee, whose controversial films dispatch didactic treatments of the complexities of race, class, and urban environments in modern American society. Perry participates in a rich tradition of black filmmaking that goes beyond entertainment to provide powerful life lessons.

Tyler Perry operates under the assumption that art misfires if it does not offer profound teaching moments. It is important to note that Perry's "Harvard" experience was in a thriving church in his hometown New Orleans, rather than in film school or a college classroom, and hence his artistic rhythms often mimic the cadences of black spirituality where instructional advocacy is expected. Perhaps Perry's ability to tap into new cinematic markets and attract Christian patrons draws upon his skill to offer explicit teachable moments. If such is the case, then it would confirm that scholars must be open to the varying teleological expectations that guide the consumption of particular forms of pragmatic artistry. And if Perry's patrons expect to get both humor and life lessons in each of his movies, we should all the more treat them as savvy customers for choosing artistry calibrated toward their needs and tastes. Perry's normative function of art is the linchpin that holds together the complexities of his ancillary functions and themes. His movies teach, confront, clarify, and explain as much as—or even more than—they entertain.

ART'S PSYCHOTHERAPEUTIC FUNCTION

The second utility of art that informs Perry's cinematic vision is a psychotherapeutic function. Perry's movies tackle traumatic events in people's lives, offering remedial calls for characters (and patrons) to find resolution to their pain. Perry has been forthright about his own anguished childhood and familial discordance, and his art readily draws from the cadences of those early struggles to offer healing for himself and others suffering similar circumstances. Perry deploys cinema as

safe space to challenge himself and his patrons to revisit painful memories, past failures, and emotional turmoil and pursue a healthier existence as the culmination of such confrontations.

As chapter 3 demonstrates, madness is often Perry's psychotherapeutic equalizer to help weak-willed individuals gain existential strength. When one considers the hardships Tyler Perry faced under the alleged bullying of his father, one could imagine why such a survivor would create a heroic madwoman like Madea, who exhibits subjective power in daunting capacities. Similarly, whether it is Sheila bashing her abusive husband over the head with a wine bottle in *Why Did I Get Married?* or Helen torturing her estranged husband in *Diary of a Mad Black Woman*, Perry's continual usage of characters going mad as means of fighting back against male oppressors might be understood as a psychotherapeutic writing/righting of the wrongs of his own childhood. Perry's harsh cinematic payback to bullies not only demonstrates how women can resist domination and reclaim agentive capacities, but also may sublimate his own hostility against his father.

Like Toni Morrison's novels, Perry's movies emphasize the power of the past in shaping the future, pushing himself and his audience to excavate the unhealed vestiges of painful experiences that impede their progress. And in this way, perhaps no mainstream filmmaker in the history of American cinema has broached the topic of sexual assault in more movies, in more scenes, and with more characters than Tyler Perry. His films are unrivaled in American cinema in capturing the emotion and trauma of sexual assault and the anguish and shame of characters revisiting past experiences, and Perry is as decisive in his denunciation of sexual assault as he is compassionate with his treatment of the victims. But rather than offering condescending pity, Perry refuses to allow sexual assault victims to wallow in defeatism. His plots offer victims urgent exhortations to transcend their trauma and forge forth toward empowered lives. On his own website and in his 2010 appearance on *Oprah*, Perry revealed that he too was a victim of sexual assault, and so his movies not only provide much-needed awareness concerning the complex ways vulnerable people become victims but also may offer the artist vicarious healing. The proactive remedial steps taken by his characters are models for sexual assault victims to both confront and transcend their pain.

In the most desperate of situations, his characters are pressed to look within for additional strength and to be agentive forces within their own recovery. Within their ability to transcend trauma and tragedy resides a particular focus on the power of forgiveness. Perry's movies repeatedly touch upon the psychotherapeutic need for an individual to let go of hate and resentment and forgive her tormentor to secure her own peace. For example, in *Diary of a Mad Black Woman*, Myrtle tells her daughter, who suffered almost two decades of emotional abuse from her husband, "No matter what he done, you got to forgive him. Not for him, but for you." Myrtle's statement reveals how forgiveness from Perry's perspective is not an act of sanctimony, but rather a selfish act of cathartic release, a way of achieving one's own healing. Myrtle continues, "When somebody hurts you, they take power over you. You don't forgive 'em, they keeps the power!" Madea articulates a similar message in a prison Bible study when she urges fellow prisoners to forgive their tormentors to secure their own healing (*Madea Goes to Jail*). Similarly, Vanessa can tell a mother who was especially cruel to her, "I forgive you with all my might, and I'm going to pray God has mercy on your soul" as a way of ensuring Vanessa's own healing and health (*Madea's Family Reunion*). Art for Perry is a strategic terrain to tap into dark places and to offer creative cinematic moments for healing and transformation.

ART'S REVISIONIST FUNCTION

In addition to normative and psychotherapeutic intentions, Perry's movies show how art can be useful toward confronting and dismantling taken-for-granted proclivities and presuppositions about life. For example, Perry's movies rupture the notion that black working-class culture is deficient in comparison to black middle-class or elitist culture, arguing instead that black folk-cultural preservation and dignity offer medicinal mechanisms for black elitist angst. And as chapter 4 delineates, Perry offers revisionist challenges against his own Christian faith. But perhaps his most common target for radical critique concerns idealized notions of the concept of love that pervade the Western imagination.

Love

While Perry presents love as exhilarating and redemptive, he balances those romantic celebrations with depictions of love as mayhem and misery. Perry displays the romantic dyad as unstable terrain wherein one partner can decide a new suitor is a desirable replacement for one's partner. In *Diary of a Mad Black Woman*, Charles callously kicks Helen out of his mansion and replaces her with his mistress, Brenda. Disoriented by her displacement from her marriage, Helen sits sadly in a restaurant listening to a song by Toni Braxton called "Stupid," which adequately sums up how she is feeling. Later in the same film, Helen's new love interest, Orlando, tells Helen that his previous girlfriend replaced him with a professional athlete who could provide a more lucrative lifestyle. Brenda eventually rejects Charles once his near-fatal injury makes him less able to meet her needs. Helen leaves Orlando to rejoin Charles, and after reconciling with her husband, Helen chooses to proceed with the divorce and permanently replace Charles with Orlando, whom she deems a more suitable love partner. *Diary of a Mad Black Woman* pierces the idyllic shell around romantic dyads, presenting love as a negotiation of rational interests mediated by leverage and personal assets that often have expiration dates.

While most of Perry's movies are romantic comedies, some culminating in wedding ceremonies, his pragmatic representations of love are surprisingly cynical. Perry depicts love as increasingly untenable with the passing of time, as partners tell untruths, lust after other people, lose interest in their partners, mistreat or replace them. In the way in which love makes people vulnerable, Perry captures its absurdity. For example, in *Daddy's Little Girls*, Julia was in a romantic relationship with a man for six years until he ended their relationship only two days before marrying another woman. Julia was devastated by the experience, as she reveals to Monty, "I never felt so low and stupid and humiliated in my life." Perry's movies show romantic dyads getting more convoluted over time, implying that it is just about impossible for partners to keep the passion of earlier years. His films also raise profound questions concerning the negotiations of love within the balance of familial and professional pressures in a rapidly changing modern world.

So as a radical critique against hyper-romanticized versions of love in Western movies and romance novels, which treat love as sufficient to secure satisfaction, Perry's recurring theme is that love is not enough. For example, in *Madea's Big Happy Family*, Byron lectures his older brothers-in-law, Calvin and Harold, to remember that as long as they love his sisters, then everything else in their marriages will be okay. Held in the power of his simplistic beliefs, Byron is unmoved by Calvin and Harold's convincing arguments for why Byron's sisters are making married life unbearable for them. Later learning that love in fact is not enough, Byron breaks up with his self-centered materialistic girlfriend, Renee, despite his love for her. Perry's movies hammer home the point that compatibility, emotional stability, and a more measured approach to romance are necessary to avoid love's absurdities and that some relationships have deep-rooted issues that need to be addressed in order to function in health and happiness.

Marriage

Within Perry's revisionist approach to idealized notions of love is an equally conflicted depiction of marriage. Perhaps Robert Patterson (2011) reads too much into the fact that some of Perry's movies end with wedding ceremonies when the scholar accuses Perry of uncritically endorsing marriage. While Patterson makes some valid points, a more careful examination of Perry's movies shows that his execution of married life is quite critical and even pessimistic. In his two marriage films—*Why Did I Get Married?* and *Why Did I Get Married Too?*—Perry paints the modern marriage as replete with power struggles and resentments, in fact as almost hopelessly dysfunctional. In the first marriage movie, Terry is incredibly needy and demanding, and his wife, Dianne, secretly gets her tubes tied so she cannot get pregnant again. In the sequel, Dianne gets her tubes untied and they have another child, but the marriage appears equally unimpressive as Dianne's happy demeanor and newfound vibrancy come from an emotional attachment to a new colleague, whom she often fantasizes about to the point of accidentally calling out his name during an intimate moment with Terry. Marcus and Angela are unfaithful to each other in the first movie and appear equally erratic and dysfunctional in the sequel. But more surprisingly we find Gavin and Patricia resolving their issues in the first

movie but heading toward a volatile divorce in the sequel. And after Sheila divorces Mike and enjoys an idyllic relationship with Troy in the first movie, we see Sheila and Troy as a married couple agitating each other in multiple scenes in the sequel. Perry's two marriage movies invite us to believe that harmonious modern marriages are mythical or at least improbable.

In *Diary of a Mad Black Woman*, we see Brian lamenting over his estrangement from his wife, Debrah, who is addicted to crack. Brian still loves her but has to ban Debrah from the house. In one absurd scene, Debrah attempts to seduce Brian with sexual favors if he lets her stay the night. Brian seems both tempted and outraged by the overture, demonstrating the precarious balance in which Debrah's drug addiction positions both partners. With Brian and Debrah, Perry depicts marriage as a terrain of unpredictability in which one partner may succumb to destructive behavior that reconfigures the contours of their relationship and familial stability.

In *Madea's Big Happy Family*, Harold and Tammy's seventeen-year-old marriage has devolved into a sexless, unaffectionate, argumentative union, and in the same movie, Kimberly and Calvin's marriage is a breeding ground for contempt. Looking at Perry's movies broadly, only a small proportion of leading characters are married and a paucity of those marriages are anything remotely close to healthy and happy. Hence, the criticism that Perry "never entertains the possibility that the institution of marriage itself warrants interrogation" (Patterson 2011, 12) falls short under a comprehensive analysis of marriage in Perry's movies.

The rare occasions when Perry's films offer idealized depictions of marriage involve either a romantic comedy that ends in a wedding ceremony or nostalgic ruminations on happy marriages. Perry's first two romantic comedies end with either a marriage proposal or an actual wedding, but we never see these hopeful couples live out their marriages. His later film *I Can Do Bad All by Myself* also ends with a hopeful wedding ceremony, so we never get to see what Sandino and April's marriage looks like in action. In *Madea's Family Reunion*, Myrtle shares fond memories of her late husband, claiming their bond was so strong that their heartbeats were in sync, but once again, we only encounter the memory of a healthy marriage rather than seeing the marriage in active engagement; and in *Why Did I Get Married Too?*

Porter and Ola testify about spending almost half a century together in loving devotion, but we have to take their word for it since we see so little of their marriage in real time. The latter marriages, while idyllic, offer retroactive looks at healthy unions rather than active simulations of how healthy marriages function. Conversely, most of Perry's simulated marriages confirm comic Louis C.K.'s assertion in *Oh My God* (2013) that divorce is the best thing that can happen to a married person. So even though several of Perry's romantic comedies end on a hopeful note with wedding ceremonies, or include maudlin recollections of marital bliss, his movies feature active marriages quite pessimistically. Judging by his movies and his enduring bachelor status, one might be tempted to presume the filmmaker's perspective on marriage is congruent with Savon's contention in Theodore Witcher's clever movie *Love Jones* (1997): "People with profound insights on life know not to get married." Perhaps this is why Perry's later film *Good Deeds* ends with Wesley and Lindsey flying off to a new life together in Africa without the hint of pending nuptials.

Family

In addition to unraveling the almost sacred support for love and marriage in Western society, Perry's revisionist function of art also offers somewhat ambivalent projections of family life. On the one hand Perry presents the family in traditional ways as a source of strength and vitality, with an ever-present power to uplift members and celebrate triumphs. One could even claim the family is an important folk-cultural motif in Perry's movies as a cherished network of support and mentorship that some black elites ignore or abandon incautiously at their own peril. But alongside Perry's valorization of familial sustenance is a radical critique against the very same romantic myths of the family as a loving sanctuary.

Perry's movies contrast the improvisational mobility of working-class African Americans who have no families against the familial dictates imposed upon wealthy blacks. Within this juxtaposition, the working-class character who seems to have no family is free to chart her own course, while the life arcs of bourgeois characters are heavily imposed upon by their families. For example, the privileged daughter Lisa must endure her mother's meticulous management of her aspirations and

commitments, whereas Lisa's working-class sister, Vanessa, is free to make her own decisions (*Madea's Family Reunion*). In *Daddy's Little Girls*, Julia Rossmore's imperturbable course to becoming an elite corporate attorney seems more motivated by her desire to please her demanding attorney father (who also wanted a son) than by her own passion. In contrast, her working-class counterpart Monty has no family, which means no familial blueprint that dictates his every move. Monty's dream to run his own auto repair shop emanates out of his own interests and imagination, while Julia is driven by her father's dream. In *Good Deeds*, the janitor Lindsey has no family and hence is free to live by her own dictates, in contrast to her rich employer and new friend Wesley Deeds, whose familial pressures seem quite stifling. Wesley lives his father's dream while Lindsey heeds her own voice. The movie culminates with the janitor inspiring the CEO to follow his own heart, and perhaps it is no coincidence that Wesley must leave the continent in order to be free from familial pressure. Perry posits the black modern wealthy or successful family as an impediment to one of its members pursuing her own dreams.

Reminiscent of the classic film *While the Patient Slept* (1935), which depicts a family harboring dysfunctional spaces and secret antagonisms, and more recent films like *Above the Rim* (1994) and *Jason's Lyric* (1994), which represent sibling strife and complex familial bitterness, Perry's movies uncover how familial space is often replete with dark undercurrents, lies, and secrets. Bad things happen to and by siblings, parents, and children in Perry's movies, as family life is often the locus of great pain and destruction. In *Madea's Family Reunion*, Victoria allows her daughter to be sexually abused by her stepfather in order to stave off his threats to leave them destitute. Candy's stepfather is more of a sexual predator than a protective guardian in *Madea Goes to Jail*. In *I Can Do Bad All by Myself*, Jennifer's own mother rents her to men for sexual favors in exchange for money to buy drugs, and in the same movie, April wants little to do with her niece and nephews until she has a final change of heart. Scandalous lies are uncovered in *Madea's Big Happy Family* concerning the true identity of Byron's mother, which had been hidden from Byron all of his life. The movie also reveals that Kimberly's irritability and resentment against her mother are residual effects of the heinous act of Kimberly's uncle raping her at the young age of twelve. In *The Family That Preys*, sisters Pam and Andrea are

always at each other's throats, and in the same movie, Charlotte is particularly disparaging of her son and daughter-in-law and admits to Abby Dexter that her family has been known to prey on each other. In *Good Deeds*, Wilimena is quite antagonistic against her son Walt, who in turn makes quite disparaging remarks to his mother. For Perry, the family is sometimes a buttress of comfort and support but more often an arena of dysfunction, jealousy, control, personal vendettas, deep-rooted resentments, and dissemblance.

Perry cleverly borrows from Shakespeare when he broaches the motif of the patriarch controlling the lives of his children from the grave. In *Hamlet*, the ghost of Hamlet's father imposes his will on the son, driving the son to spend the rest of the play avenging his father's death. In Shakespeare's *The Merchant of Venice*, Portia's father leaves an obtrusive stipulation in his will for how the heiress can choose her life partner. Likewise, Perry's protagonist Wesley in *Good Deeds* is entrapped within a dutiful fulfillment of his deceased father's dream. Wesley's father also leaves the company in the hands of the more responsible Wesley instead of the more business-minded Walt, which drives Walt's bitterness and despondency through much of the film. A sardonic toast between Hamlet, Portia, Wesley, and Walt might sound like this: "To our dead fathers. May they continue to haunt us."

ART'S EXISTENTIAL FUNCTION

Tyler Perry assumes a fourth utility of art, an existential function, and in this way shows striking similarity with Woody Allen. While Allen and Perry take drastically different paths toward securing loyal patrons, both filmmakers function as celebrated artists who enjoy the creative space and artistic freedom of independent filmmakers, along with the profitability of large studio productions. Allen and Perry are among the few contemporary filmmakers who control not only content but also the production and postproduction processes of their films and hence are existential auteurs of sorts who are shielded from the kinds of fierce capitulations to presumed market concerns that dominate other filmmakers. But where the two existentialists differ is in the redemptive import of their conversations with late-modern life. If Woody Allen mocks the tragic absurdity of modern living, Tyler Perry rather san-

guinely seeks to heal it, even as his movies often embody the very modern ambivalence he seeks to disabuse.

One could argue that Perry's existential message is summed up best in his movie *Meet the Browns* when eighteen-year-old Michael commences in his new career as a drug dealer to relieve his family's plight with poverty, and his mentor, Harry, steps in to remind Michael that no matter what situation we face, we have choices, and our choices can make our struggle better or lead us into more pain and trouble. Similarly, others might contend that Perry's existential imperative is best articulated in Lisa's last words in *Madea's Family Reunion*, "It's time for me to start making my own decisions and live for Lisa," or when Madea critiques Christians for praying all the time and failing to act, in *Madea's Big Happy Family*. Lisa learns from Madea how to act decisively, demonstrating Madea's therapeutic function for weak-willed women in teaching them how to stand up to bullies, harness their environment, and impose their will on the world. No custom or spiritual precept can contain or constrain Madea's erratic entanglements, as disruption and disproportionality are crucial features of her existential repertoire. She has a strong will and allows no institution, moral order, or familial convention to obstruct her willful exuberance. So while scholars and critics carelessly reduce Madea's efficacy, this work revisits Madea as Tyler Perry's existential force.

Notwithstanding Perry's repeated displays of Madea's muscular interiority, the unfolding plot of *Good Deeds* is where the filmmaker's existential vision comes into its sharpest focus. On the surface *Good Deeds* appears as just another Cinderella story where a rich man saves a poor woman from the vulnerabilities of her humble existence. But unlike Cinderella stories, in Perry's film the working-class woman emerges as the "savior" and mentor, infusing into the rich protagonist new existential values that enrich his life. *Good Deeds* is simultaneously a critique of bourgeois conventionality and a celebration of the synergy that can come out of meaningful connections between black elites and black working-class sojourners. The movie features a hip-hop-loving black female janitor named Lindsey setting the powerful CEO of her company, Wesley Deeds, free from his lack of subjectivity.

While Lindsey faces challenges as a single mother trying to hold everything together, we learn early on that if anyone needs salvation or redemption, it is the powerful CEO, Wesley Deeds, who has been

conforming to the dictates of his privileged family and bourgeois society since the age of five. Using the language of philosopher Jean-Paul Sartre (1956), we would accuse Wesley Deeds of acting in bad faith and living an inauthentic life because he loses himself in familial expectations and corporate responsibilities at the expense of his own capacity for transcendence. Lindsey may desperately lack economic resources, but she is strong in spirit and confident in her own identity. In deliberate contrast, while enjoying the comforts of his high status, high-rise condo, and high-class fiancée, Natalie, Wesley is an existential zombie representing people Perry perceives as performing a sterile conformity to the strictures of late-modern society rather than learning how to hear and heed their own voices. Lindsey mentors Wesley on how to free himself from the shackles of conformism. If art for Tyler Perry is normative, art's greatest lessons most often have existential import.

While Perry seems pessimistic about the modern marriage of commerce and culture and how the yoke of corporate pressures and mounting bureaucracies stifles a person's individuality, the filmmaker forges a new kind of modern mind-set that enjoys the perks of urban sophistication without sacrificing the existential clarity exhibited within the simplicity of the black folk-cultural resources. Within this synthesis, Perry teaches individuals that modern living can actually be improved by tapping into a repository of rich cultural assets that have sustained humble black communities for generations. Perry's movies also teach urban sophisticates and upper-status socialites that disappointments are sure to follow when they buy into the modern myth that success can secure satisfaction. As chapter 2 demonstrates extensively, Perry teaches post-soul sojourners that while their hyper-capitalist age has hypnotized some of them into believing money can buy happiness, the more important existential resources that provide exultant, jubilant living are within their grasp without spending a dime.

An important dimension within Perry's existential function is to expose human capacity for untruth. Perry's movies, like the popular existential television show *House* (2004–2012), emphasize that people lie. In the television drama, the notion of people as liars is in and of itself a revealing element of the human dimension, even as the show's leading character, Gregory House, an existential detective of sorts, makes little attempt to put people through redemptive processes after exposing their lies. For Gregory House, exposing a character's lie is just a fun

intellectual exercise, a respite from ennui. But within Perry's cinematic vision, uncovering the self-deception is only part of a normative journey toward existential liberation. Perry pushes characters and patrons to expose and extirpate the untruths and facades that prevent them from achieving their full potential, believing that the lie's exposure will lead to self-reclamation.

On matters regarding spirituality, Perry's existential cinematic vision complements Derek Hicks's (2012) cogent assessment of the therapeutic components of African-American religion and Christianity. Within his study of antebellum slaves and their creative uses of religion, Hicks uncovers that Christianity offered many slaves a restorative tool kit to recalibrate their humanity in the face of a dehumanizing modern institution called chattel slavery. Perry's deliberate deployment of spiritual principles toward an artistic prescriptive vision of existential health for African Americans has much in common with the ways in which antebellum slaves strategically deployed spiritual assets to counter the contingencies of slavery and dehumanization. And Perry's existential engagement with religious cultural tools marks out space encompassing a celebration of Christian empowerment and a radical critique against that same tradition. As chapter 4 discusses, the filmmaker's plots often unfold solutions to pressing human problems in ways that on the surface seem to affirm Christian ideals but in actuality accentuate human initiative instead of divine intervention. So while at times Perry's characters exemplify the cultural tool kit of Protestant preachers like Bishop T. D. Jakes, more notable are the times the filmmaker crafts scenes and sentiments in line with the humanist visions of Delores Williams (1993) and Anthony Pinn (1995, 2002). And this conflicted and deeply personal dimension to Perry's existential vision is what makes his movies so modern.

So in this way, spirituality in Perry's cinematic vision has a corresponding role for existential empowerment. Religion most often serves as a repository of existential resources rather than a harbinger of rules and stipulations. Although his Christian characters show an emblematic respect for scripture, they never use it as an epistemological constraining force. More crassly put, Tyler Perry and his Christian characters are no Bible thumpers. Some characters are celibate, but not all of them abstain, and none of them claim celibacy as a way of fulfilling God's biblical prescriptions. Christians like Vanessa (*Madea's Family Reun-*

ion) utilize celibacy as a means of accentuating personal health, as a case-specific choice, not out of slavish devotion to scriptural mandates.

ART'S ENTERTAINMENT FUNCTION

The fifth cash value of art that drives Perry's cinematic choices is art as a formidable form of entertainment. Notwithstanding Perry's teaching moments, psychotherapeutic impositions, revisionist critiques, and existential mentorship, the filmmaker recognizes that art should entertain and that humor is a trusty device toward realizing that aim. Part of Perry's cinematic appeal is his willingness to participate within the rich American tradition of slapstick comedy, which includes the madcap movies of the Marx Brothers, Laurel and Hardy, the Three Stooges, Peter Sellers, Jerry Lewis, Madeline Kahn, Mel Brooks, Gene Wilder, Richard Pryor, Bill Murray, Rodney Dangerfield, Leslie Nielsen, Whoopi Goldberg, Tina Fey, the Wayans family, and many more comedic performers who have pushed the limits of artistic zaniness.

Perry's slapstick indulgences make him controversial to critics who presume that such representations inescapably recapitulate the minstrel era of yesteryear, as sociologist Zandria Robinson confirms: "For Perry's critics, his characters are twenty-first-century coons, hardly updated versions of Amos 'n' Andy or Stepin Fetchit and grotesque reminders of an oppressive southern past" (2014, 159). Acting as a veritable "minstrel police" of sorts, scholars and journalists criticize Perry and other black artists' zany movements and performances under the quest to leave the minstrel era behind. Such critiques fail to consider how the minstrel era, despite its pernicious political motivations, impacted the subsequent American slapstick tradition of comedy in profound ways.

Many intonations, exaggerated movements, and other comedic tactics in physical comedy that were incubated within minstrel artistry would later morph into Vaudeville, other theatrical genres, and then American television and cinema. Thus, the zany arsenals of early twentieth-century comic films owe debts to the innovations of minstrel performers like Bert Williams (Rogin 1996; Forbes 2008), despite the art form's racist origins and detestable desire to denigrate black bodies. As one of the earliest American art forms, black minstrelsy was an incubator of American slapstick comedy. Criticisms against Perry's slapstick

tendencies are persistent reminders that within the scholarly examination of artistic humor, a pernicious racial double standard affords white comedic performances a full range of tools from a slapstick repertoire, while equally clever black slapstick performances that borrow from the same creative tradition are deemed as retrofitted minstrel implementations. While a vibrant American tradition of slapstick comedy offers safe space for an endless range of wild and zany behaviors, scholars, activists, and intellectual elites meticulously monitor black comedic performances for remnants of minstrelsy. Perry's fifth function of art as entertainment claims as its inheritance the full rights and privileges reserved for comedic artistry to engage in zany, wild, crazy behavior.

Whereas most comedies offer one or two slapstick forces, Perry's later film *Madea's Big Happy Family* has four memorable farcical characters. Whether it's driving her car through the walls of a fast food establishment, giving the rude tween HJ a super smackdown, or threatening her family by hook or by crook to conform to her agenda, Madea offers her usual brand of volatile energy in this movie. But three other superb slapstick characters complement Madea's impulsive antics. Mr. Brown adds burlesque muscle with his malapropisms and erratic physical comedy, especially in hospital scenes where he frantically undergoes tests to diagnose his health problems. In one sequence, Madea slaps Brown and he hits the floor with his body contorting like he was struck by lightning. The kind of skillful physical comedy that gets critically acclaimed when performed by white actors is overlooked when accomplished by Perry's character Brown. Sabrina is Perry's first young rival to Madea, giving the elderly woman a run for her money in confrontations, while keeping patrons in stitches with her annoying pronunciation of her baby's father's name as Byreeeeeen! And Aunt Bam is an array of paradoxes as an elderly lustful Christian woman who declares, "Praise the Lord!" after smoking marijuana in the hospital bathroom and spends many of her waking moments trying to get high.

Madea's Big Happy Family offers four memorable slapstick performances as a rare comic feat. Had Mel Brooks directed the same movie and instead featured white comic actors of similar creativity and energy, critics would likely have once again affirmed him as a comedic genius. And *Madea's Big Happy Family* one-ups Brooks's movies by blending tragedy with humor, tackling heavy issues like death, theodicy, and sexual assault, while maintaining clever comedic releases from four dy-

namic slapstick performances. Notwithstanding all of Madea and Brown's crazy antics, no Perry movie indulges in more madcap moments than Woody Allen's futuristic comic science fiction film *Sleeper* (1973) or comes close to any Leslie Nielsen film in allowing for buffoonish actions and scenes. But a bifurcation of comedic evaluation allows for Allen, Nielsen, and numerous other white comic forces to indulge in the American tradition of slapstick exuberance, while black filmmakers like Keenan Ivory Wayans and Tyler Perry are harshly critiqued for doing the same. And if one were to remake Woody Allen's *Sleeper* using all of the same movements, jokes, and madcap moments (like the protagonist stealing the president's nose, for example) but replacing white actors with black actors, the remake would more than likely draw harsh criticisms from the minstrel police claiming the film drags black people back a hundred years.

Scholars and intellectual elites who accuse Perry of promoting bad images for African Americans are heirs to a longtime tradition of policing black art for representational crimes and offenses. Black elites of the early twentieth century similarly criticized numerous black art forms including jazz and the blues for failing to submit "to a code of temperance, thrift, polite manners, sexual purity, cleanliness, and rectitude" (Brundage 2011, 9). While scholars today deem Oscar Micheaux to be a pioneer black filmmaker of great talent and import, black elites of his day also criticized his films on representational grounds, as Micheaux discussed:

> "I am told almost daily by super-sensitive members of my race that, in producing Colored motion pictures, I should show nothing bad, that I should not picture us speaking in dialect, shooting craps, bootlegging, drinking liquor, fighting, stealing, or going to jail; that I should, in effect, portray only the better side of our lives—and they have promptly gone to sleep on such pictures when offered." (McGilligan 2007, 197)

Micheaux here acknowledges that conforming to black elitist pressures would produce boring films. Perry likewise recognizes that the entertainment function of cinematic art releases him from the expectation to create characters with the weight of the black race in mind, allowing his films to indulge in featuring what Perry perceives as the good, the bad, and the ugly in representations of black life.

And while Perry's movies are quite normative in offering moral and existential lessons, the filmmaker is careful to avoid easily conceived dogmatic moral schemes. Put another way, Perry's films feature high-functioning respectable Christian characters next to wilder, crazier, marijuana-smoking, alcoholic, dysfunctional ones. Joe, the insufferable brother of Madea, perhaps is Perry's most dreadful character, appearing in several movies as a dirty old man incessantly breaching the boundaries of acceptable discourse. Joe is rude, crude, callous, and conniving; there is no redeemable trait in him. The entertainment function of art allows Perry to implement Joe's behavior without agonizing over racial stereotypes and political concerns. Perry enjoys his artistic freedom to construct Joe as an unprincipled man who is not to be taken seriously. And some of Perry's funniest scenes involve trifling statements and actions brokered by this despicable character.

Like Oscar Micheaux and many black filmmakers, comics, singers, dancers, and writers, Tyler Perry understands that functioning as a curator of black life does not require a commitment to strictly positive representations. The filmmaker also comprehends that such an artistic sanctimony would obstruct his ability to create a full range of black personalities and experiences. So while activist scholars and arbiters of black culture continue to petition for dignified appendages of black representation in film, Perry has no shame in featuring a single parent like Vanessa in *Madea's Family Reunion*, whose two children have different fathers, and Brenda in *Meet the Browns*, whose three children have three different fathers, even at the cost of enduring the charge of supporting stereotypes about African-American women. Similarly, Perry creates a lustful, weed-smoking elderly black woman like Bam in *Madea's Big Happy Family*, without worrying about what his critics might perceive in Bam as black misrepresentation.

Resembling his filmic forefathers Oscar Micheaux and Spencer Williams, Tyler Perry insinuates through his entertainment function of art that racial uplift need not dominate the concern of black filmmakers. Perry claims to have met a lot of wild and crazy people during his childhood years in New Orleans and satirizes those people the same way that a hip-hop artist exaggerates the cadences of street life. Perry understands that hyperbole is part of artistic representation and that it is the imaginative element that adds spice to the enjoyment of such representation. And so it is within Perry's entertainment function of art

that we see the culmination of what philosopher Richard Shusterman (2000) calls the evaluative dimension of art, the acknowledgment that the aesthetic experience is cherished and pleasurable. Watch one of Tyler Perry's romantic comedies in a jam-packed theater, and you will hear the same voracious laughter and vigorous audience responses you might have heard at the premiere of slapstick classics like *Airplane* (1980) and *Caddyshack* (1980). Perry's movies produce visceral responses, tapping into passional dimensions of the aesthetic experience through both the power of humor and the efficacy of existential inspirations. His entertainment function allows him to lampoon religion, satirize Southern tropes and types, and make light of some of life's depressive moments. So while this work overwhelmingly acknowledges Perry's function as a filmic steward of overlooked dimensions of black Southern lives and tropes in the post-soul era, it also recognizes that such a role does not carry the responsibility of speaking for the entire black race and that the entertainment function of art allows for a full range of black representations.

CONCLUSION

Within the filmic textures of Perry's pragmatic deployments of cultural and existential resources reside the mechanisms of his populist appeal among post-soul African Americans. Perry's movies engage the complexities and contradictions of post–civil rights black experiences, simulating the unprecedented economic and educational gains while informing us of the simultaneous deficiencies and vulnerabilities in the form of poverty, housing crises, and drug epidemics. The same way that early race films tackled the significance of urbanization for African Americans within the formation and negotiation of black modern identities during the early to mid-twentieth-century Great Migration (Stewart 2005; Weisenfeld 2007), Tyler Perry's films give shape to urbanized black Southern identities, treat race and religion as intricately interconnected, and offer vital solutions to contemporary problems within the post–civil rights era. Perry's movies are not only lenses through which we can explore undiscovered terrains of our late-modern moment, but also serve as restorative mechanisms to disabuse what he perceives as

the deficits of that very same moment, all while curating its African-American sociocultural and aesthetic artifacts.

Notwithstanding the intricate components of the filmmaker's inimitability, it is important to note that Perry's cinematic popularity is itself a product of post-soul privilege. The path of his intriguing options as a filmmaker is paved not only by race films of the early to mid-twentieth century, but also by the new wave of black cinema pervading the 1990s and 2000s. For example, when Perry embarks upon crafting cinematic representations of the vitality of black spirituality, he has earlier movies like *Jason's Lyric* (1994) and *The Preacher's Wife* (1996) to shape his imagination. Similarly, when Perry depicts urban chaos and the harrowing effects of the drug epidemic on African-American communities and families, he can build on earlier movies like *New Jack City* (1991) and *Dead Presidents* (1995), which explore the megalomania of a power-crazed dealer like Nino Brown and a tragic heroin addict like Skip, respectively. And when Perry creates more sympathetic treatments of drug dealers as young men pressured into the drug game by complex structural factors in *Meet the Browns* and *Madea's Big Happy Family*, he can access a complex character like Roemello Skuggs in *Sugar Hill* (1994) for inspiration.

What I am suggesting is that within Perry's pragmatic depictions of social problems and contemporary black experiences, the Gen X filmmaker did not have to start from scratch; he had a host of films to work from to shape his post-soul imagination. Accordingly, we should not be surprised that the family reunion scene in Perry's second movie, *Madea's Family Reunion*, draws intriguing parallels with the "Jackson Family Reunion Celebration" featured in the urban classic film *Poetic Justice* (1993), and it is no coincidence that both cinematic reunions capture the scene-stealing folk wisdom of characters played by the late poet Maya Angelou. Correspondingly, Perry's decision to feature a struggling black mother and children from Chicago who are revitalized through a relocation to the South and concomitant connections with new Southern relatives (*Meet the Browns*), might have been partly inspired by Maya Angelou's earlier film *Down in the Delta* (1998), in which the protagonist, Loretta Sinclair, and her family leave behind the harrowing streets of Chicago and are reborn in their move to the South and new bonds with Southern relatives.

Similarly, in Perry's first movie, *Diary of a Mad Black Woman*, when Madea goes on a mad rampage in Charles's mansion to destroy Brenda's expensive clothes, the filmmaker no doubt draws dramatic inspiration from Bernie's mad destruction of John's clothes in the movie *Waiting to Exhale* (1995). When Perry creates a character like Candy who suffers damaging abuse by football players that eventually leads to her becoming a prostitute (*Madea Goes to Jail*), the filmmaker pays homage to his legendary predecessor Julie Dash, whose character Yellow Mary in *Daughters of the Dust* (1991) likewise suffers trauma and becomes a prostitute. And it is no accident that Byron's early naïveté in counseling his brothers-in-law with the mantra that love is all that matters in *Madea's Big Happy Family* draws striking similarities with Tanya's simplicity in instructing her ex-boyfriend Roland that love is all that matters to relieve him of wedding day anxieties in the urban classic film *The Wood* (1999).

It is not surprising that Perry's romantic comedies extrapolate nuances from earlier black new wave films like *Love Jones* (1997), *The Best Man* (1999), *Brown Sugar* (2002), and many other cinematic articulations of the post-soul era. Likewise, Perry's existential spirituality owes tremendous debts to larger-than-life spiritual icons of the post–civil rights era, even as the filmmaker adds his own innovative and revisionist contributions. So any discussion of Perry's pragmatic functions of film must acknowledge that Perry is both the product and the producer of an intriguing late-modern pragmatic moment of black cinema and spirituality. But in addition to benefitting from taken-for-granted privileges secured through civil rights struggle, access to sociocultural scenarios depicted in black new wave cinema, and engagement with cultural tools from black modern spirituality, Perry's unique life experiences helped secure personal assets that make him both a post-soul curator of sociocultural changes and a late-modern medicine man of sorts who conjures up existential resources to help his patrons emerge as empowered subjects. Perry may draw inspiration from a post-soul age of cinematic achievement, but his artistry stands by itself as offering groundbreaking contributions and unprecedented achievements.

Bishop T. D. Jakes, Oprah Winfrey, and Tyler Perry—perhaps the three most famous African Americans alive whose names are not Barack and Beyoncé—offer pragmatic artistic templates for spirituality and ex-

istential redemption. All three pop-cultural icons come from humble beginnings, have extensive familial ties to the South, were exposed to the cadences of black Protestant churches at an early age, and draw on those intriguing elements of their trajectories to blend the worlds of spirituality and artistry. All three offer the nexus of entertainment and educational instruction and propose new ways to consider the pragmatic virtues of art and self-actualization within our late-modern social geographies. All three serve as signposts of post–civil rights black entrepreneurial fervency through their keen ability to commodify spirituality and pragmatic assets. And all three serve as existentialists at heart who offer patrons safe spaces for rigorous self-therapy. Hence if Jakes, Winfrey, and Perry are able to generate intensely loyal followings by addressing the needs and tastes of the masses, then it logically follows that their fans are an impressive constellation of evaluators and consumers of art who are intent on maximizing their moments, to borrow a phrase from Bishop Jakes.

While many media scholars analyze black popular culture from the vantage point of racial, gender, and neo-Marxist representational politics, fewer scholars consider the pragmatic assets exhibited by pop-cultural icons toward drawing patronage and popularity. More specifically in the context of Perry's filmic career, with a few exceptions (Coleman and Williams 2013; Persley 2013) scholars are incurious as to why Perry's films are so appealing to his largely African-American patronage. And the rare moments some scholars do show interest as to why Perry draws so many African Americans to his artistry, they offer condescending theories alluding to alleged pathologies of Perry's patrons. In this way, the needs and tastes of Perry's loyal fan base are not taken seriously when they are problematized rather than respected and strategically assessed. As Nicole Hodges Persley aptly asserts against hasty dismissals of Perry's movies, "little consideration is given for the ways that poor and working-class blacks have spoken what is important to them by using their economic and community resources (such as black media outlets) to support the director's works" (2013, 224). So rather than dispatching patronizing overtures toward Perry's audiences, this study is keenly invested in assessing the ways that Perry's movies deploy pragmatic assets for his patrons and appeal to their needs and tastes.

Like neo-Pentecostal worship services and hip-hop sound tracks, Perry's films provide sustained discursive ground for the post-soul

intersection of class, religion, and existential well-being; articulate and rearticulate the changing contours of black modern metropolitan living; and attempt to help patrons negotiate their environments and renegotiate their identities with agency and clarity. And so it is befitting that a neo-Pentecostal spiritual superstar like Bishop T. D. Jakes, a hip-hop artist like Lil Wayne, and a filmmaker like Tyler Perry all function as pragmatist informants on late-modern African-American triumphs and tragedies in diverse ways. They offer uniquely calibrated visions of black identities within our sight-and-sound social geographies, demonstrating that perhaps mega churches, hip-hop CDs, and movies resonate with millions of contemporary African Americans precisely when they present strategic synergies between black cosmopolitan life and cherished folk sensibilities.

Assuming that church attendees, hip-hop fans, and movie patrons are for the most part rational actors, we can see how Bishop Jakes's ability to draw thirty thousand members to his congregation, Lil Wayne's platinum-selling CDs, and Tyler Perry's impressive filmic patronage are the result of strategic assets wielded by these three pop-cultural icons to appeal to the needs and tastes of their clients. And those assets do not come out of nowhere but are the offspring of cultural tools acquired while matriculating through early years as a coal-mining preacher in West Virginia, as an urban kid roaming the streets of Holly Grove, and as another New Orleans native answering Oprah's call to chronicle his pain through writing. And so we should acknowledge that Tyler Perry's appeal calls for the artistic creation of continuous links to the humble origins, folk-cultural dynamism, and populist passions that inspire the best of black preaching and hip-hop ingenuity.

Perry's characters and plots reveal what he perceives as the cynicism, greed, and constraints of late-modern life as well as the naïveté of a drug dealer like Jamison Jackson, who believes he can rule the world with a bag full of money (*Diary of a Mad Black Woman*). I can imagine Woody Allen arguing that there is a little bit of Jamison Jackson in all of us, a desire to fix our lives by striving for an illusion. Allen alludes to this theme in two of his recent movies, *You Will Meet a Tall Dark Stranger* (2010) and *Midnight in Paris* (2011), pressing forth the idea that humans naively assume certain goals and attainments can secure ultimate happiness. Allen makes it an identifiable marker of our humanity to create illusions by which we define absolute formulas for personal hap-

piness, and his movies explode these myths, unfolding how life is not retrofitted with simple formulas that guarantee happiness. And we can presume that Allen learned much on this matter from his favorite filmmaker Ingmar Bergman, whose works often expose the human capacity for chasing after illusions. Indeed, perhaps Lauren Berlant's (2011) concept of cruel optimism has much in common with illusion-chasing because Bergman, Allen, and Berlant all depict in vivid detail how illusions bite back and complicate life for the pursuers.

Like Ingmar Bergman, Woody Allen, Lauren Berlant, and perceptive filmmakers like Julie Dash and Ava DuVernay, Tyler Perry perceives illusion-chasing as a fundamental dimension of human angst. Perry's movies demonstrate that illusions eventually evaporate, and then humans have to handle the harsh realities of their predicaments. In *Diary of a Mad Black Woman*, for Jamison and Charles the illusion is the nexus of money, power, and success, while for Helen and Debrah the illusion resides in their early fantasy of being swept away by rich husbands. For Andrea the illusion is enjoining herself to the power and privilege of the Cartwright family (*The Family That Preys*). For Jennifer the illusion is seeking power and riches as the partner of a drug kingpin at the expense of her own integrity and her children's well-being; in the same movie, for Julia the illusion is losing herself in the expectations of her friends and father at the cost of learning how to live for her own happiness (*Daddy's Little Girls*). For Wesley Deeds the illusion is captured in the double entendre of the movie's title (*Good Deeds*), alluding to the troubled protagonist's incessant quest to be "good" in hopes of satisfying everyone else's expectations for his life at the expense of fulfilling his own dreams. All of the preceding characters suffer existential or physical wounds as a result of their illusions.

Sociologist Karyn Lacy (2007) explores the complexities and tensions of identity formation regarding high-earning subjects she calls blue-chip blacks who also reside in Southern communities. If Lacy provides a new hermeneutical framework toward explicating the black elite's cultural repertoire, Perry shows us the dangers that arise when that cultural repertoire fails to draw from the rich folk-cultural tool kit that sustained black communities for generations. Both Lacy and Perry are on a quest to understand black elites' engagements with modern capitalist parameters: Lacy focusing on the diversity and deepening divisions,

Perry on the developing deficits of illusion-chasing, bourgeois con-
straints, and blind ambition.

While media often portray working-class blacks as problematic and
scholarly studies often depict the black lower classes in terms of their
vulnerabilities and deficiencies, Tyler Perry insists on exploring the aes-
thetic beauty and existential power of black working-class lives and
cultures. Whenever we see Monty, he's surrounded by the familial
warmth and comfort of a black working-class community, an aesthetic
component that Perry himself discusses in his commentary for the
DVD for *Daddy's Little Girls*: "I wanted it to have a sense of commu-
nity, a sense of family. I wanted people who are watching the movie to
see that this little small community is very tight-knit and they are very
supportive one to another." The movie's opening scene offers a pano-
ramic view of the aesthetic beauty of this humble working-class com-
munity and the movie's last scene ends in a triumphant communal
celebration, with Monty hailed as a heroic figure. Willie, an elder states-
man of that very same community, offers an impromptu speech that
retells the rich folk-cultural legacy of their humble Atlanta locality,
affirming its longstanding tradition of communal awareness and acti-
vism.

In *Madea's Family Reunion*, the working-class hero Frankie likes his
blue-collar job, has artistic outlets through his drawings, dotes on his
son, and gladly enters a new relationship with his working-class
counterpart Vanessa. Frankie is a self-identified Christian who pro-
claims to Vanessa that not all men are solely interested in her body—
"some men come to restore"—to dispel her suspicions that he might be
displeased with her commitment to celibacy. All of Vanessa's life she
has come to see men as exploiters, as individuals unworthy of trust, and
Perry uses Frankie as a symbol of the honor and integrity of black folk
culture, which often takes hits by the media and the black intelligentsia
in real life. Vanessa herself is a strong, confident, caring mother who
loves life and cherishes her children even if she is unable to spoil them
with material possessions. And in the family reunion scene, Myrtle of-
fers a passionate plea to her family to reconnect to the dignity and
strength of their humble origins rooted in slavery and generations be-
yond. Perry, a true populist at heart, uses his movies to counterbalance
the misguided message that all has gone wrong in black working-class
realities.

More vividly and expansively, Perry's movies challenge the naive assumptions that materialism and professionalism position African Americans in line for more fulfillment. Whether it is Brenda and her longsuffering family in *Meet the Browns*, Helen and her redemptive journey as a waitress falling in love with a steel plant worker in *Diary of a Mad Black Woman*, Monty the loving father and happy mechanic in *Daddy's Little Girls*, Alice the cheerful Christian owner of a small diner, or Lindsey the agentive janitor in *Good Deeds*, Perry's cinematic vision goes beyond problematizing the particularities of the black urban struggle to take crucial steps toward humanizing and even idealizing the strength, courage, and existential health of black working-class individuals who live happy and fulfilled lives despite their lack of material excess. Carlos may be rich, drive a fancy car, and live in a luxury condo, but his working-class counterpart Frankie appears happier and much more fulfilled in his relationship to Vanessa in *Madea's Family Reunion*.

Whereas a classic film like *Bonjour Tristesse* (1958) could mock the blueblood privilege and aimless living that occurs on the French Riviera without fear of reprisal, Perry catches much heat when he offers social satire on what he perceives as the excesses and interior weaknesses of black elites. Perry's cinematic choice to show that upper-status African Americans too need cultural and existential retooling and that working-class blacks can loan them the requisite tools for the task exhibits a rousing populism that many critics find discomforting. Perry's movies are not only creative representations of cultural developments within post–civil rights black experiences but, more importantly, serve as populist revisionist projects on what the filmmaker believes it means to be healthy and whole within our late-modern moment. Put more simply, Perry functions as a cinematic curator of black modern lives and a healer of black modern pains.

APPENDIX

Tyler Perry and the Social Import of Film

This work presents Tyler Perry's oeuvre as an intriguing intersection of race, religion, class, and culture and shows how facets of his cinematic vision lend interpretive insights toward gaining a better understanding of this post-soul epoch. Such an exploration fits nicely within a thriving paradigm in cinema studies that focuses on the social import of film. Whereas film scholars before the 1970s were less concerned with the sociological or philosophical dimensions of cinematic texts (Stoehr 2002), and more engrossed with film's aesthetic features, newer generations of film scholars have been more apt to recognize film's social and representational dimensions (Nichols 2010). As cinema became more personal and self-aware during its neo-realist and new waves, cinema studies responded by shifting its focus more toward seeing cinema as a site for the articulation of sociocultural, political, racial, sexual, and class identities.

Aptly recognizing the social potency of filmic content, scholars have tackled cinema as a means to explore the power of the male gaze (Mulvey 1975; Kaplan 1983), feminism and psychoanalysis (Creed 1993), the dimensions and regulations of the female social subject (de Lauretis 1994; Staiger 1995), critical debates in women's filmmaking (Butler 2002), the role of women theorists (Thornham 1997), neo-feminist cinema (Studlar 1988; Radner 2011), and a host of related issues concerning feminist film criticism. Similarly, works documenting film's repre-

sentational abuses and stereotypes among, for instance, Latinos (Frego-
so 1993; Richard 1994; Berg 2002), Asian Americans (Feng 2002), Na-
tive Americans (Churchill 1998; Kilpatrick 1999), and lesbians (White
1999) along with general analyses on identity and the hegemonic strug-
gle over race (Bernardi 1996, 2009) demonstrate how the contemporary
paradigm for cinema studies navigates a broad constellation of sociolog-
ical, philosophical, and critical discussions on representational politics
and social inequality.

Scholarly works that address African-American representation and
identity in American cinema are among the earliest and most influential
studies within this paradigmatic shift to the social emphasis of film.
Daniel Leab's (1973) groundbreaking tome analyzes over two thousand
films to trace a historical progression of black stereotypes in film, and
Donald Bogle (1973) reveals the consistent lack of dimensionality in
generations of black representation in film. Both works set an early
course for contemporary scholars to expound on the social and racial
facets of filmic representation. Thomas Cripps (1993) carefully eluci-
dates how black depictions in film helped to reconceptualize American
perceptions on race, and Mark Reid (1993) distinguishes black inde-
pendent films that embody sociopolitical and structural changes im-
pacting social conditions of African-American lives from black commer-
cial films that have no direct connections to real-life conditions in black
communities. Ed Guerrero (1993) shows how Hollywood utilizes a col-
onizing technology of black racial narratives to mediate how audiences
perceive race and class. S. Craig Watkins (1998) explores the nexus
between black cultural production and the cinematic sociocultural
imagination and explicates how symbolic practices projected through
film and media affect black youth cultural practices. Gladstone Year-
wood (2000) unpacks how filmmakers exercise expressive technologies
of signification corresponding to the vagaries of African-American expe-
riences.

Paula Massood (2003) offers the urban city as important terrain to
explore cinema's social dimensions, and Jacqueline Stewart (2005) of-
fers cinema as a means to explore the multilayered racial politics in the
urban city. Yvonne Sims (2006), Stephane Dunn (2008), bell hooks
(2008), and Mia Mask (2009) bring sexual politics and gender represen-
tation into play in assessing black female filmic depictions in contempo-
rary cinema. Celeste Fisher (2006) studies audience reception of black

urban films, Cedric Robinson (2007) reveals the link between the imperative to secure financial capital and the way movies proliferate racial narratives, and Dan Flory (2008) establishes how black noir films provide viewers with enhanced cultural toolkits to renegotiate their perspectives on race and social inequality. Ryan Jay Friedman (2011) shows how early black films embodied changes that challenged preexisting technologies of mass culture, disputing the popular notion that such films failed to cope with the sociopolitical complexities and divergences of the early twentieth century. Robin Means Coleman (2011) discloses how African-American integration into the horror genre has important social and cultural implications regarding the politics of representation and the arbitration of and resistance against dominant ideologies. Zandria Robinson (2014) shows there is much to be learned about contemporary black Southern identities from their populist constructions in film. All of the preceding works offer impressive evidence that studies on black representations in film are major sites for the articulation of film's social import.

Tyler Perry's America: Inside His Films converges three promising directions within the broader discussion of black cinematic representation and the social import of film, demonstrating the potential of black films as (1) windows through which we may gain a clearer understanding of modern identities, (2) sites for exploring the nexus of religion and film, and (3) fertile terrain for existential contemplation. The first dimension is informed by Jacqueline Stewart's (2005) pioneering work, uncovering the ways in which black representations in cinema serve as mechanisms for detecting and dissecting black modern identities. The second draws inspiration from Judith Weisenfeld (2007), exploring black filmic representations as sites for the convergence of religion and film, and the third examines the as-yet-uncharted ways in which black filmic content offers contexts for existential contemplation.

MODERN IDENTITIES

My assertion that Tyler Perry's movies are windows through which we can assess the changing contours of black modern identities finds its snuggest fit within the quest of the new cinema studies paradigm for interpretive understanding as to how movies are themselves the arti-

facts of modern ingenuity and repositories of modern spatial and temporal articulations (Gunning 1995; Burch 2001); mediate modern experiences and function as iterations of futuristic shocks and technological transcendence (Fischer 2006; Gunning 2006); offer new modes of modern music (Gabbard 2006); disclose broad social, economic, and cultural transformations (Charney and Schwartz 1995); engage in humanist interpolations on the triumphs and challenges of our modern moment (Cavell 2005); provide imaginative looks at the significance of urbanization for African Americans within their ongoing negotiations with modern identities and at the vagaries of African Americans functioning as equal players in modern society (Stewart 2005; Weisenfeld 2007); and make viewers more amenable to modern change while engaging modernity in all its intricate dimensions (Orr 2001). Tyler Perry's films contribute to this rich filmic tradition by exploring social, religious, and aesthetic dimensions of what it means to be black and modern in the post-soul era.

Comparable to how the early-twentieth-century expressionist filmmaker Fritz Lang offered movies that provided insight on the escalation of modern urban spaces, the menace and potential of modern technology, the character and quality of modern tyrannical political regimes, and the modern interruption of traditional transcendental values (Gunning 2008), Tyler Perry's films mediate the messiness of this late-modern era, unfolding in cities and explicating such diverse black working-class vulnerabilities as problems of poverty, loss of manufacturing jobs, the quest for affordable housing, the pesky conundrum of homelessness, the struggle for affordable day care, the trauma of sexual assault, and the lingering impact of drugs on both those individuals who sell them and those who succumb to addiction.

The same way that pioneer black filmmakers like Oscar Micheaux and Spencer Williams provide a panoramic view of both the promise and deficits of black modern identities during the pre–civil rights era (Stewart 2005; Jackson 2011), Perry's movies maneuver black modern identities against the backdrop of post–civil rights struggles and successes, socio-religious innovations and complexities, and folk-modern continuities and contradictions. The same way Spike Lee's films expose the depths of social inequality and racial oppression within late-modern black urban experiences, Perry's movies critique modern myths of American progress by demonstrating how increasing levels of social

mobility for some African Americans are juxtaposed to dim prospects for others. Just as Ava DuVernay's films address complex familial negotiations within the paradoxes and tensions of the post–civil rights epoch, Perry's movies offer artistic templates on how the torrential tides of modern momentum come crashing up against black identities and social relationships.

Like the neo-Pentecostalism of his early church membership, the dynamism of his hometown New Orleans, and the volatile strands of his social geography in the age of mass media, Perry's cinematic artistry offers intriguing polarities between the old and the new, the folk and the urbane, post–civil rights black promise and black urban disintegration, theistic governance and humanism, rugged individualism and communal solidarity. Perry's movies are also modern in how they are deeply personal, pushing patrons to ask penetrating questions about their relationships to their families, religion, future, and overall happiness. And similar to how Ousmane Sembène and a coterie of filmmakers forged a new wave of African cinema as an important sociocultural site for negotiating old African ideas and traditions against a mandate for new modern African representation (Ukadike 1994), Perry presents cinema as a means to make sense of a rich African-American folk-cultural past juxtaposed to the promise of modern ingenuity and urban sophistication. Hence, Perry's themes and plots occupy titillating spaces within our contemporary ruminations on whether we are brokering a postmodern reprieve from modern momentum or if being modern itself has dimensions to its efficacy that play out like postmodern interpolations.

Whereas the French sociologist Bruno Latour (1993) asserts that the West has never been modern, Tyler Perry's retort would sound much like the earlier assessment of German philosopher Jürgen Habermas (1981) that the West, although admittedly modern, is not modern enough. And Perry's indecisive and paradoxical engagement with modern ideas and ideals finds much in agreement with Habermas's later depiction of modernity as a tense cultural combination of contradictory elements (Habermas 2002) as well as with Anthony Giddens's (1991) and Christian Metz's (2001) understanding of the modern moment as laced with ambiguity and ambivalence. Perry shows how medicinal components of black folk culture can recalibrate modern thinking and living toward what the filmmaker perceives to be more healthy aims.

But his movies are also modern in how they offer biting critiques against social conformity as well as the ways in which his plots deemphasize (or eliminate) supernatural activity.

RELIGION AND FILM

A second new direction in the social import of film approaches the complex ways in which religion (and theology) fuses with film to complicate our understanding of contemporary identities. This burgeoning trend offers new judgments concerning the similarities between the underlying structures of religion and the formal elements of film (Plate 2008); the emergence of the Christian film industry (Lindvall and Quicke 2011); sociological perspectives on religious symbolism in films (Bergesen and Greeley 2003); the multivariate ways religious faith and philosophy converge in cinematic texts (Geivett and Spiegel 2007); how the rearticulation of religious representation shapes technologies of race (Weisenfeld 2007); and how secular movies accomplish religious functions in contemporary American society (Lyden 2003), have religious impact on Latin American viewers (Brant 2012), and facilitate dialogues and strategic partnerships between theology and contemporary culture (Marsh and Ortiz 1997; Deacy 2005; Deacy and Ortiz 2008). Scholars are gradually recognizing that film has much to say and show when representing the religious dimensions of sociocultural identities, but unfortunately this exciting new trend in cinema studies is almost silent concerning African-American representations of religion in film.

For example, *The Routledge Companion to Religion and Film* (Lyden 2009) omits African-American religious representations and identities from its formative analyses. The anthology's thoughtful chapter on Islam and Muslim lives in film (Hussain 2009) fails to mention Spike Lee's provocative movie *Malcolm X* (1992), which depicts the formation and explosive influence of the Black Muslim movement in America. Similarly, the anthology's chapter on treatments of Christianity in film (Detweiler 2009) references almost two hundred films without discussing mainstream black religious films like *The Preacher's Wife* (1996) or any of Tyler Perry's movies and other films that converge Christian themes with black representations. Such omissions confirm that scholars often overlook black religions and representations within their treat-

ments of the nexus of religion and cinema. What contributes to this gap is the fact that scholars who study black religions or black theologies don't say much about cinema, while scholars of black cinema give diminutive attention to black religious practices and perspectives. Religious representation is a crucial mechanism of black modern identities (Meyer 2003, 2009), as well as folk-cultural nostalgia (Best 2005), and hence scholars of film would benefit immensely by paying greater attention to the ways in which cinematic representations of black religious cultural tools are rich parts of post–civil rights black identities and experiences.

And so this exploration of Perry's movies owes a large debt to Judith Weisenfeld (2007) for offering the first book-length treatment of religion and African-American representation within American films. Studying films from the 1920s to the 1940s, Weisenfeld addresses the ways in which black-audience films of this era reveal how religion was a crucial variable in the negotiation of tradition and modernity. These so-called race films, Weisenfeld informs us, wrestled with a complex array of social matters within black communities, including the rise of secular entertainments, anxieties about commercial cultures, and the growing criticism of corrupt clergy. Building on Weisenfeld's tremendously useful study, I argue that Tyler Perry's films establish new identity formation parameters regarding the nexus of black religion with cinema in ways that inform our understanding of post-soul black modern identities. Contemporary black religion offers Perry a populist lens through which to envision artistic identities in response to modern change. Perry's artistry exudes the cadences of the South and Southern religion while simultaneously reflecting modern modulations. His deep connections to and familiarity with black neo-Pentecostal churches, leaders, and networks offer a repository of cultural tools to utilize when capturing the nuances of post-soul religious vitality.

Tyler Perry's movies also extrapolate from less-alienating strands of Protestant sensibilities and accordingly stand in stark contrast to the thick evangelical sanctimony of Eloyce and James Gist's early films, which were replete with fire-and-brimstone exhortations to get right with God. Perry's Christian characters, for the most part, conform their lives and behaviors to pragmatic principles of healthy living rather than preoccupying themselves with mechanical adherence to biblical dictates. Perry's relational religion and pragmatic faith resonate with a

broad stream of post-soul African-American perspectives that too are the product of the sight-and-sound generation, media explosions of ideas and social tapestries, and the eclectic spirituality of Oprah Winfrey and neo-soul singers like Erykah Badu.

Analogous to how the legendary Swedish director Ingmar Bergman's films offer an ambivalent interconnection between uncompromised faith and materialistic secularity (Orr 2014), Perry's movies synthesize secular elements, perspectives, and technologies as modernity-confronting composites of black folk-religious embrace. To be modern and Christian is not necessarily a compromise or contradiction to either commitment from Perry's vantage point, even though some of his modern mollifications may be disconcerting to more conventional Christians. Perry's films capture contemporary changes in Christian cultures, styles, and perspectives, while finessing dialogues displaying how Christians make sense out of the secularity of their modern worlds. So if certain black churches and preachers are especially proficient at setting the sails of an ancient Near Eastern Christian faith to navigate the swells of late-modern momentum (Harrison 2005; Lee 2005; Lee and Sinitiere 2009; Walton 2009), then Perry is a filmic captain of that recalibration.

Perry's cinematic attention to spiritual formations and expressivities in black church cultures captures post-soul nuances that are too often ignored in mainstream cinema as well as in scholarly expositions on post-soul aesthetics (Tate 1992; Neal 2002; George 2004). The filmmaker figured out a way to be both a custodian of black religious artifacts and an existentialist who fleshes out the penetrating psychic and social implications of religious perspectives in tension. This makes Tyler Perry an intriguing recapitulation of gospel music pioneer Thomas Dorsey and Swedish filmmaker Ingmar Bergman all rolled up into a contemporary package of folk-modern religion and existential angst. Perry offers a pragmatic spirituality that is light on doctrine and heavy on experience, light on obtrusive stipulations and heavy on self-actualization. So in addition to presenting African-American cinema as a site for the negotiation and renegotiation of black modern identities and the nexus of religion and film, this study also taps into a third important direction for the social import of film: the uncharted scholarly treatment of black cinema as a site for existential contemplation.

EXISTENTIAL REFLECTION

While existentialism in film is a budding segment of cinema studies, there are no works that explicitly explore the existential potential of black films or black representation in films. For example, the anthology *Movies and the Meaning of Life* (Blessing and Tudico 2005) offers careful explorations of the existential and philosophical dimensions of nineteen movies, none of which have a black cast or context, and only one (*Pulp Fiction*) has a black character of import. Similarly, Falzon's (2007) work on philosophy and film references scores of movies without engaging one with a majority African-American cast, while Pamerleau's (2009) insightful book-length treatment on the existential potential of film does not make mention of any black films or characters. Film scholars have been reticent about how Michael Roemer's *Nothing But a Man* (1964), Charles Burnett's *Killer of Sheep* (1977), Julie Dash's *Daughters of the Dust* (1991), Ava DuVernay's *I Will Follow* (2010), and many other masterworks confirm that black cinema is fertile terrain for existential contemplation. Hence, this analysis of Tyler Perry's oeuvre provides an overdue exploration of the existential import of black representations in film.

Probing deep philosophical issues regarding the human condition, Tyler Perry functions as an existential detective of sorts, not unlike the gurus that the protagonist Albert Markovski hires to unravel the turmoil in his life in David O. Russell's movie *I Heart Huckabees* (2004). Perry learned a simple anthropological truism from his own troubled childhood, early years in church, and longstanding love of gospel music: that art and spirituality can be tactically attuned to provide assets toward self-examination and self-actualization. Perry's films are replete with scenes confronting and renegotiating what it means to be human and free, attempting to empower patrons to hear their own voices and to harness their environments in the midst of constricting social, corporate, and familial pressures. Too often we reduce such existential concerns to European intellectualizing in French cafés, but Perry broadens our understanding of how contemporary African-American art and religion are just as capable of offering complex existential gradations as the provocative writings of Jean-Paul Sartre and Simone de Beauvoir or the celebrated novels of Fyodor Dostoyevsky and Albert Camus.

Tyler Perry contextualizes late-modern life in ways that reveal the existential deficits of privilege and reckless ambition. We see this in *Diary of a Mad Black Woman* with Charles's misguided pressure for Helen to isolate herself from her working-class family; we see it in *Madea's Family Reunion* with Victoria's unrelenting pressure on her daughter Lisa to sacrifice her physical well-being to secure a life of privilege by marrying an abusive yet rich and successful man; we see it in *Good Deeds* with Wesley's burden of living his father's dream and his mother's meticulous management of that burden; and we see it in *Madea Goes to Jail* with Linda's pressure on her fiancé, Joshua, to disconnect himself from his humble past. Perry constructs the existential costs of black privilege and ambition, and shows how black working-class guides offer the redemptive capacities to chart one's own vision toward a peaceful and willful existence.

FILMOGRAPHY

TYLER PERRY'S FILMS IN THIS STUDY

Diary of a Mad Black Woman (2005)
Madea's Family Reunion (2006)
Daddy's Little Girls (2007)
Why Did I Get Married? (2007)
The Family That Preys (2008)
Meet the Browns (2008)
I Can Do Bad All by Myself (2009)
Madea Goes to Jail (2009)
Why Did I Get Married Too? (2010)
Madea's Big Happy Family (2011)
Good Deeds (2012)

OTHER FILMS CITED

Within Our Gates (1920)
Body and Soul (1925)
The Jazz Singer (1927)
Hellbound Train (1929)
The Black King (1932)
The Goddess (1934)
Symphony in Black: A Rhapsody of Negro Life (1935)
While the Patient Slept (1935)

The Wizard of Oz (1939)
The Blood of Jesus (1941)
Go Down, Death! (1944)
Dirty Gertie from Harlem, USA (1946)
Juke Joint (1947)
Possessed (1947)
Key Largo (1948)
Pinky (1949)
Souls of Sin (1949)
Senso (1954)
Bonjour Tristesse (1958)
Nothing But a Man (1964)
I Am Curious (Yellow) (1967)
The Madwoman of Chaillot (1969)
Super Fly (1972)
Coffy (1973)
Sleeper (1973)
Touki Bouki (1973)
Foxy Brown (1974)
Hester Street (1975)
Mahogany (1975)
In the Realm of the Senses (1976)
Killer of Sheep (1977)
Airplane (1980)
Caddyshack (1980)
The Chosen (1981)
The Brother from Another Planet (1984)
The Color Purple (1985)
Women on the Verge of a Nervous Breakdown (1988)
Crimes and Misdemeanors (1989)
Misery (1990)
New Jack City (1991)
Daughters of the Dust (1991)
The Quarrel (1991)
Thelma and Louise (1991)
Malcolm X (1992)
Poetic Justice (1993)
Above the Rim (1994)

Jason's Lyric (1994)
Pulp Fiction (1994)
Sugar Hill (1994)
Dead Presidents (1995)
Waiting to Exhale (1995)
Breaking the Waves (1996)
The Preacher's Wife (1996)
Love Jones (1997)
Down in the Delta (1998)
The Best Man (1999)
Compensation (1999)
The Wood (1999)
Brown Sugar (2002)
G (2002)
The Pianist (2002)
I Heart Huckabees (2004)
Woman Thou Art Loosed (2004)
Opium: Diary of a Madwoman (2007)
Welcome Home, Roscoe Jenkins (2008)
Not Easily Broken (2009)
A Serious Man (2009)
I Will Follow (2010)
You Will Meet a Tall Dark Stranger (2010)
Jumping the Broom (2011)
Midnight in Paris (2011)
Pariah (2011)
Broken Kingdom (2012)
Joyful Noise (2012)
Red Hook Summer (2012)
Savages (2012)
Oh My God (2013)
Temptation: Confessions of a Marriage Counselor (2013)

REFERENCES

Alexander, Michelle. 2010. *The New Jim Crow: Mass Incarceration in the Age of Colorblindness*. New York and London: The New Press.

Anderson, Elijah. 1999. "The Social Situation of the Black Executive: Black and White Identities in the Corporate World." In *The Cultural Territories of Race*, edited by Michele Lamont, 3–20. Chicago: University of Chicago Press.

Barnes, Sandra. 2005. *The Cost of Being Poor: A Comparative Study of Life in Poor Urban Neighborhoods in Gary, Indiana*. Albany: State University of New York Press.

Berg, Charles Ramirez. 2002. *Latino Images in Film: Stereotypes, Subversion, Resistance*. Austin: University of Texas Press.

Bergesen, Albert J., and Andrew Greeley. 2003. *God in the Movies*. New Brunswick, NJ, and London: Transaction.

Berlant, Lauren. 2011. *Cruel Optimism*. Durham, NC: Duke University Press.

Bernardi, Daniel. 1996. "Race and the Emergence of U.S. Cinema." In *The Birth of Whiteness: Race and the Emergence of U.S. Cinema*, edited by Daniel Bernardi, 1–11. New Brunswick, NJ: Rutgers University Press.

———. 2009. "Different Visions, Revolutionary Perceptions: Race, Gender, and Sexuality in the Work of Contemporary Filmmakers." In *Filming Difference: Actors, Directors, Producers and Writers on Gender Race, and Sexuality in Film*, edited by Daniel Bernardi, 1–13. Austin: University of Texas Press.

Best, Wallace D. 2005. *Passionately Human, No Less Divine: Religion and Culture in Black Chicago, 1915–1952*. Princeton, NJ, and Oxford: Princeton University Press.

Blessing, Kimberly, and Paul Tudico. 2005. *Movies and the Meaning of Life: Philosophers Take on Hollywood*. Chicago: Open Court.

Bogle, Donald. 1973. *Toms, Coons, Mulattoes, Mammies, and Bucks: An Interpretive History of Blacks in American Films*. New York: Continuum.

Bonilla-Silva, Eduardo. 2013. *Racism without Racists: Color-Blind Racism and the Persistence of Racial Inequality in America*. Lanham, MA: Rowman & Littlefield.

Brant, Jonathan. 2012. *Paul Tillich and the Possibility of Revelation through Film: A Theoretical Account Grounded by Empirical Research into the Experiences of Filmgoers*. Oxford and New York: Oxford University Press.

Brontë, Charlotte. [1847] 2009. *Jane Eyre*. Reprint edition. Radford, VA: Wilder Publications.

Brundage, W. Fitzhugh. 2011. "Working in the 'Kingdom of Culture': African Americans and American Popular Culture, 1890–1930." In *Beyond Blackface: African Americans and the Creation of American Popular Culture, 1890–1930*, 1–42. Chapel Hill: University of North Carolina Press.

Brunious, Loretta. 1998. *How Black Disadvantaged Adolescents Socially Construct Reality: Listen, Do You Hear What I Hear?* New York and London: Garland Publishing.

Burch, Noel. 2001. "Spatial and Temporal Articulations." In *Post-war Cinema and Modernity: A Film Reader*, edited by John Orr and Olga Taxidou, 66–75. New York: New York University Press.

Butler, Alison. 2002. *Women's Cinema: The Contested Screen*. London and New York: Wallflower.

Cavell, Stanley. 2005. "What (Good) Is a Film Museum? What Is a Film Culture?" In *Cavell on Film*, edited by William Rothman, 107–14. Albany: State University of New York Press.

Charney, Leo, and Vanessa Schwartz. 1995. "Introduction." In *Cinema and the Invention of Modern Life*, edited by Leo Charney and Vanessa Schwartz, 1–12. Berkeley and Los Angeles: University of California Press.

Churchill, Ward. 1998. *Fantasies of the Master Race: Literature, Cinema and the Colonization of American Indians*. San Francisco: City Lights Books.

Coleman, Robin Means. 2011. *Horror Noire: Blacks in American Horror Films from the 1890s to Present*. New York and London: Routledge.

Coleman, Robin Means, and Timeka N. Williams. 2013. "The Future of the Past: Religion and Womanhood in the Films of Tyler Perry, Eloyce Gist, and Spencer Williams, Jr." In *Interpreting Tyler Perry: Perspectives on Race, Class, Gender, and Sexuality*, edited by Jamel Santa Cruze Bell and Ronald L. Jackson II, 152–65. New York and London: Routledge.

Creed, Barbara. 1993. *The Monstrous-Feminine: Film, Feminism, Psychoanalysis*. New York and London: Routledge.

Cripps, Thomas. 1993. *Making Movies Black: The Hollywood Message Movie from World War II to the Civil Rights Era*. New York: Oxford.

Deacy, Christopher. 2005. *Faith in Film: Religious Themes in Contemporary Cinema*. Burlington, VT: Ashgate.

Deacy, Christopher, and Gaye Williams Ortiz. 2008. *Theology and Film: Challenging the Sacred/Secular Divide*. Malden, MA: Blackwell Publishing.

de Lauretis, Theresa. 1994. "Rethinking Women's Cinema: Aesthetics and Feminist Theory." In *Multiple Voices in Feminist Film Criticism*, edited by Diane Carson, Linda Dittmar, and Janice R. Welsch, 140–61. Minneapolis: University of Minnesota Press.

Detweiler, Craig. 2009. "Christianity." In *The Routledge Companion to Religion and Film*, edited by John Lyden, 109–30. London and New York: Routledge.

Dewey, John. 1934. *Art as Experience*. New York: Penguin Group.

Duneier, Mitchell. 1992. *Slim's Table: Race, Respectability, and Masculinity*. Chicago and London: University of Chicago.

Dunn, Stephane. 2008. *"Baad Bitches" & Sassy Supermamas: Black Power Action Films*. Urbana and Chicago: University of Illinois Press.

Falzon, Christopher. 2007. *Philosophy Goes to the Movies: An Introduction to Philosophy*. New York: Routledge.

Feng, Peter X. 2002. "Introduction." In *Screening Asian Americans*, edited by Peter X Feng, 1–18. New Brunswick, NJ: Rutgers University Press.

Fischer, Lucy. 2006. "The Shock of the New: Electrification, Illumination, Urbanization, and the Cinema." In *Cinema and Modernity*, edited by Murray Pomerance, 19–37. New Brunswick, NJ, and London: Rutgers University Press.

Fisher, Celeste. 2006. *Black on Black: Urban Youth Films and the Multicultural Audience*. Lanham, MD: Scarecrow Press.

Flory, Dan. 2008. *Philosophy, Black Film, Film Noir*. University Park: Penn State University Press.

Forbes, Camille. 2008. *Introducing Bert Williams: Burnt Cork, Broadway, and the Story of America's First Black Star*. New York: Basic Civitas.

Frazier, E. Franklin. 1957. *Black Bourgeoisie: The Rise of a New Middle Class in the United States*. New York: Collier Books.

Fregoso, Rosa Linda. 1993. *The Bronze Screen: Chicana and Chicano Film Culture*. Minneapolis and London: University of Minnesota Press.

Friedman, Ryan Jay. 2011. *Hollywood's African American Films: The Transition to Sound*. New Brunswick, NJ, and London: Rutgers University Press.

Gabbard, Krin. 2006. "Miles Davis and the Soundtrack of Modernity." In *Cinema and Modernity*, edited by Murray Pomerance, 155–74. New Brunswick, NJ, and London: Rutgers University Press.

Geivett, R. Douglas, and James Spiegel, eds. 2007. *Faith, Film and Philosophy: Big Ideas on the Big Screen*. Downers Grove, IL: IVP Academic.

George, Nelson. 2004. *Post-soul Nation: The Explosive, Contradictory, Triumphant, and Tragic 1980s as Experienced by African Americans (Previously Known as Blacks and Before That Negroes)*. New York: Penguin Books.

Giddens, Anthony. 1991. *Modernity and Self-Identity: Self and Society in the Late Modern Age*. Stanford, CA: Stanford University Press.

Gilbert, Sandra, and Susan Gubar. 1979. *The Madwoman in the Attic: The Woman Writer and the Nineteenth-Century Literary Imagination*. New Haven, CT, and London: Yale University Press.

Gilkes, Cheryl Townsend. 2001. *If It Wasn't for the Women: Black Women's Experience and Womanist Culture in Church and Community*. Maryknoll, NY: Orbis Books.

Guerrero, Ed. 1993. *Framing Blackness: The African American Image in Film*. Philadelphia: Temple University Press.

Gunning, Tom. 1995. "Tracing the Individual Body: Photography, Detectives, and Early Cinema." In *Cinema and the Invention of Modern Life*, edited by Leo Charney and Vanessa Schwartz, 15–45. Berkeley and Los Angeles: University of California Press.

———. 2006. "Modernity and Cinema: A Culture of Shocks and Flows." In *Cinema and Modernity*, edited by Murray Pomerance, 19–37. New Brunswick, NJ, and London: Rutgers University Press.

———. 2008. *The Films of Fritz Lang: Allegories of Vision and Modernity*. New York: British Film Institute.

Habermas, Jürgen. 1981. "Modernity versus Postmodernity." *New German Critique* 22: 3–14.

———. 2002. *Religion and Rationality: Essays on Reason, God, and Modernity*. Cambridge, UK: Polity Press.

Harris, Cherise A., and Keisha Edwards Tassie. 2012. "The Cinematic Incarnation of Frazier's Black Bourgeoisie: Tyler Perry's Black Middle-Class." *Journal of African American Studies* 16: 321–44.

Harris, Michael W. 1992. *The Rise of Gospel Blues: The Music of Thomas Andrew Dorsey in the Urban Church*. New York: Oxford University Press.

Harrison, Milmon F. 2005. *Righteous Riches: The Word of Faith Movement in Contemporary African American Religion*. New York: Oxford University Press.

Hicks, Derek. 2012. *Reclaiming Spirit in the Black Faith Tradition*. New York: Palgrave Macmillan.

hooks, bell. 2008. *Reel to Reel: Race, Class and Sex at the Movies*. New York and London: Routledge.

Hussain, Amir. 2009. "Islam." In *The Routledge Companion to Religion and Film*, edited by John Lyden, 131–40. London and New York: Routledge.

Jackson, Robert. 2011. "The Secret Life of Oscar Micheaux: Race Films, Contested Histories, and Modern American Culture." In *Beyond Blackface: African Americans and the Creation of American Popular Culture, 1890–1930*, edited by W. Fitzhugh Brundage, 215–38. Chapel Hill: University of North Carolina Press.

Jones, Gayl. 1976. *Eva's Man*. New York: Random House.

Kaplan, E. Ann. 1983. *Women & Film: Both Sides of the Camera*. London and New York: Routledge.

Kierkegaard, Søren. [1843]1986. *Fear and Trembling*. New York: Penguin.

Kilpatrick, Jacquelyn. 1999. *Celluloid Indians: Native Americans and Film*. Lincoln and London: University of Nebraska Press.

Kitwana, Bakari. 2002. *The Hip Hop Generation: Young Blacks and the Crisis in African-American Culture*. New York: Basic Civitas.

Kopano, Baruti, and Jared Ball. 2013. "Tyler Perry and the Mantan Manifesto: Critical Race Theory and the Permanence of Cinematic Anti-Blackness." In *Interpreting Tyler Perry: Perspectives on Race, Class, Gender, and Sexuality*, edited by Jamel Santa Cruze Bell and Ronald L. Jackson II, 32–46. New York and London: Routledge.

Lacy, Karyn. 2007. *Blue-Chip Black: Race, Class, and Status in the New Black Middle Class*. Berkeley: University of California Press.

Landry, Bart. 1987. *The New Black Middle Class*. Berkeley and Los Angeles: University of California Press.

Larkin, Iliana. 2013. "If the Fat Suit Fits: Fat-Suit Minstrelsy in Black Comedy Films." In *Interpreting Tyler Perry: Perspectives on Race, Class, Gender, and Sexuality*, edited by Jamel Santa Cruze Bell and Ronald L. Jackson II, 47–56. New York and London: Routledge.

Latour, Bruno. 1993. *We Have Never Been Modern*. Cambridge, MA, and London: Harvard University Press.

Leab, Daniel. 1973. *From Sambo to Superspade: The Black Experience in Motion Pictures*. Boston: Houghton Mifflin.

Lee, Shayne. 2005. *T. D. Jakes: America's New Preacher*. New York and London: New York University Press.

———. 2010. *Erotic Revolutionaries: Black Women, Sexuality, and Popular Culture*. Lanham, MD: Hamilton.

Lee, Shayne, and Phillip Sinitiere. 2009. *Holy Mavericks: Evangelical Innovators and the Spiritual Marketplace*. New York and London: New York University Press.

Lewis, C. S. 1960. *Mere Christianity*. New York: Macmillan.

Lincoln, C. Eric, and Lawrence Mamiya. 1990. *The Black Church in the African American Experience*. Durham, NC: Duke University Press.

Lindvall, Terry, and Andrew Quicke. 2011. *Celluloid Sermons: The Emergence of the Christian Film Industry, 1930–1986*. New York and London: 2011.

Lyden, John C. 2003. *Film as Religion: Myths, Morals, and Rituals*. New York and London: New York University Press.

———, ed. 2009. *The Routledge Companion to Religion and Film*. London and New York: Routledge

Marsh, Clive, and Gaye Ortiz, eds. 1997. *Explorations in Theology and Film: Movies and Meaning*. Oxford, UK: Blackwell Publishers.

Mask, Mia. 2009. *Divas on Screen: Black Women in American Film*. Urbana and Chicago: University of Illinois Press.

Massood, Paula J. 2003. *Black City Cinema: African American Urban Experiences in Film*. Philadelphia: Temple University Press.

McGilligan, Patrick. 2007. *Oscar Micheaux: The Great and Only*. New York: HarperCollins.

Merritt, Bishetta, and Melbourne Cummings. 2013. *The African Woman on Film: The Tyler Perry Image*. In *Interpreting Tyler Perry: Perspectives on Race, Class, Gender, and Sexuality*, edited by Jamel Santa Cruze Bell and Ronald L. Jackson II, 187–95. New York: Routledge.

Metz, Christian. 2001. "The Modern Cinema and Narrativity." In *Post-war Cinema and Modernity: A Film Reader*, edited by John Orr and Olga Taxidou, 54–65. New York: New York University Press.

Meyer, Birgit. 2003. "Pentecostalism, Prosperity, and Popular Cinema in Ghana." In *Representing Religion in World Cinema: Filmmaking, Mythmaking, Culture Making*, edited by S. Brent Plate, 121–43. New York: Palgrave Macmillan.

———. 2009. "From Imagined Communities to Aesthetic Formations: Religious Mediations, Sensational Forms, and Styles of Binding." In *Aesthetic Formations: Media, Religion, and the Senses*, edited by Birgit Meyer, 1–28. New York: Palgrave Macmillan.

Morgan, Joan. 1999. *When Chickenheads Come Home to Roost: A Hip-Hop Feminist Breaks It Down*. New York: Simon and Schuster.

Morris, Aldon. 1984. *The Origins of the Civil Rights Movement*. New York: The Free Press.

Morrison, Toni. 1970. *The Bluest Eye*. New York: Holt, Rinehart, and Winston.

———. 1992. *Jazz: A Novel*. New York: Alfred A Knopf.

Mulvey, Laura. 1975. "Visual Pleasure and Narrative Cinema." *Screen* 16: 6–18.

Neal, Mark Anthony. 2002. *Soul Babies: Black Popular Culture and the Post-soul Aesthetic.* New York: Routledge.

Nichols, Bill. 2010. *Engaging Cinema: An Introduction to Film Studies.* New York and London: W.W. Norton.

Nietzsche, Friedrich. [1887]2006. *On the Genealogy of Morals.* Cambridge: Cambridge University Press.

Orr, John. 2001. "Introduction." In *Post-war Cinema and Modernity: A Film Reader,* edited by John Orr and Olga Taxidou, 5–11. New York: New York University Press.

———. 2014. *The Demons of Modernity: Ingmar Bergman and European Cinema.* New York and Oxford: Berghahn.

Pamerleau, William C. 2009. *Existentialist Cinema.* New York: Palgrave Macmillan.

Patterson, Robert J. 2011. "Woman Thou Art Bound: Critical Spectatorship, Black Masculine Gazes, and Gender Problems in Tyler Perry's Movies." *Black Camera* 3: 9–30.

Pattillo, Mary. 2013. *Black Picket Fences: Privilege and Peril among the Black Middle Class.* 2nd ed. Chicago: University of Chicago Press.

Persley, Nicole Hodges. 2013. "Bruised and Misunderstood: Translating Black Feminist Acts in the Work of Tyler Perry." *Palimpsest* 1(2): 214–36.

Pinn, Anthony. 1995. *Why, Lord? Suffering and Evil in Black Theology.* New York: Continuum.

———. 2002. "Introduction." In *Moral Evil and Redemptive Suffering: A History of Theodicy in African-American Religious Thought,* edited by Anthony Pinn, 1–20. Gainesville: University of Florida Press.

Pitt, Richard. 2012. *Divine Callings: Understanding the Call to Ministry in Black Pentecostalism.* New York and London: New York University Press.

Plate, S. Brent. 2008. *Religion and Film: Cinema and the Re-Creation of the World.* London and New York: Wallflower.

Radner, Hilary. 2011. *Neo-Feminist Cinema.* New York and London: Routledge

Reid, Mark. 1993. *Redefining Black Film.* Berkeley and Los Angeles: University of California Press.

Richard, Alfred Charles, Jr. 1994. *Contemporary Hollywood's Negative Hispanic Image: An Interpretive Filmography 1956–1993.* Westport, CT: Greenwood Press.

Robinson, Cedric. 2007. *Forgeries of Memory and Meaning: Blacks and the Regimes of Race in American Theater and Film before World War II.* Chapel Hill: University of North Carolina Press.

Robinson, Zandria. 2014. *This Ain't Chicago: Race, Class, and Regional Identity in the Post-soul South.* Chapel Hill: University of North Carolina Press.

Rogin, Michael. 1996. *Blackface, White Noise: Jewish Immigrants in the Hollywood Melting Pot.* Berkeley: University of California Press.

Rousseau, Nicole. 2013. "Social Rhetoric and the Construction of Black Motherhood." *Journal of Black Studies* 20:1–21.

Sanders, Cheryl J. 1996. *Saints in Exile: The Holiness-Pentecostal Experience in African American Religion and Culture.* New York and Oxford: Oxford University Press.

Sartre, Jean-Paul. 1956. *Being and Nothingness: An Essay on Phenomenological Ontology.* New York: Philosophical Library.

Shusterman, Richard. 2000. *Aesthetic Alternatives for the Ends of Art.* Ithaca, NY, and London: Cornell University Press.

Sims, Yvonne D. 2006. *Women of Blaxploitation: How the Black Action Film Heroine Changed American Popular Culture.* Jefferson, NC, and London: McFarland.

Spock, Benjamin. 1946. *The Common Sense Book of Baby and Child Care.* New York: Duell, Sloan and Pearce.

Staiger, Janet. 1995. *Bad Women: Regulating Sexuality in Early American Cinema.* Minneapolis: University of Minnesota Press.

Stewart, Jacqueline Najuma. 2005. *Migrating to the Movies: Cinema and Black Urban Modernity.* Berkeley and London: University of California Press.

Stoehr, Kevin. 2002. "Introduction: Integrating Images and Ideas." In *Film and Knowledge: Essays on the Integration of Images and Ideas*, edited by Kevin Stoehr, 1–16. Jefferson, NC, and London: McFarland.

Studlar, Gaylyn. 1988. *In the Realm of Pleasure: Von Sternberg, Dietrich, and the Masochistic Aesthetic*. New York: Columbia University Press.

Tate, Greg. 1992. *Flyboy in the Buttermilk: Essays on Contemporary America*. New York: Simon and Schuster.

Thompson, Lisa B. 2009. *Beyond the Black Lady: Sexuality and the New African American Middle Class*. Urbana and Chicago: University of Illinois Press.

Thoreau, Henry David. [1854]2014. *Walden*. New York: HarperTorch.

Thornham, Sue. 1997. *Passionate Detachments: An Introduction to Feminist Film Theory*. London and New York: Arnold.

Ukadike, Nwachukwu Frank. 1994. *Black African Cinema*. Berkeley and London: University of California Press.

Walton, Jonathan. 2009. *Watch This! The Ethics and Aesthetics of Black Televangelism*. New York and London: New York University Press.

Watkins, S. Craig. 1998. *Representing: Hip Hop Culture and the Production of Black Cinema*. Chicago and London: University of Chicago Press.

Weisenfeld, Judith. 2007. *Hollywood Be Thy Name: African American Religion in American Film, 1929–1949*. Berkeley and London: University of California Press.

Wharton, Edith. [1905] 2002. *The House of Mirth*. Mineola, NY: Dover Publications.

White, Patricia. 1999. *Uninvited: Classical Hollywood Cinema and Lesbian Representability*. Bloomington and Indianapolis: Indiana University Press.

Williams, Delores. 1993. *Sisters in the Wilderness: The Challenge of Womanist God-Talk*. Maryknoll, NY: Orbis Books.

Wilson, William Julius. 1978. *The Declining Significance of Race: Blacks and Changing American Institutions*. Chicago and London: University of Chicago.

———. 2009. *More Than Just Race: Being Black and Poor in the Inner City*. New York and London: W. W. Norton.

Wright, Richard. [1940]1985. *Native Son*. New York: Harper Perennial Modern Classics.

Yearwood, Gladstone. 2000. *Black Film as a Signifying Practice: Cinema, Narration and the African-American Aesthetic Tradition*. Trenton, NJ: Africa World Press.

ACKNOWLEDGMENTS

In the exciting endeavor of writing the first book-length analysis of Tyler Perry's movies, I received vital assistance along the way. I am enormously grateful to Ryon Cobb for helping me to see the urgency of studying one of our most popular filmmakers and for pressing me to suspend other research projects until its completion. I am equally indebted to Kamasi Hill for introducing me to the groundbreaking work of Judith Weisenfeld. I must also thank Sarah Stanton of Rowman & Littlefield for believing in the project as well as for her encouragement and guidance. I am also grateful to the outside readers of earlier drafts whose trenchant comments greatly enhanced this work. I thank my family and friends for indulging me with countless conversations about Perry's movies, and I also owe a debt of gratitude to numerous colleagues in cinema studies, sociology, and other disciplines for their critical input. Elaine Lee, Carol Ross, and Camille Sutton deserve my deepest gratitude for their exhaustive engagement with every chapter and for offering tremendously useful suggestions for revisions.

INDEX

ABOUT THE AUTHOR

Professor Shayne Lee earned a PhD in sociology at Northwestern University and is currently associate professor of sociology at the University of Houston. He is the author of several books, including *Erotic Revolutionaries: Black Women, Sexuality, and Popular Culture*; *Holy Mavericks: Evangelical Innovators and the Spiritual Marketplace*; and *T. D. Jakes: America's New Preacher*. Professor Lee has been a guest expert on CNN, ABC, Fox, and *HuffPost Live* and has offered editorials and commentary in numerous periodicals and media outlets. His research interests include cinema, religion, media, sexuality, and culture.